USING DIGITAL C

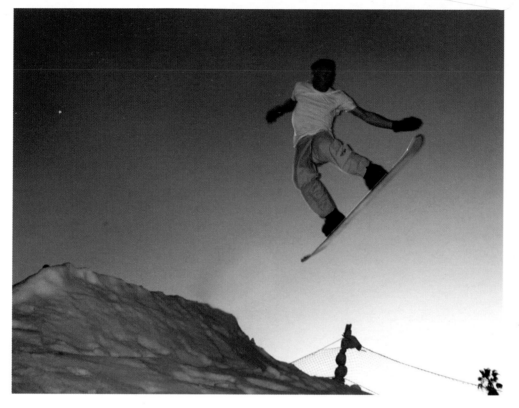

A Comprehensive Guide to Digital Image Capture

Joel Butkowski and Andra Van Kempen

Joel Butkowski, a professional photographer with a studio in Minneapolis, was one of the first photographers in Minnesota to offer digital services to clients of his 4 x 5 work with people, food, and still-life products.

Andra Van Kempen, Butkowski's assistant, recently opened a studio with her husband, photographer Paul Middlestaedt.

Acknowledgments

We would like to thank the companies that helped with the research for this book: Lighthouse, Optical Express, Plug-in Systems Inc., Professional Imaging/National Camera Exchange, and Litson Design.

We would also like to thank Jennifer Butkowski, Steve Engdal, Dr. Fish, Greg Meyers, Andrew Paule, and John Pepper.

The illustrations on pages 22, 23, 24, 25, 27, 28, 29, and 32 were taken from an Agfa publication entitled *An Introduction to Digital Photography*. This volume is one of a series of educational and reference materials for photographers, designers, and printers. For more information, contact Agfa Educational Publishing at 1-800-395-7007, or www.agfahome.com.

First published in 1998 in New York by Amphoto Books, an imprint of Watson-Guptill Publications, a division of BPI Communications, 1515 Broadway, New York, NY 10036

Library of Congress Cataloging in Publication Data
Butkowski, Joel.
 Using digital cameras : a comprehensive guide to digital image capture / by Joel Butkowski and Andra Van Kempen.
 p. cm.
 Includes index.
 ISBN 0-8174-3790-8
 1. Digital cameras—Handbooks, manuals, etc. 2. Photography—Digital techniques—Handbooks, manuals, etc. I. Van Kempen,
 Andra. II. Title.
TR256.B88 1997 97-34329
778.3—dc21 CIP

Manufactured in Malaysia

1 2 3 4 5 6 7 8 9/06 05 04 03 02 01 00 99 98

Senior editor: Robin Simmen
Production manager: Hector Campbell

Picture information:

Half-title page: Michael Corrado
Title page: Studio Fineman
Pages 12-13: Studio Fineman
Pages 46-47: Butkowski Photography

CONTENTS

INTRODUCTION

When you hear the phrase "digital photography," the *National Geographic* magazine cover of the two pyramids that were moved closer in order to create a better visual might come to mind. Or perhaps you think of how using image-editing programs can enable you to create new images. While altering images digitally is certainly possible, *Using Digital Cameras* isn't about manipulating pictures, but about the digital cameras used to capture, or photograph, the image.

This book was written as a comprehensive guide to help those interested in understanding how digital cameras work, and to give an overview of the many different types and models of digital cameras available, and to address some of the concerns you might have regarding the storage and output of images. This book shows samples of how you can utilize digital image capture. We incorporated a gallery section showcasing professional photographers who use digital image capture regularly to demonstrate that it can be used for a wide range of subjects, from simple shots to gallery-quality landscapes.

How This Book Got Started

This book grew out of frustration and confusion. Back in late 1993/early 1994 (ancient times in digital-camera terms), I was looking for information—samples, resource material—anything I could get my hands on that explained the world of digital cameras and image-making. I already had a computer, an investment I'd made in hopes of expanding my business into the computer-retouching area. But this didn't work well: I still had to send my film out to be scanned before I could input the images into the computer. Needless to say, my scanning bills were getting pretty high. Photo CD had recently become widely available, but I didn't like the wait and the hassle involved with shipping images back and forth to be pressed to CD. My clients wanted the work done now.

I looked into a buying a scanner, but I was a photographer and image maker, not a scanner operator. I'd been hearing and reading about digital cameras and started to look toward that direction. I wanted to learn how digital cameras could have an impact on my business. In response, I received sales hype and beautiful brochures that used technical jargon, such as "pixel size," "image compression," and "bit depth." All of these terms were a foreign language to me. I didn't get any real answers to my questions.

The more I searched, the more frustrated I became. But I did learn that going digital involves more than having a camera and a computer; it requires knowing about image file formats, the visible-light spectrum, and making RGB (red/green/blue) to CMYK (cyan/magenta/yellow/black) conversions. That is a lot to absorb. I needed to stand back and figure out what amount of products I shot, who my client base was, and what types of shooting I did (I shoot 70 percent in the studio). I also had to calculate the amount of time and money I would have to invest to learn this new way of shooting. I also had to compare one camera system with another, and to determine what type of lights each camera required. I was overwhelmed by the cost of everything and the salespeople's lack of working knowledge of and day-to-day experience with this new technology.

First, I had to figure out which camera to buy. This would be the cornerstone of all my image-making. I looked at only professional-level cameras. At that time, choosing a digital camera was easier than it is now. In 1994, there were only about six professional-level digital cameras on the market that I thought would work for me. Today there are more than 30, and the list is growing. When you count all the different digital cameras currently available, the number exceeds 100. When I was looking to buy, Leaf and Kodak had cameras out. (Kodak introduced and shipped its first digital camera in 1991; Leaf was next.) Dicomed and Phase One scanning backs were just becoming available. Because the cameras were all relatively new, I didn't have long product track records to go on. Furthermore, the cameras had different features and a wide price range. In 1994, digital cameras cost between $15,500 and $35,000. This is a lot of money to a photographer who complains when film prices go up 5 to 8 percent a roll.

As time went by, I rented a Leaf digital camera back (DCB) for my Hasselblad and started to work with it. I loved the control and the color it reproduced. I was new to digital photography, and I had to rent the Leaf back each time I wanted to shoot. My clients loved what the digital camera could do, but they weren't willing to pay the cost of renting it for a day to photograph only a couple of products. I couldn't convince any clients to just shoot digitally, so I would shoot the jobs both on film and digitally. I would set up the shot, shoot it with film and my 4 x 5 camera, and then have to move it out of the way to set up the Leaf DCB on my Hasselblad and shoot. This made the pictures

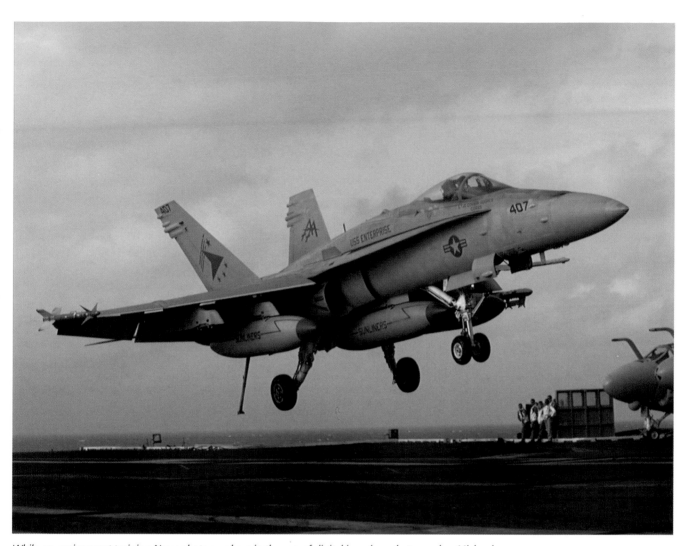

While on assignment training Navy photographers in the use of digital imaging, photographer Michael Corrado made this shot of an F-18 landing on the active flight desk of the USS Enterprise. Taking full advantage of his Nikon E2s camera's ability to shoot at 3 frames per second, he selected shutter-priority mode, matrix metering, and a Nikkor 35–70mm F2.8 AF zoom lens to expose this image.

take twice as long as I thought they should. I figured that if I owned the digital camera, it would be available all the time and be used more. And if I were serious about going digital, sooner would be better than later.

At this point I began to eliminate the digital cameras that weren't suited to my needs. I ruled out the Kodak DCS 420 camera because the image files it produced had too low a resolution—only 4 to 5 megabytes (mb) each—for my use. I eliminated the Leaf DCB because it called for too much switching of camera formats. I shoot a lot with a 4 x 5 camera. There was no local dealer for the Phase One, so I couldn't get one to see.

That left the Dicomed 7520 scanning back. A local dealer said he would have one in a couple of days and invited me to check it out, which I did. After a 30-minute hands-on demonstration, I'd found my camera. I liked

the ease of operation. Also, the Dicomed 7520 was compatible with my computer and gave me large scans to work with; these were on the order of 130 mb. The only drawback was that it required tungsten lights, which I'd never worked with before.

When it came time to start learning how to use the scanning back, I found operating the software easy. It took me only about 20 minutes to get acquainted with the camera. This seemed too simple. I knew that using a digital camera had to be harder than this. Throughout the next six months, though, I discovered that it wasn't as easy as it first appeared to be. So I worked at familiarizing myself with the idiosyncrasies of the camera (all new equipment seems to have some). I wanted to be confident and completely comfortable using it before I did jobs with it.

Once I felt confident, I decided to introduce my clients to capturing a digital image slowly. I knew if I could get some of them to use it, the rest would soon follow. I began by telling them about the camera and how it worked, planting the seed of curiosity and sparking their interest. The next time I was working with a particular client, I recommended digital; many clients agreed to give it a try. At first many of them were cautious, but they also knew that I wouldn't steer them wrong. Most of my clients already worked with computers, so digital seemed the natural way to go. After their first experience with digital photography, they were hooked.

I've had my scanning-back camera since August 1994. Working with it has been great. I wouldn't go back to shooting just film. I also feel in retrospect that it was a good decision for my creative mind, and for my business to survive longterm.

Going digital is both a business change and a lifestyle change. The "I'm just a photographer" attitude no longer exists. In order to keep up with the changing times and the marketplace, photographers need to adapt, as well as to expand their horizons. There will come a time very soon when a supervisor or client will say, "Transparencies? No, I want to go straight to disc."

Using digital cameras isn't limited to professional photographers, and it doesn't call for having a large studio either. Inexpensive consumer models available on the market are perfect for amateur photographers who don't require an expensive digital camera. These are, for example, realtors needing a quick snapshot of a house whose print size doesn't exceed 3 or 4 inches, and individuals using low-resolution images for a Web site. These people would find one of the many consumer models more than adequate.

And as camera prices continue to drop and technology in the digital arena gets better and better, more and more average Joes and Janes will own digital cameras, whereby they'll be able to download their images and send them to family members or friends via modem. We feel that digital image capture will be a necessity for professional photographers. My hope is that this book will help those looking now to buy a digital camera and start to answer most of these questions.

What You Need to Learn

Digital photographers have many of the same concerns that traditional photographers do, including light, shadow, and exposure control. But digital photographers also need to know about such concepts as file formats, monitor calibration, PPI, and dot gain. Digital image capture means

learning about more than just cameras and lighting. It means getting involved in the whole process that takes place whether an image is destined for printing or the Worldwide Web.

What Is Available

Digital cameras can be broken down into several categories. The consumer point-and-shoot models include the Kodak DC20 and the Olympus D200. Fuji, Nikon, Polaroid, Canon, Agfa, and Kodak offer high-resolution, interchangeable-lens cameras that professionals, such as photojournalists, use. Some digital backs, like the Leaf DCBII, the Leaf CatchLight, the MegaVision S2, and the Dicomed BigShot, use area-array chips to fit primarily on the back of medium-format cameras. These cameras are made by Mamiya, Fuji, Hasselblad, and Rollei. The last group of digital cameras is the large 4 x 5 format scanning backs that Phase One and Dicomed manufacture; these are capable of high resolutions.

Because digital image capture is growing in complexity and scope, more advanced technology is being applied to the development of better cameras everyday. Built-in LCD displays are being added to show the image immediately after it is taken. Better algorithms are being developed to compress image information to facilitate getting larger file sizes from smaller CCD chips. And the number of pixels on the CCD chip is increasing, thereby allowing for better image quality and higher resolution.

How Digital Cameras Are Being Used

The wide variety of digital cameras on the market is slowly making its way into the domains that traditional film cameras formerly occupied exclusively. These areas include family-vacation pictures and real-estate photographs for flyers, newsletters, and technical reports. Photojournalism, a profession devoted to getting the news as fast as it is made, is also going digital. Digital photography enables photojournalists to photograph an event, download the images immediately onto a laptop computer, and send them over the wire from anyplace—just so long as there is access to a telephone line—thereby permitting newspapers to get late-breaking news into the paper.

Catalog and high-volume image producers have started to capture their images digitally because of the consistency and the quick turnaround time available. Commercial and fine-art photographers are also exploring the advantages of digital photography. If there is something to shoot, there is a way to do it digitally.

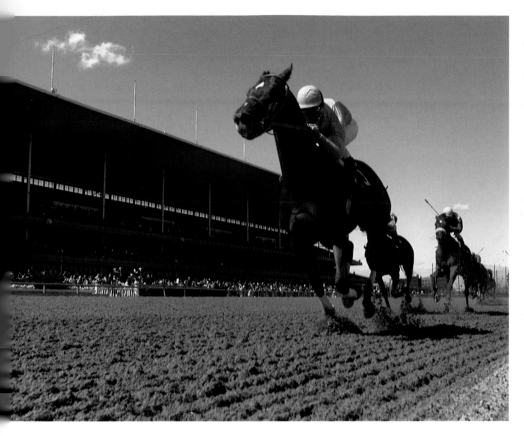

For this shot of a horse race, photographer Michael Corrado used a Nikon E2s set to shutter priority automatic and a Nikkor 20-35mm F2.8 AF zoom lens set at 20mm. Since the E2s fires at 3 frames per second in 7-frame bursts, he had to precisely time the firing of the sequence of the horses finishing the race. Corrado tripped the camera using a Nikon MC-20 remote cord.

Who This Book Is For

This book is for anyone who wants to get acquainted with digital cameras and gain a sense of familiarity with the technology it utilizes, from the hobbyist to the professional photographer. It is meant to provide a broad overview of different areas of digital photography for users of digital cameras, as well as for those involved in selling digital cameras, in the production of output from digital cameras, and in using the image files from digital cameras in their daily work. Here is a list of some of the people who might benefit from reading this book:

• *Professional photographers.* Both portrait and commercial photographers may use digital image capture to have their work stand apart from traditional photography. Shooting digitally allows them to offer more services and a quicker turnaround to their clients, and to become a valuable resource.

• *Amateur photographers.* Digital photography lets them input pictures into their home computer and play with the images, or to send them via e-mail to friends and family.

• *Art directors.* Digital image capture is great for location scouting, ad mockups, and conceptual work. It also permits quick delivery of scanned images, which is important when deadlines are tight.

• *Prepress/press suppliers.* Digital photography lets these suppliers keep up with technology and supplement the services they already offer.

• *Students.* By the time many students read this, digital cameras will account for a larger percentage of the images being created. This book provides a working knowledge of digital photography for those new to the job scene.

• *Photo retailers.* After reading this book, these sellers will become much more knowledgeable about the world of digital image capture and help clients pick the right camera for them.

Photography as we know it won't die. Far into the future, film-based photography will still exist as an art form or as a hobby, in the same way that canning garden-fresh vegetables and quilting are today. The thrill of seeing that first image develop in the darkroom will still be there. But if photographs are destined to be scanned, input into a computer, and digitally tweaked using image-editing programs like Photoshop, Xpres, and Live Picture for use on the Worldwide Web or a printed page, film may be an unnecessary and expensive part of the process. And the clients who know that are going to find photographers who know it, too.

UNDERSTANDING DIGITAL IMAGE CAPTURE

WHY GO DIGITAL?

If it ain't broke, why fix it? If an old way works, why change? That might be the consensus of diehard photographers who feel anything less than film isn't photography, but for many in the design world, from the person designing the layout, to the creative director, to the photographer who is embracing this new technology, digital photography is the best image-making tool since the invention of the computer.

But why go digital instead of continuing to shoot traditionally with film? First, both digital and film photography are a means to an end: capturing an image. Think of it this way. When you drive a car someplace, you decide how you get to your final destination. Do you go the quickest way, or do you take the scenic route? Do you want to drive all the way yourself or share the driving? Digital photography and film photography offer a similar choice. Shooting digitally follows a more direct path to capturing an image than shooting with film. It also gives you instant feedback without using expensive Polaroids. The final image is ready in moments, not days. And you can produce a better image because you have more tools (camera software) at your disposal.

When you work with film, there are more turns in the road, or steps, involved because of the need for film

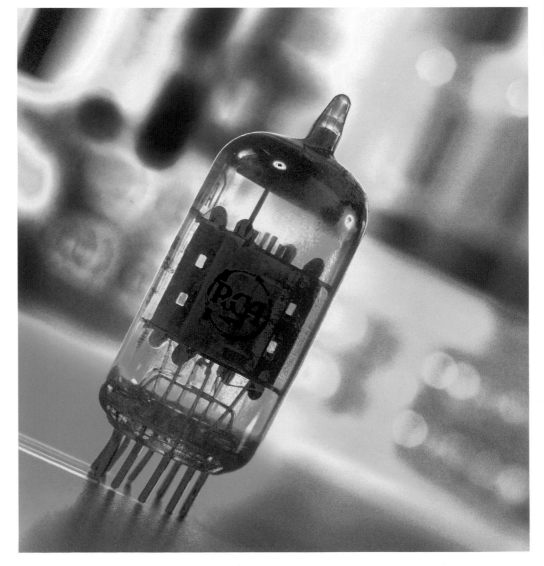

"Radio Tube" is an example of the expansive realm of creativity that you can explore when you conceive and execute a digital-photography treatment of a subject. Photograph © Lightspeed Studios, Inc.

This shot combines the present and the future of photography: traditional film is draped around a CCD wafer, which is the piece of silicon the CCD chip is made of. The image was captured using a Dicomed 7520 scanning-back camera and a 200-watt spotlight.

pretesting, Polaroids, film and film processing, and film scanning. You shoot the image, then hand over the keys to someone who then drives. In digital photography, the captured image goes from the camera to the computer, where it is seen and approved by all involved, and then output to the printed page. With conventional photography, the image is captured on film; the film is processed, scanned into the computer, corrected for such possible problems as color casts, and output to the printed page.

While many photographers are content keeping to the old, familiar, and comfortable path of shooting with film, turning over the responsibility of the driving and the final image to someone else, more and more photographers are finding that the digital road leads to a whole new world of exciting possibilities, and they prefer doing the driving themselves. For photographers incorporating this new technology into their work, digital photography has redefined and expanded their role. Digital photography has given them more creative and technical control by enabling them to remain in the driver's seat longer. Photographers once took the product, photographed it, handed the client film, and were done. The client then had to have the film scanned, and then someone had to make any necessary corrections. This process could take several days. Now photographers can digitally capture the image and input it directly into the computer. Once the image is on the monitor, they are able to do any needed color or image correction, with the client's input, and hand over a more finished product to the client by the day's end.

IMPROVED COLOR ACCURACY

In comparison to conventional photography, digital image capture enables photographers to achieve greater color accuracy in a shorter period of time by using the camera's software to balance the color of the scene. This can remove any unwanted color cast that is present in film-based photography. The exact neutrality of film isn't critical for many uses of photography, but color accuracy is essential for photographing a product, such as clothes. Here, special steps are required. The image produced must be an accurate representation of the real thing, so you need to take certain measures to ensure that the film doesn't have a color cast that affects its neutrality. You can do this by pretesting your film.

When you pretest film, you're checking for any color casts inherent in any one type of film. Even among rolls of the same film type and brand, slight variations in color cast can occur from batch to batch. Batches of film are manufactured in mass bulk, and on each box of film is a batch number. Some photographers purchase film of like batch number to be used at one time to ensure consistent color throughout.

Certain types or brands of film are noted as producing either warm or cool tones. This characteristic is the result of one color in the layer of film emulsion being denser compared to another. For pretesting, first you shoot a neutral-gray target. After the film is processed, you can use a densitometer to measure each color layer in the film to see if one color is more dominant, thereby affecting the neutrality of the film and image. If the densitometer shows that one color is in fact dominating the others, you have to take specific steps to correct the imbalance. To accomplish this, you place a color-correction filter over the camera lens to compensate for the color cast. For example, when you shoot color reversal or transparency film, if the densitometer shows that the film is denser in the blue layer, you'll add yellow, the opposite color on the color wheel, to compensate.

Consider the following little scenario. A client wants a very accurate picture of a multicolored product, like a quilt made up of several different colored fabrics and patterns. To get this shot, you want to pretest your film to insure its neutrality. After the film is processed, you have it read on a densitometer to check for any color shift. With this information in mind, you add the correct compensation filter to the camera to produce the correct colors and once again retest the film. After photographing the product for the second time, you have the film processed. You might have to retest again upon seeing the results.

Once you're satisfied with the color of the film, you photograph the client's product. You then send the film to a photofinishing lab for processing, hoping that variations in the processing chemistry won't cause any color shifts in the film. This would, of course, change the color of the film you just spent a day correcting.

To get this same accurately colored photograph digitally, you would proceed as follows. Your first step is to set up to capture the image by placing a piece of white paper inside the area to be scanned. This piece of paper is used to color-balance the image via the camera's software while doing a "prescan," which is like taking a "digital Polaroid" of the product. Once you color-balance the image and take a final scan of the product, you're done. The color in the digital image is more accurate than that in the traditional image because the color balancing took out all of the casts that would normally exist when using film.

In film, even with all of the color correction, you still get a color-shift variation of about 2 percent to 5 percent. Color shifts occur especially with colors like teal and deep greens, which don't reproduce well on film. But with digital photography, you can see how they look right on your monitor and can make the necessary adjustments on the spot, thereby giving the client a more accurate and correct image.

TIME SAVINGS

Even though some digital exposures can take minutes, the overall speed from image exposure to final image viewing is many times faster than it is with film. Remember, with digital photography, there is no need for Polaroids, waiting for the film to be processed, or waiting for the delivery service to drop off the film. And, after all of this, you might discover that something went wrong during the shooting. With conventional photography, after the image is exposed and input into a computer, you can view it just minutes later.

EASE OF MANIPULATION

Once the image is captured and on the computer screen, digital photography enables you to remove any unwanted elements, such as logos, scratches, or blemishes, undetected with the click of the mouse. Now you see it, now you don't. Because digital photography is just digital information made up of ones and zeros, you can manipulate and retouch images on a computer with accurate control. If your last retouching step wasn't quite right, with just a click of a button, you can "undo" and "redo" the correction until you get it right. You can also copy or duplicate images countless times without having to worry about degradation. The control is now in your hands. The ease is a combination of digitally capturing the image, instantly viewing it, and instantly retouching or manipulating it.

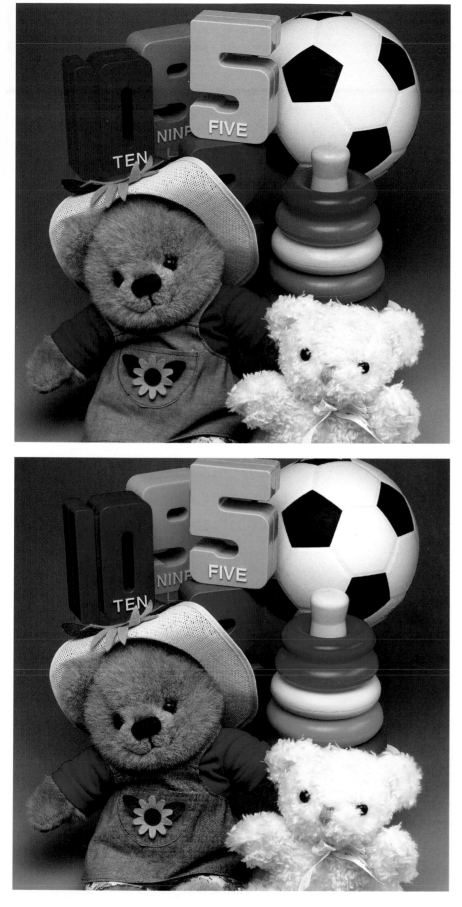

Conventional images shot on film are subject to inherent flaws, such as weak color reproduction and noticeable grain. When the film is scanned and enlarged, these flaws are magnified as well. Scans from film also lose another generation, thereby decreasing image quality. Digital images, on the other hand, are "grainless" and first generation. Also, any color reproduction can be tweaked immediately on the computer monitor using an image-editing program, such as Adobe Photoshop. I photographed this toy setup two ways. First, I shot Ektachrome 100 4 x 5 sheet film; the grain is evident in the detail (top). I used a digital scanning-back camera for the second shot of this colorful setup (bottom).

INCREASED IMAGE CONTROL

Capturing an image digitally enables photographers to view a final image on their monitor, and to enlarge any portion to check for focus and detail—far more than they could by looking at a Polaroid. Digital image capture also permits photographers to change the contrast and color balance via the camera's software. This lets the image makers (photographers) customize the exposure for a particular output, such as a desktop printer, a Web page, or a catalog.

ENHANCED CREATIVITY

Shooting digitally lets you be more creative than shooting traditionally. In fact, instead of just being a photographer who shoots the picture, you are more of a designer of a concept that wasn't possible with film. Digital photography opens the door to a whole new realm of possibilities because it allows you to experiment without worrying about the cost of the film.

Suppose that you want to create an image portraying the concept of time. Before, you probably would have used a multiple exposure, in which different portions of the film are exposed to various elements of the image. This is a lengthy and unpredictable process. Now, when you shoot digitally, the image is captured quickly and brought into the computer where image-editing programs enable you to apply a variety of filters or effects to expand on the concept. You can change the image numerous times and see immediately whether or not the image is exactly what you want.

DELIVERING HIGH-QUALITY IMAGES

Capturing an image digitally enables you not only to be more creative, but to deliver high-quality images that can surpass those made on film. In general, slide film can capture a dynamic range of around only 6 *f*-stops, print film can capture 10 *f*-stops, and high-end digital cameras can capture between 9 and 11 *f*-stops. This allows for greater detail in highlight and shadow areas (which you can see in minutes on the computer monitor). A fine-grained (ISO 100) 35mm slide film has an equivalent resolution of 25 million pixels, while a high-end, scanning-back digital camera, such as the Dicomed scanning-back camera, can capture 40 million pixels of information.

Although some high-end digital cameras can match or exceed the quality of film, consumer and low-end digital cameras capture much less information than a 35mm negative—approximately 640 x 480 pixels, producing about 300,000 pixels—but their quality is acceptable for what they're used for: documentation, Web sites, and e-mail. Midrange digital cameras are primarily used in the professional arena, such as for photojournalism and in-house publications. The image quality that these cameras are capable of is sufficient for the final destination: newsprint, company newsletters, and magazine reproduction. High-end digital cameras are extensively used for their ability to produce image files that are used, in turn, for one-to-one art reproduction, large photographic spreads in brochures, and gallery-quality fine-art photographs.

Many people have commented to me that digital photography simply isn't good enough yet. My response to this remark is simple: When an image is enlarged from a 4 x 5-inch transparency to an $8^1/_2$ x 11-inch or larger image, for example, any dust, film grain, color cast, or color shift that existed on the film is also enlarged. Some flaws can be corrected for, but not all. Film runs the risk of being scratched or damaged by poor handling as well. Digital photography is essentially grainless. It is also first generation, while images from film are second and third generation, and exhibit a loss of quality.

INCREASED PROFITABILITY

Digital photography is the missing link in the digital chain. With everything else going digital, from the image needing to be scanned in order for design firms to work on it, to the printing of the piece, photographing the image digitally eliminates extra steps. So it gets the image into the work flow sooner.

Digital photographers can make or have the potential to make more money than strictly conventional photographers because they can offer their clients more services. Now, besides shooting the product, they perform some prepress services, such as color-correcting, file conversion, and image manipulation. Photographers are seeing an increase in profits and a decrease in expenses because there is no need for Polaroids, film, film processing, and costly film scans. (This is good for the environment, too. Digital photography eliminates the need for all of the conventional-photography consumables, and no harmful chemicals are being poured down the drain.) On the other hand, you need to invest in digital storage devices and batteries, and pay higher electric bills, too.

CLIENT BENEFITS

Besides changing the photographer's role, digital photography has dramatically altered the way clients view and approach a photo shoot. Take instant gratification, for example. Today people want things now if not yesterday.

Photographing a product digitally lets clients view an image on the computer monitor within seconds or minutes of making the exposure. Looking at their product on the monitor is like being able to view a screen-size Polaroid, and clients are able to see immediately what changes, if any, they want to make.

Clients realize the time savings digital photography has to offer, too. If their catalog isn't where it should be by a specific date, they lose money. Shooting digital keeps the production schedule on track and gets the catalog into the customers' hands sooner. The time-savings benefit is particularly noticeable in the field of photojournalism. A photojournalist can download captured images almost immediately to the computer at the office without having to wait to process the film or make prints. As a result, same-day news gets into print. Also, photojournalists are more productive when they work digitally because they're freed up to take pictures, instead of being stuck in the darkroom.

Since digital photography has a quick turnaround, it enables clients to shave days off their production schedule. Clients can bring in the product to be photographed and have it in their layout within minutes of taking the picture. There is no more waiting for the film to be processed and then scanned, or for the possible dreaded reshoot. When digital photography was first introduced, clients were a bit hesitant and skeptical to say the least. Now, as they see for themselves the benefits of digital photography, one of the first questions our new clients ask is if we can shoot digitally.

SIMPLIFYING THE ART DIRECTOR'S JOB

Like clients, art directors experience the time savings that shooting digitally offers. They can bring up the layout on the computer monitor, as well as input the image into the document to check for correct sizing and placement immediately after it is shot. Art directors don't have to fumble with a sizing wheel, a ruler, or a copy machine any more. They also don't have to be worried about correct proportions—within reason, of course. If the image doesn't fit, they can see this problem right away. There is no more guessing off of a Polaroid, either, or having to wait days before the film comes back from the lab.

When talking about digital image capture versus film-based image capture, a person is actually comparing apples to apples. One is red, and the other is green. Shooting digitally and shooting conventionally, then having the film scanned, share many image-taking principles. Both approaches use lenses through which the light bouncing off the image is transmitted and focused onto the film or the CCD chip in the camera. They record an image that is made up of areas of light and shadows onto some type of medium. The two approaches also use traditional aperture openings to control the amount of light entering the lens, and use a shutter speed to control the length of time light is transmitted to the film plane (unless a scanning-back camera is involved). Both forms of photography require a thorough knowledge of lighting. And if the photographer has a feel for the aesthetic, the final image, whether digital or conventional, will look better.

But if your images are destined for the printed page, you'll find that this is when digital photography and film-based photography divide. With a scan from transparency film, you're scanning an original that has imperfections. When you scan film, its grain structure, its color cast, any scratches in the emulsion or on the plastic base, and any contaminants that were present in the film development process are enlarged. Also, transparency film has a great deal of contrast, and fewer steps from black to white. So the file you're working on doesn't have all the detail and color of the original. You'll have to make sacrifices even with the best scanners. Scanners can't pick up all the detail in the film; they're limited by their dynamic range. This feature indicates the scanner's ability to reproduce shades ranging from black to white. The greater the dynamic range, the more shades and the better the scan. Remember, though, that you might need to sacrifice detail in the white areas in order to keep detail in the black areas, or vice versa.

With digital image capture, on the other hand, there is no grain, and there is no physical material that can be scratched or contaminated by chemicals. And since you're scanning or capturing directly from the subject, you can adjust the contrast in order to keep all the detail you want. For example, if you want to maintain detail in the highlights but the shadows are too deep, you simply need to add some light in those specific areas.

HOW THE CCD CHIP REPLACES FILM

For some people digital photography has the same magical appearance that conventional photography did back in the 1800s, but without the smoke. When you hear the word "digital" in relation to photography, all sorts of visions might get conjured up in your head. Digital cameras once seemed futuristic and beyond this lifetime; however, they're becoming increasingly popular and in demand.

Although digital cameras might not emit a puff of smoke, they aren't unlike traditional SLR cameras, either. But their different manner of capturing an image places the two on opposite sides of the same coin. While traditional cameras use film to record an image, digital cameras require what is known as a *charge coupled device*, or *CCD*. This CCD is used to measure and record light energy.

A 2,000-watt Fresnel light was placed above this CCD chip, allowing the light to skim across the chip. This setup accented the CCD chip's detail and color. For this shot, I used a Dicomed 7520 scanning-back camera and a Rodenstock 150mm lens.

The CCD is a multilayered silicon chip. As light strikes the CCD, it first passes through a color filter layer, which determines which color each pixel, or photo site, is sensitive to. The light passes through, striking the electrode layer. This layer is made up of electrodes that form a grid to divide the area into pixels. The last layer is the silicon substrate. Once light enters the lens and strikes the CCD chip, electrons are released from within the silicon substrate in direct proportion to the intensity of the light. These electrons are caught in a potential well and transferred from the well via a shift register.

The CCD chip records each pixel's contents, thereby converting the number of electrons into an analog signal. Next, this electrical signal is assigned a digital value according to how many electrons are released. When combined, these values form the image. You can think of this in terms of a paint-by-number drawing in which each area is painted a certain color according to its number. The same is true when you photograph an image digitally: different numbers of electrons drawn together in a charge packet are assigned their own value or color.

TRADITIONAL VERSUS DIGITAL PHOTOGRAPHY

In order to understand how a digital camera works, it is important for you to understand how digital photography compares to traditional photography. They are similar in several basic ways. First, the camera lens is used to focus the incoming light. Second, the image is captured on some type of light-sensitive medium. Third, the camera aperture determines how much light enters the camera. Fourth, the shutter speed controls the length of time that light enters. Fourth, the lens is used to focus the incoming light.

Traditionally, black-and-white photographic images have been captured on a light-sensitive material that has been coated with an emulsion containing silver-halide molecules. These react to the amount of light reflected off an image. Color film contains dye layers in addition to the silver-halide molecules. When light hits the film plane, the light changes the grain, or the chemical content of the molecules, of the film. These grains are the exposed and developed silver-halide molecules that become areas of black metallic silver and form an image on a negative.

So digital images are captured in much the same way as traditional photographic images. The difference between the technologies is the medium on which the image is recorded and what happens after capture. With conventional photography, a photochemical process is used to convert a latent image into a visible image on the surface of light-sensitive film. With digital photography, on the other hand, the image starts as an electrical signal and is converted into thousands of pixels by an analog-to-digital converter. These pixels are made up of three values: red (R), green (G), and blue (B). The computer monitor uses the RGB values to create each displayed pixel. Thousands of pixels are displayed per second, and as a group they appear on the computer monitor as an image.

FILM'S SENSITIVITY TO LIGHT

Films have a specific sensitivity to light that is determined by their emulsion, which is a light-sensitive coating. This sensitivity is called the ISO rating and indicates the film speed. The ISO rating is dictated by the size of the grains and how tightly packed they are. Films with large grains that aren't too compacted are very sensitive to light, have a high ISO rating, and are considered fast films. This group includes, for example, ISO 400 and ISO 1000 film. Slow-speed films, such as ISO 64 film and ISO 100 film, have small grain molecules that are tightly packed. These films require more light than fast-speed films to produce a proper exposure. This can be accomplished by using a long exposure time or by opening up the aperture to admit more light.

Fast-speed films are better suited to low-light or fast-action conditions than slow films. Fast films are more sensitive to light than slow films because the silver-halide grains found in their emulsion are larger, so they can react more quickly to the light. Keep in mind, though, that when an image shot on fast film is greatly enlarged, the grain is noticeable. This is why most commercial photographers usually prefer slower-speed—and finer-grained—film.

Traditionally, color film is made up of three or more emulsion layers filled with light-sensitive crystals. Each emulsion layer is primarily sensitive to a specific portion of the light spectrum, which can be broken down into red, green, and blue light. Each emulsion layer is paired with a dye layer of the exact opposite color. The processing of the exposed film produces a silver image in each layer of the emulsion; at the same time, a dye image is formed in the opposite color. For example, red-sensitive layers produce a cyan image, blue-sensitive layers produce a yellow image, and green-sensitive layers produce a magenta image. Further film processing removes the silver, leaving behind the dye image to form a negative image. Processing color reversal or transparency film produces a positive image. This is accomplished through a second development stage that introduces transparent dyes. These dyes form the positive image by subtracting appropriate colors from the transmitted light.

A good way to understand how film is sensitive to light involves the light-to-rain analogy (this concept was given to me compliments of Andrew Paule, formerly of Dicomed, Inc.). Rain is made up of little things called raindrops, and light is made up of photons. The brightness of a scene or object can be thought of in terms of "How hard is it raining?" To answer this question and accurately measure the rainfall, you must know how many raindrops falling on a given area over a given time period. For example, a million raindrops falling on the entire state of Arizona over the course of a million years doesn't constitute a lot of rain. But if a million raindrops fall into a measuring cup in a second, it is raining hard.

By definition, brightness equals the number of photons in a given area in a given time. In traditional color and black-and-white photography, visible brightness equals the number of visible photons per unit area per unit time. The visible spectrum is a band or series of colors that the human eye can see. The colors range from blue on one end at 350 nanometers (nm), to green in the middle at 550nm, to red on the other end approaching 800nm. Extending from each end is radiation that the human eye can't see, with ultraviolet radiation past the blue light (at 400nm) and infrared radiation past the red light (at 800nm). Just as a film's emulsion reacts to the amount of light hitting it, digital photography requires a way to measure the brightness being reflected off an object. This is where the CCD chip comes in.

THE CCD CHIP

As light passes through the CCD chip, electrons are freed in the silicon substrate. These electrons are drawn together by a positive charge applied to the electrodes in the pixel (photo site). The brighter the light, the more electrons that are drawn together. The captured electrons

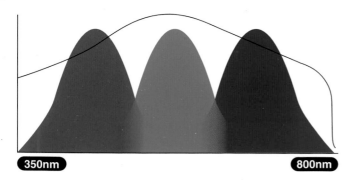

350nm 800nm

The visible spectrum is a band of colors the human eye can see. These range from blue at 350nm, to green at 550nm, to red at 800nm. Beyond the blue range is ultraviolet light, and beyond red is infrared light, both of which the eye can't see. (Illustration courtesy of Agfa.)

are transferred one by one via an analog-to-digital converter and given a digital value according to the number of electrons at each site.

The intensity of the charge in each pixel area (see below) varies according to the amount of light reflected from the image being captured. The brighter an area, the greater the intensity of the charge. The CCD chip then transfers the captured electrons to an analog-to-digital converter, which allots each site a digital value that corresponds to the number of electrons the site holds. These sites are like seats in a stadium that are assigned by section, row, and seat.

When the converter translates the charges into numbers that the computer can understand and when all of these values are read and reassembled in an orderly way, they recreate the original image. The image is composed of picture elements or individual pixels. Each pixel is assigned its own color value, and all of these pixels put together form the image you see on the monitor. If the image is greatly enlarged, you'll be able to see individual pixels. These usually appear as a square.

IMAGE RESOLUTION

The number of pixels per inch (PPI) determines the image resolution. Image resolution refers to how much pixel information a CCD chip is able to capture. The higher the number of pixels, the better the resolution and quality of the image. The smaller the number of pixels, the poorer the image resolution and quality will be. In other words, the greater the number of pixels, the greater the amount of information of an image a digital camera can capture, thereby allowing for more detail and a larger final image size.

The pixel dimension (size) of the chip provides the easiest way to judge image quality and the final output size of the image. Pixels range in size from 6 microns to 15 microns. A ¼-inch CCD using 6-micron technology could have much higher resolution than a ⅓-inch CCD using 15-micron technology. The larger size of the ⅓-inch CCD would cause less image magnification than the ¼-inch CCD. Because of the usually smaller size of a CCD chip compared to 35mm or 2¼-inch film, the lenses used on these cameras no longer capture the same field of view. (The chip size also determines the rating a lens will receive regarding its field of view.)

The resolution of digital cameras varies from model to model. At 300 dpi, a low-end consumer model captures an image size of roughly 640 x 480 pixels, or 2 x 1½ inches. A high-end model at 300 dpi, on the other hand, can capture an image area up to 6,000 x 7,500 pixels, or 20 x 25 inches.

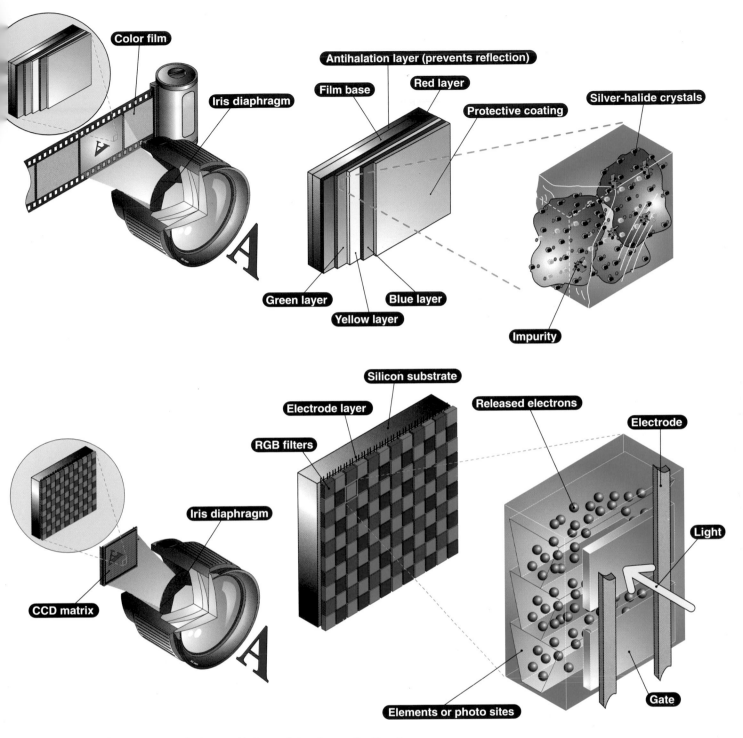

When you shoot film, light enters the lens and is focused sharply onto the film plane, forming an image that is the exact copy of the subject, but upside down and reversed (top left). Black-and-white film has a coating that contains silver-halide crystals (top right); color film is also composed of three or more color layers (top center). When light hits the film plane, it changes the crystals' structure; once exposed, they form an image on the film. With digital image capture, light enters the lens and strikes the CCD chip's surface (bottom left). Electrons are released from each photo site of the silicon substrate in direct proportion to the light intensity (bottom center). These electrons are transferred via an electrode that acts like a gate (bottom right). Each site is assigned a digital value according to how many electrons are released, or how light or dark it is. These combined values form the image. (Illustrations courtesy of Agfa.)

In addition to being dictated by the type and size of the CCD chip, image quality is also determined by pixel depth, or how much information the CCD chip is able to capture. Pixel depth is also known as "bit depth" (see below). Bit depth is the number of bits representing a pixel in an image, which determines its color or tonal range. A bit is a binary digit, composed of a one or a zero. These bits form different combinations of numbers.

A 1-bit image, such as text, is either on or off, black or white. A 2-bit image has four number combinations of 00, 01, 10, or 11. For each additional number of bits, the number of combinations is factored by the power of 2. So, for example, a 3-bit image has 8 combinations (2^3, or $2 \times 2 \times 2$), and a 4-bit image has 16 combinations (2^4, or $2 \times 2 \times 2 \times 2$). The greater the bit depth, the more combinations possible. This allows for more colors and tonal range, which, in turn, produces greater image detail. Adobe Photoshop, a computer-editing program, uses eight bits of color per red, green, and blue channel to give 256 different shades of color or tonal ranges of each color per channel. If your monitor has a 24-bit display capacity, Photoshop produces a total of more than 16 million colors (256 x 256 x 256).

Bit depth is limited by the camera's support amplifier and the A/D converter. Most CCD chips are capable of capturing a tonal range of 8 *f*-stops for consumer models, and 9 to 11 *f*-stops or professional cameras. For each additional *f*-stop, the tonal range is doubled. In order to maximize tonal information during A/D conversion, the bit depth of the camera should match or slightly exceed the *f*-stop capability. If the camera can capture a dynamic range of 8 *f*-stops, the A/D converter should have a higher bit number. Since most converters are evenly numbered, this number would be 10.

Image quality is only as good as the weakest link in the chain. Think of it like a stereo. Suppose that you have a powerful antenna that is able to pick up a strong signal, you turn up the volume, but you have horrible speakers; you won't get good sound. This is similar to having a good CCD chip and amplifier but a poor A/D converter.

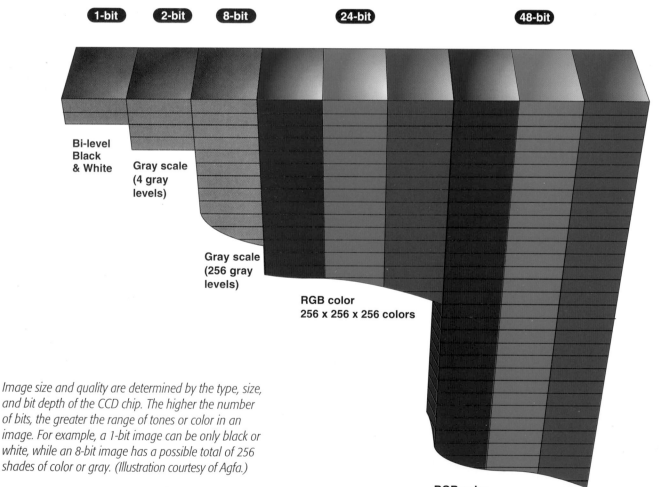

1-bit **2-bit** **8-bit** **24-bit** **48-bit**

**Bi-level
Black
& White**

**Gray scale
(4 gray
levels)**

**Gray scale
(256 gray
levels)**

**RGB color
256 x 256 x 256 colors**

**RGB color
65,536 x 65,536 x 65,536 colors**

Image size and quality are determined by the type, size, and bit depth of the CCD chip. The higher the number of bits, the greater the range of tones or color in an image. For example, a 1-bit image can be only black or white, while an 8-bit image has a possible total of 256 shades of color or gray. (Illustration courtesy of Agfa.)

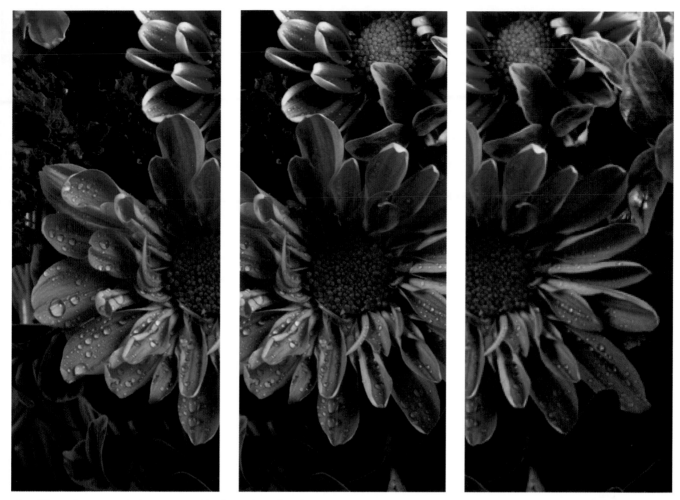

The different image resolutions captured by the various digital cameras on the market correspond to the quality of the final photographs. The greater the resolution, the smoother and more detailed the image. Here, the same flower setup is shown at 72 ppi (left), 150 ppi (center), and 300 ppi (right).

And having a really good stereo with big speakers but an antenna that can't pick up anything is like having a good amplifier and converter but a poor CCD chip.

Andrew Paule (formerly of Dicomed, Inc.) offers another analogy, this time to help clarify the CCD-chip concept. CCD chips can be compared to automobiles. A car's tires dictate to some extent how fast you drive. Technically, the car might be capable of going 200 miles per hour (mph), but if driven at such speeds, the tires will most likely blow apart.

Adobe Photoshop, a computer-editing program, supports images with 8 bits of information per color (red, green, and blue), thereby providing 256 different shades of color or gray. Film has only 32 levels or tones of gray. Pixel (bit) depth defines how many tones or color every pixel in an image is assigned. Twenty-four bits of information will result in millions of colors—and a photographic-quality image.

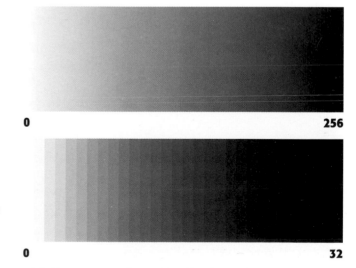

Digital image capture is capable of 256 levels of color or gray, which produces a smooth gradation of tones (top). Film is capable of only 32 levels ranging from white to black (bottom). (Illustration courtesy of Agfa.)

The same is true for most digital cameras with a bit depth of 12 or 14. Color images usually consist of 24-bit color information (8 bits for each primary color, red, blue, green). Most software applications, from the conversion of the signal in the CCD chip to the print from the digital word onto paper, support only 8 bits per color as well. Higher bit depth, known as *super sampling,* does allow for finer detail in highlight and shadow areas. But if the signal is converted by an A/D converter with only 10 bits per color, or is printed on a printer capable of handling only 8 bits per color, the additional information is discarded. The only way to emphasize a certain portion of the tonal range is to use camera software that lets you set the exposure curve before you take the picture.

Keep in mind that one problem you might encounter when using a digital camera with poor bit depth is the phenomenon known as "blooming." Blooming occurs when electrical charges exceed the CCD-chip storage capacity of electrons in each pixel, spilling over to the next adjacent pixel. This is usually caused by extreme overexposure of an area, showing up in the highlight regions of an image, thereby producing a flare effect.

IMAGE COMPRESSION

Most point-and-shoot cameras utilize some sort of image compression to shrink file size and maximize storage space. They usually offer two modes (but sometimes

When part of a digital image is greatly overexposed, blooming occurs. The resulting flare effect shows up in the highlight regions of an image.

three) of compression quality. The less compression used, the larger the file size. While a higher number of smaller files can be stored, they typically are of lesser quality.

Two methods of image compression exist: lossy and nonlossy. Once nonlossy images are uncompressed, they are just as good in terms of quality as the original. In other words, they don't "lose" any resolution. Lossy images permanently discard information to shrink the image. Since data is lost with each compression, repeated compression can degrade an image considerably.

CCD BACKS

Digital cameras use two types of CCD-chip sensors to capture images: area-array sensors, which are also known as "matrix-array sensors," and linear-array sensors. Both types of CCD chips have strengths and weaknesses. Each type is better suited to certain applications than the other. The intended use of the image, the subject matter being photographed, and the amount you're willing and able to spend will determine which type of CCD chip is required. While one chip might have a disadvantage in one area, it makes up for it in another.

Linear-Array Cameras

A linear-array camera's CCD back has its pixels all aligned in a row and scans information line by line across an image, much like the way a copier scans a document reading information from one end to the other. In order for a linear-array camera to capture full RGB color information in a single pass, a "trilinear" CCD chip is used where each of the three rows of CCD elements is coated with a colored filter that is red, green, or blue. So trilinear scanning-back cameras capture full RGB color data because each row captures RGB information. With the Dicomed scanning-back camera and the Phase One Power Phase, for each picture pixel element, all three colors are captured as each separate filtered element passes over. Each pixel, which is 12 microns wide, is about 1/5 as wide as a human hair.

As the linear array moves across the film plane, it exposes one line at a time. These types of cameras are capable of producing very large, high-quality images exceeding 100 megabytes (mb) in size. Scan sizes in this range are most needed when you copy large artwork in a 1 to 1 ratio and when the output is a big display poster.

But because these cameras scan only one line at a time, scan times vary from several seconds to several minutes. As a result, the subject being photographed must be stationary. Also, scanning-back cameras require a constant light source. This means that most work must be done in the studio. But some field and location

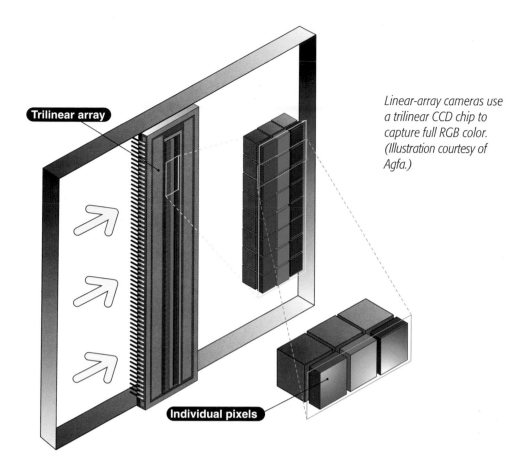

Trilinear array

Individual pixels

Linear-array cameras use a trilinear CCD chip to capture full RGB color. (Illustration courtesy of Agfa.)

photographers using a Dicomed 4 x 5 scanning back, which is able to operate off an external battery pack, can take their digital cameras on location by using a laptop computer to control the exposure of the image. Once the image has been captured, it is stored in the Dicomed's 1-gigabyte hard drive. An example of a linear-array camera is the 35mm Leaf camera; the 4 x 5 Dicomed 7250 digital camera and the Phase One Power Phase are trilinear-array scanning-back cameras.

Area-Array Cameras

On these cameras, the CCD elements are arranged in a matrix, which is either a square or rectangular format. The matrix captures the entire image in one exposure, but it might require several exposures to build full color information. Most digital cameras use a matrix or area CCD chip because of their ability to capture an image instantaneously; in that way, they operate like traditional cameras.

The exposure time of an area-array camera is short, 1/30 sec. to 1/200 sec., thereby allowing for the photography of animate objects. Some cameras have a very short exposure time, exceeding 1/2000 sec. Canon's line of professional 35mm cameras offers an exposure

time of 1/8000 sec. However, since CCDs are monochromatic, they can detect only black and white. So the challenge is to capture color images. CCDs must use a filtration system to separate incoming light into its three component colors of red, green, and blue. Area-array cameras do this several different ways.

One-Shot, Three-Chip Method

The first method is the "one-shot, three-chip" approach, which captures all of the color information in one exposure (see top diagram on page 28). As the light enters the camera lens to strike the CCD, a beam splitter, such as a prism, separates the light at each individual chip; each chip records color information for either red, green, or blue. The three images, each representing one color, are then realigned with the aid of software to form a complete RGB range.

Because the human eye is most sensitive to the green spectrum of light, some three-chip digital cameras are made with two of the arrays registering green color information; the third array is made up of a mosaic of red and blue filters. Since gaps in the red and blue information exist, interpolation is used to create additional color information (see below).

Area-array cameras capture color information three ways. In the "one-shot, three-chip" method, the light entering the lens is separated; three chips record red, green, or blue color information, and the images are realigned to form a complete RGB photograph (top). In the "one-shot, one-chip" approach, the individual pixels are coated alternately with RGB filters in either a striped (center) or mosaic (bottom) pattern. (Illustrations courtesy of Agfa.)

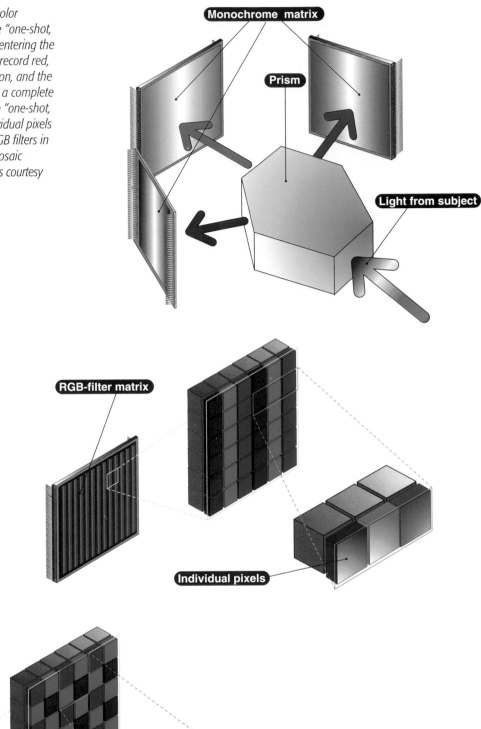

Monochrome matrix

Prism

Light from subject

RGB-filter matrix

Individual pixels

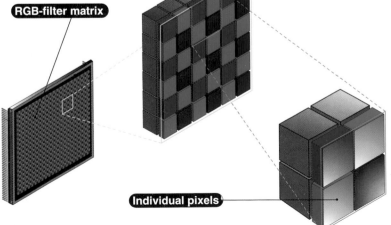

RGB-filter matrix

Individual pixels

Three-Shot, One-Chip Method

The second method that area-array cameras use to capture color information is the "three-shot, one-chip" approach (see diagram below). Here, the camera uses a filter wheel through which three individual exposures must be made to record information for each color in the light (red, green, and blue). The three separate images are then combined using the camera's software.

Problems might arise when the camera software improperly realigns the images, which show up as out of register. Because three distinct shots must be taken to capture the color information, the photographer using an area-array camera is limited to still objects. Also, variations in light emissions during exposure can alter the color balance of an image. A three-shot digital camera can capture monochromatic (black-and-white) images of objects that are moving. This is because the color filter wheel, besides having three separate colored filters—one each for red, green, and blue—also has a clear filter that is used to capture black-and-white images. And since only

one exposure is needed, the object doesn't have to be stationary.

One-Shot, One-Chip Method

The third method is the "one-shot, one-chip" approach. Here, a CCD chip is used with a "striped-array" or mosaic filter; the elements are coated alternately with red, green, and blue filters in either a striped or mosaic pattern (see center and bottom diagrams opposite). Some chips have more green than red and blue to accommodate the fact that the human eye is more sensitive to green in the visual spectrum, as well as the fact that using more green improves resolution.

Each photosensitive pixel captures just one color and must get additional color information from neighboring pixels, which is known as "interpolation." Interpolation might pose problems if incorrect color information is assigned to pixels. This is usually most apparent around high-contrast edge areas, such as black text, where colored fringes "bleed" into the text.

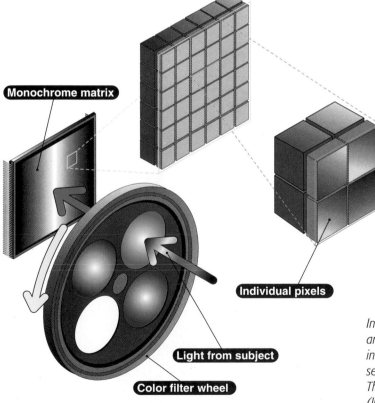

Monochrome matrix

Individual pixels

Light from subject

Color filter wheel

In the "three-shot, one-chip" approach, an area-array camera uses a filter wheel to record information for red, green, and blue in three separate exposures, which are then combined. This method is limited to still-life subjects. (Illustration courtesy of Agfa.)

LIGHTING FOR DIGITAL PHOTOGRAPHY

Lighting for any form of photography, whether it is for film-based cameras or digital image capture, plays an important role in giving life to the object being photographed. Through lighting, photographers are able to be creative and set themselves apart. And they simply can't hide bad lighting. With traditional photography, however, basically any type of light would work. This includes strobe and tungsten.

Basically, in black-and-white photography, the type of light being used to illuminate the subject doesn't matter, whether it is candle light, the sun, or fluorescent bulbs, just as long as the amount of light is sufficient. But with color film, the type of lighting used becomes apparent when you look at the pictures. Although your eyes ordinarily don't detect the differences in lighting because of your own perception of how things "should" look and

Lighting for photography has a scientific side as well as an artistic element. Various lighting techniques can create a "visual feel" or mood in a photograph. Light and the use of shadows help to define the image and place or decrease emphasis.

because you compensate for slight discrepancies, color film does react to different types of light. What might have looked "right" to you in an office setting under fluorescent lighting now looks sickly green on film. While the green cast can be compensated for during printing if you used color-print film, when you use slide film what the film sees is what you get when the film is processed.

In order to achieve the correct color balance when shooting color-transparency or -negative film, you might need a color-correction filter. Another option is to use the correct type of film for the lighting conditions. In an office setting with fluorescent lighting, for example, placing a magenta filter over the camera lens will compensate for the green cast that the fluorescent lights produced.

Fortunately, you don't have to be so concerned about color correction when working with a digital camera. The white-balance capabilities that many digital cameras have can correct the color balance of the scene. What you do have to consider, though, is whether the illumination is produced by a quick flash, such as a strobe, or by a continuous light source, such as a tungsten/halogen lamp. This is because of the varying sensitivity and configuration of the CCD chips used to record the image.

Many different lights are available for digital photography. The type of light used is dependent on the type of digital camera being used, a linear-array (scanning-back) camera or an area-array camera. Scanning-back cameras work only with a constant light source because of the longer duration of the scan. Most area-array cameras, though, operate like traditional film cameras: they capture the image via a "one-shot" or "three-shot" process, and they can use strobe lighting as well as a constant light source. So, lighting for digital photography isn't so much film-specific as it is CCD-specific.

STROBE LIGHTING

This kind of illumination, which is also known as "flash," has been the preferred lighting tool for most conventional photographers. The light weight, the variety of sizes, and the versatility of strobes, as well as the amount of light they produce, make them simple to work with. Light is emitted in a quick burst by a high-voltage electrical discharge lasting anywhere from 1/100,000 sec. to 1/250 sec. Strobes are daylight-balanced, measuring in temperature between 5500K and 6000K. This means that they are the same color temperature as the midday sun. Strobes are also compatible with any instant-capture digital camera that is capable of using synchronized flash.

You can easily alter the intensity and direction of the light that strobes emit can by placing various light modifiers over the strobe head. These include softboxes,

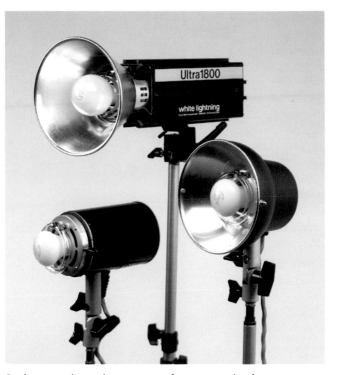

Strobes come in varying amounts of power, ranging from 400 watts to more than 1,800 watts. They are either self-contained, such as White Lightning's Ultra 1800, or have a separate flash head and power-pack system.

grids, snoots, and gels. Softboxes range from 1 foot to more than 6 feet in size. Softboxes help to direct the illumination and soften the quality of the light through the use of a diffusion panel. Grids are honeycomb-like screens that narrow the beam of light and come in various 5- or 10-degree increments. Snoots are long, tubular devices that attach to the front of the light source to direct the light and act as a spotlight. Gels are colored heat-resistant plastics that are placed in front of the strobes to change the color of the light. The effects are similar to that of stage and concert lights.

CONSTANT HARD LIGHTING

On the opposite side of flash units are constant light sources. These emit either a hard or a soft light (see page 34). Hard-light sources can be modified to produce a soft light, but soft-light sources can't be changed to produce a hard light. Also, hard-light sources are more directional than soft-light sources for two reasons. First, the light is projected from a smaller area in comparison to the size of the subject, so it is harsh and results in a more defined delineation between the light and shadow portions of the image. For example, the sun produces very distinct shadows at noon. Second, there is more output per lamp.

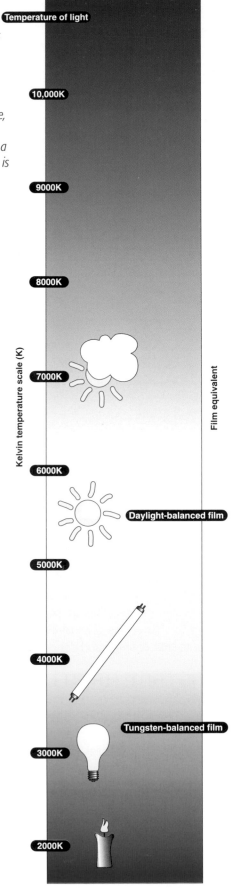

The temperature of a light source, indicated in degrees Kelvin (K), is determined by the color of light it produces, not how hot it is. For example, the early-morning sun, which gives off a warm, golden glow, is about 3500K, while cloudy sunshine is rated 7000K. (Illustration courtesy of Agfa.)

Temperature of light

Kelvin temperature scale (K)

10,000K

9000K

8000K

7000K

6000K

Film equivalent

5000K — Daylight-balanced film

4000K

3000K — Tungsten-balanced film

2000K

The Sun

One of the biggest constant light sources available, free of charge, is the sun. Sunlight can be either hard or soft lighting, depending on cloud coverage. If it is cloudy, the sunlight will be soft. You can see this by looking for your shadow on an overcast day.

Sunlight also has a great range of color. As the sun rises and travels across the sky from morning, to midday, and then to evening, the color of the light is continually changing. The quality of light ranges from a warm, golden glow in the early morning or early evening, to more neutral at high noon, to slightly bluish if the sky is overcast. The quality of the light source, in this case the sun, is measured in degrees Kelvin (K).

When light sources give off light, they release heat. The color of the light produced varies from source to source because the temperatures at which they burn differs. Because of these variations, each light source emits a different mixture of wavelengths to produce the colors of the illuminated object. Light is measured as a temperature because when an object, such as a piece of metal, is heated, it emits light ranging from red, to yellow, to white, and would eventually emit blue light if no chemical or physical change occurred. The number assigned as a color temperature isn't the temperature at which the light source burns; it indicates the color of the light produced. Candles, for example, are rated at 2000K because of the yellowish-red color they produce, not because they burn at 2000°F.

Picture in your mind, for example, the color of the sun's rays at sunrise and sunset. Both early-morning sunlight and evening light produce a warm, golden glow that is about 3500K. This golden color is the result of the sun's rays traveling through atmospheric particles, such as dust. This warm glow is similar in color temperature to a regular household bulb. For that reason, pictures shot indoors on daylight film balanced at 5500K tend to have a yellow cast. During the afternoon when the sun is high in the sky, the temperature of the sun's light rises. This produces the neutral or bluish tint that is visible in photographs shot during that time of day (see diagram opposite).

Tungsten Lights

One type of constant hard-light source is incandescent or halogen tungsten lights. Tungsten lights produce a light temperature in the 2800K to 3400K range and are the same type of bulbs typically used in household lamps. At this light temperature, lamps emit a warm, yellowish-red light. So, for example, family photographs taken indoors might be yellowish in color if no flash was used or if a lamp is visible in the pictures.

Tungsten lamps emit a continuous light that is balanced around 3200K. These self-contained units vary in size, ranging from a powerhouse 20,000-watt lamp, to a large 5,000-watt lamp to a 150-watt lamp.

Although continuous-emission HMI lights look similar to tungsten lights, they actually emit a light temperature closer to that of daylight, around 6500K. HMI lamps have varying power output, ranging from a small 125-watt lamp to a large 18,000-watt lamp.

Film made for tungsten lighting is blue-biased, which neutralizes the red hue emitted from the light. Tungsten lights are an easily controlled light source. They can project beams of light and can be modified with softboxes for an even blanket of light.

Tungsten lights used for digital-photography or studio-photography purposes are also known as "hot lights" because of the tremendous amount of heat they produce while in use. You must be very careful when using these lights to photograph perishable items. Be aware, too, that tungsten lights are big power drainers and require electrical outlets capable of supporting their rather significant energy requirements. Much of their energy is wasted through heat loss.

HMI Lights

These lamps are a hybrid version of mercury-vapor lights, which are found in street lamps and gymnasiums and emit discontinuous green-blue and ultraviolet wavelengths. HMI, which stands for "hydragyrum medium-arc-length iodide," lights are available in fixture styles like tungsten lights but don't produce the intense heat of their counterparts. HMIs emit a light temperature close to that of daylight, 5600K. They're known as "discharge lamps" because the light is produced by exciting gases (the elements within these gas particles increase in speed to produce light).

Lamp life is rated to last up to 750 hours, but for every hour of lamp usage, the color temperature falls by about 0.5K to 1K, depending on the wattage of the lamp. As a result, if you use several lamps bought at different times, their color temperatures might vary, thereby producing an inconsistent quality of light. HMI lamps range in size from 125 watts to 18,000 watts.

According to OSRAM Corporation, a large producer of HMI lights, HMI lamps generate three to four times the light of conventional tungsten halogen lights, yet consume up to 75 percent less energy for the same light emissions, which is also known as "luminous flux." A drawback to HMI lights is that they're tethered to a ballast that operates the light via a system of chokes, transformers, capacitors, and relays.

Fortunately, these traditional magnetic ballasts for the HMI lights, which are big and heavy, are being replaced by smaller, more lightweight electronic ballasts. These new ballasts also produce a continuous output by turning

the lamp on and off 10,000 times per second, which is a marked improvement over the 120 times per second on-off rate of the old magnetic ballasts. (A fast shutter speed is only a drawback when old magnetic ballasts are used with a slower on-off rate. The new, fast electronic ballasts, which use a square wave rather than a sine wave, always appear to be continuous.) All HMIs require high-voltage at ignition when turned on, and don't reach maximum output or stable color temperature until several minutes after start-up.

CONSTANT SOFT LIGHTING

The second type of lighting available for digital photography comprises soft-light sources, such as fluorescents. Fluorescent lighting is primarily used with scanning-back cameras, which require a constant light source. (Photographers working with area-array cameras most likely will use their traditional strobes as sources of light.) Fluorescent light sources have a bigger area of transmission but at lower power than hard lights. Fluorescent light contains gases that react with the phospors inside them to produce a soft light that looks milky white in color.

Fluorescent Lights

Like HMI lights, fluorescent lights are discharge lights and require a ballast. Fluorescent lights traditionally emit a light that fluctuates, turning on and off 120 times per second. The human eye can't detect this fluctuation, but it produces a flicker that shows up in digital scans. Fortunately, several manufacturers now make flicker-free fluorescents, which are also known as "high-intensity fluorescents." Although these lights do actually flicker, their on-off rate is so high—around 167 times per second—that the camera can't detect the fluctuation.

The benefits of using fluorescent lights is that they are energy-efficient and don't emit heat. When you work with fluorescent lights, just as when you work with HMIs, it is important that you are aware that once the lamps burn out, you must recycle them. Don't simply throw them in the trash; they contain mercury and phosphors. There are three major manufacturers of flicker-free fluorescents meant for photographic purposes: Videssence, Kinoflo, and Scandles.

Videssence Lights

These belong to the group of luminescent light sources, which are capable of producing sustained light. The

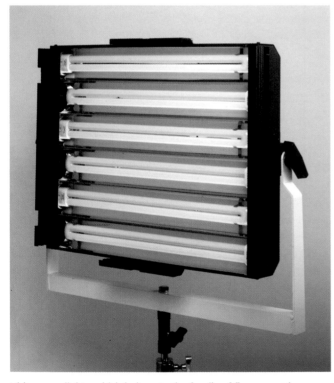

Videssence lights, which belong to the family of fluorescent lamps, produce a soft light, in both their daylight- and tungsten-balanced forms. This 2 x 2-foot light has a metal housing and an additional electrical-voltage stabilizer to prevent the light from dimming during electrical-power fluctuations.

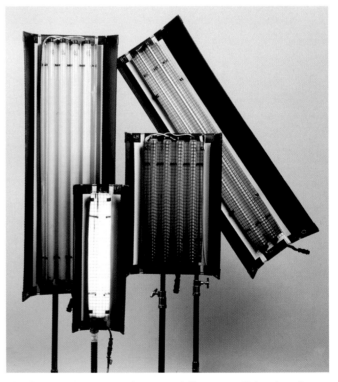

Kinoflo manufactures another type of fluorescent light. These lamps are available in both daylight- and tungsten-balanced varieties and range in size from 6 watts to 110 watts.

Scandles are compact fluorescent tubes that come in daylight- and tungsten-balanced forms. Their 600-watt output is equivalent to that of a 1,600-watt tungsten lamp.

Videssence lights are available in three main sizes: the Baselight 110, the Baselight 220, and the Baselight 330. Lamps are available in both tungsten-balance and daylight-balance forms. These lamps are quite energy-efficient because a great deal of their energy is put into the red, green, and blue spectrum.

The Baselight 110 outputs 9,000 lumens while consuming only 125 watts of energy, the 220 outputs 18,000 lumens while consuming 250 watts of energy, and the 330 outputs 27,000 lumens while consuming 375 watts of energy. (A lumen is a unit of measurement equal to the luminous flux emitted by one candle.) Videssence lamps aren't heat-emitting, so no cool-down time is necessary. This is especially beneficial when you're shooting in small, confined areas and when shooting perishable food.

Because Videssence lights are compact, it is easy to carry them, store them, and to operate in tight spaces. They have low power requirements and can even be powered by batteries and a small inverter. The purchase price of a Videssence unit ranges between $600 and $2,000 per fixture, depending on the size. Keep in mind, though, that the long lamp life—10,000 hours—offsets the cost.

Kinoflo Lights
The second type of fluorescent light is made by Kinoflo. Traditionally, fluorescent lights emit a greenish spike cast. The poor color rendering in the final images makes these lights unacceptable for photographic work. In order to solve this problem, Kinoflo designed the KF55 (daylight) and the KF32 (tungsten) lamps. These lights are specifically engineered to correspond to the spectral sensitivity of film and the electronic imaging media.

The lights were also created with location work in mind and were built to be both lightweight and durable. Tube sizes come in 2-, 4-, and 8-foot lengths. The ballast is a separate unit from the light, which keeps the unit as light as possible and easy to conceal. Unlike HMIs, Kinoflos don't require a huge start-up voltage, and they use little energy draw while in operation.

Kinoflo also offers small lighting units with 5-, 9-, or 12-inch tubes, such as the Mini-flo and the Micro-flo lights. These miniature lighting systems are ideal for table-top work, as well as for when the light source must be concealed. Kinoflo's line of lighting products now include the Wall-O-Light, a 10-lamp fixture that when used in conjunction with others creates a virtually seamless wall of light. Start-up costs for a Kinoflo unit is dependent on the size of the system. They range in price from $400 for a single 2-foot light to more than $2,000 for the Wall-O-Light.

Scandles
The third type of fluorescents is called Scandles. These compact lights come in a cluster of tubes that look like small prongs. One of the advantages to using scandles is the ability to add softboxes and other light-modifying devices to them. As with most other fluorescent lights, the drawback to using Scandles is the great light dropoff. In order to maximize the light from a Scandle, you must position it very close to the object you're going to photograph.

The bandwidth of light from a Scandle closely matches the one that CCD chips need to record an image. Scandles are a new model of lamps that emit daylight color balance but at low heat and low power consumption. These lights are quite promising for digital photography, but as of this writing aren't very bright and produce flat, low-contrast lighting.

STORING DIGITAL IMAGES

Once an image is captured digitally, you need to store it some place, whether to the computer's hard drive, to an external drive, or on some type of removable media. It used to be fairly simple to store and move information around back when my largest file took up a few kilobytes (kb) and a 3½-inch floppy disc could hold my life's history. In fact, the 3½-inch floppy handled small files quite nicely. In addition, these discs were convenient, small, and inexpensive. Everybody used them.

Today, however, 3½-inch floppy discs are the equivalent of pennies: nobody saves them, and it takes a lot of them to amount to anything. As file sizes have grown, the need for high-capacity storage has, too. And to meet that need, an array of storage devices and media has flooded the market. With the use of large-scale graphics and 100-plus megabyte image files, storing images safely, quickly, and easily is big business.

SELECTING A STORAGE SYSTEM

You can transport files between the photography studio, the advertising agency, and the printing house most conveniently by using some type of removable media. When you first look into buying storage devices and media, the main factors to consider are: (1) the cost of both the drive and the removable media, (2) the amount of information that you can store, (3) the life of the

It is very important to protect and save your images. I made this shot with a Sinar F1 camera, a Schneider 90mm lens, and a Dicomed 7520 scanning back. I directed a 6-inch, 2,000-watt Fresnel light through two black cards to create the beam of light.

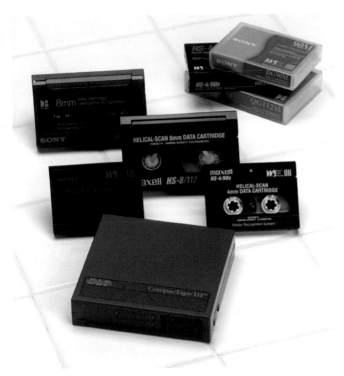

Digital audiotapes (DAT) look a lot like music cassettes and come in different sizes and lengths. DAT is used mainly for long-term archival purposes, not for the quick access of images.

Other members of the magnetic-media family include 3½-inch floppy discs, SyQuest discs, Zip discs, and Jaz discs. While these storage options don't hold as much information as DAT, they retrieve and transfer image files faster.

media, and (4) the speed at which information can be retrieved from and written to the disc. This is known as the data-transfer rate, which is drive-dependent.

Most storage and transportation media used to transport or archive digital images can be broken down into two categories: magnetic media, such as DAT tape, diskettes, and 3½-inch floppy discs, and nonmagnetic media like opticals and CDs. There is also a hybrid of the two known as "magneto opticals."

Digital images can also be stored directly onto the camera's removable flash memory cards, which are also known as "PCMCIA cards." These cards, which contain tiny random-access memory (RAM) chips, are able to store from 64K to more than 170 megabytes (mb) of information. A PCMCIA card looks similar to a credit card, acts like a 3½-inch computer floppy disc, can be filled to capacity, removed, and exchanged for another card. These memory cards don't have any moving parts and are, therefore, able to be used over and over without wearing out.

MAGNETIC MEDIA

With the first type of storage-magnetic media, information is recorded and read magnetically onto tape or onto a magnetic disc. Information on magnetic media is

physically read by a head that makes direct contact with the tape. Although information can be recorded and deleted many times on magnetic media, because it has direct contact with a moving head, it is more frequently subjected to heat. This results in data degradation, demagnetization, and decreased integrity of the discs. Magnetic media and drives are usually less expensive than optical media and drives, and most aren't able to hold as much information. As a result, users must purchase more physical discs for additional storage.

Imation's LS-120 discs, also known as "super discs," look and operate like the long-running standard 3½-inch floppy; however, a super disc has a 120 mb storage capacity that holds 100 times the information of a floppy disc. This is made possible by a tracking system built into the drive and writing the bits of information much smaller. The advantage to these drives is that they are backwards compatible: they can read standard 3½-inch floppy discs, so don't throw them out just yet. Compaq now offers these drives as an option in its high-end models. In general, the drives and required media are affordably priced.

DAT Tape

One of the first types of magnetic media is known as DAT tape, which stands for "digital audiotape." The tape, which

looks similar to that found inside a stereocassette, comes most commonly in 4mm and 8mm widths.

DAT tapes also come in different lengths and are able to store varying amounts of information, from 1 to 8 gigabytes (gb). This type of storage is used mainly for long-term archival and backup purposes and rarely for quick access of image files because it is hierarchical in nature. This means that information is written in linear order and can't be randomly accessed, once again like a stereocassette tape. You need to fast-forward or rewind a DAT tape to find a particular piece of information, thereby slowing down access time.

Zip Discs

Another common type of magnetic media is the Zip disc. Unlike the DAT tape, information is erased and rewritten with a direct overwrite on Zip discs. These are high-density discs contained in a cartridge and coated with a magnetic film. Zip discs are hardly bigger than a standard 3 1/2-inch floppy but provide almost 100 times the amount of storage. The drive for these discs is relatively inexpensive and lightweight, which makes it quite appealing to the mass market. The discs themselves are inexpensive, too.

A relative of the Zip drive is the Jaz drive. While more expensive than a Zip disc, a Jaz disc can store a gigabyte of information.

SyQuest Discs

Other popular magnetic discs are SyQuest discs, which store 88 mb, 105 mb, 200 mb, and 270 mb of information. These discs are larger than Zip discs and look similar to a skinny 8-track cassette. SyQuest media consists of a rigid platter coated with a magnetic film and encased in a cartridge. Each SyQuest disc costs about twice as much as a Zip disc. Unfortunately, the SyQuest discs aren't cross-compatible, with the 105 mb and 270 mb discs available in the 3 1/2-inch format, and the 88 mb and 200 mb discs available in the 5 1/4-inch format. As of this writing, N-hand, a 2 1/2 x 2 1/2-inch, 20 mb disc will be marketed for use with digital cameras, cellular phones, games, printers, and GPS systems, among others. This inexpensive disc will serve as a competitor to flash and mini-flash technologies.

NONMAGNETIC MEDIA

The second type of storage is nonmagnetic media, which include removable opticals and removable cards. On opticals, information is read and written on the media by a laser. (This doesn't include PC cards, which use a micro chip to store data, just as a computer's hard drive does.) These are noncontact media, which means that there is no direct contact between the laser and the opticals and removable cards. As a result, opticals and removable cards are believed to have a longer life than magnetic tape. The useful lifespan of tape is thought to be between five and eight years. While CDs haven't been around long enough to really know for sure, estimates are that they'll last 10 years or more (depending on who you talk to: tests have shown that under certain conditions, CDs are expected to have a life expectancy of 100 years).

Optical Discs

Optical discs, which are also commonly called opticals or CDs, can generally store much more information than magnetic discs. This capacity makes them a more viable choice than magnetic discs for the storage of large quantities of information. CDs are polycarbonate discs coated with a protective layer. Within each CD is a reflective, or metal, layer and a recorded, or molded-pit, layer. Three basic types of opticals are available on the market: CD-Rs, CD-ROMs (the "ROM" stands for "read-only memory") and reusable or erasable discs.

CD-Rs

The first type of optical is the CD-R, also known as a "writable" or a CD-WORM, which stands for "write once, read many." Here, the information is permanently burned onto the CD via a laser. The laser physically alters the surface of the disc to record information, and another laser is shined onto the disc and reads it. Once the information is written, it can't be erased.

Knowing that the information can't be accidentally erased provides a sense of security. You purchase these discs blank with the sole intent of storing information permanently, not just for a specific length of time and then erasing it. The problem with this type of storage is that you must have access to a CD writer, which costs between $700 and $2,000. The price depends on its speed, which ranges from 2x to 8x—4x is the standard—and on its gaining. On the plus side, though, CDs themselves are very inexpensive, and each one can store between 550 mb and 650 mb of information.

One type of CD making its way onto the storage scene is called PD, which stands for "Phase Dye." The PD is similar to the optical CD disc and the drive is able to read CD-ROMs, but it is able to be rewritten innumerable times. The information is stored on a magneto-optical-like cartridge (see below). A phase change (hence the name) in the physical makeup of the CD takes place. A laser

Writable CDs are available in 550 mb and 650 mb capacities. Once information is burned onto a writable CD's surface by a laser, it can't be erased or reused.

changes the recordable area from a solid state into a liquid state and is able to write over any previously written information.

CD-ROMs

Unlike CD-Rs, you purchase CD-ROM discs with existing (prewritten/prerecorded) information that you can't erase. In this way, CD-ROMs are most like music CDs. CD-ROMs are actually molded, or prewritten, by injecting hot plastic into a molding that is smooth on one side and pitted on the other according to the information it contains. Uses for this type of disc range from the music-industry recordings to home-computer games and programs, all of which involve the production of mass quantities.

The digital videodisc, or digital versatile disc, (DVD) falls into this category. A DVD is the same thickness as a regular CD and looks like one, but is able to hold much more information. A single-layered DVD can hold 4.7 gb of information. If you double the layers, the storage capacity jumps to 8.5 gb. And if you use both sides of a single-layer DVD, the capacity is 9.4 gb. If you double the layers on both sides, the capacity increases to 17 gb of information; Imation, a spinoff of 3M, makes such a DVD.

Producing DVDs can be cost-prohibitive, with prices starting in the low thousands to make a molding. Production, however, is intended for the mass market, and discs are produced at 5 seconds per disc. (Try writing 4.7 gb of information in 5 seconds with a consumer CD writer.) The largest user of DVD technology is the movie industry. Prices for DVD players begin at $500; the cost goes up in proportion to the number of features a player has. DVD drives are backwards-compatible to existing CD-ROM discs, which means that the drives can read CD-ROM discs as well as DVD discs. Two types of DVDs are available: the DVD-R is recordable once, and the DVD-RAM is rewritable. (Don't expect the recorders to be inexpensive.

When the DVD writers hit the shelves, their prices will probably start in the $13,000–$15,000 range, and the discs will cost about $50 or more.)

Writable Discs

Another type of opticals consists of the rewritables, or reusables. Here, the opticals are able to be erased and repeatedly written over. The opticals, which look just like a CD, are contained inside a hard, rugged case that acts like a protective shell to guard the magnetic fields from the elements, such as heat and dust. Information is again written by and read by a laser. But with rewritables, a laser is able to change the physical makeup of the CD's surface and write over information again and again. These rewritable discs are intended to be erased and reused repeatedly. Both the R and RW can read ROM. A CD-R disc can be read on a CD-ROM player, but a CD-RW can be read only on a recorder or a CD-ROM drive with special-circuit, multi-read CD-ROM drives.

Magneto opticals (MOs) combine magnetic and nonmagnetic technology. Information is written using a combination of a laser and magnetic fields. In other words, this is optically assisted, magnetic writing. The construction of 3¹/₂-inch rewritable discs is similar to that of CD-Rs, complete with pits molded into them. There are thin film stacks where the magnetic orientation is changed by the heating of the laser to produce the bit pattern, which can be changed repeatedly.

MO drives require at least two passes for each "write to the disc." The first pass erases any existing data, while the second pass writes the new information. A third pass verifies what was written. This increase in steps greatly slows performance to half or less the speed of the computer's hard drive. Read time requires only one pass, so it is three times as fast as write time.

Early versions of MOs, which are about the size of an old 8-track tape, hold 1.3 gb of information. New MOs hold at least twice that amount. Smaller MOs are available as well; these discs are close in size to a thick 3¹/₂-inch floppy disc and can hold 128 mb or 230 mb of data.

PCMCIA Cards

Another type of storage worth mentioning is the removable cards used as storage devices and inserted directly into digital cameras. These cards are known as PCMCIA cards, which stands for "Personal Computer Memory Card International Association," and look similar to a credit card. PCMCIA cards vary in storage capacity, ranging from just a couple megabytes to a couple hundred megabytes. The cards are relatively expensive, costing anywhere from around $100 for a 2 mb card to $6,000 or more for a 170 mb card.

The types of storage devices discussed here are by no means exhaustive. It seems that everyday bigger, better, and less expensive drives appear on the market. As always when making an important purchase, it pays to do your homework and a little research before making a decision. This will ensure that you get the drive that works best for you.

Magneto opticals are a hybrid of both magnetic and optical media. They range in size and storage capacity from 128 mb to more than 2.6 gb.

OUTPUTTING THE IMAGE

For a digital image, the road doesn't end on the computer's monitor; it is most likely destined for the printed page. The type of printer required depends on the intended use of the image: a quick mock-up of a document for positioning purposes only, a "proof" to show a client a layout and design, a four-color "slick" for a magazine, or a large poster for display. Basically, three types of printing or proofing systems are used for digital files: one involves the inkjet printer; another, the dye-sublimation printer; and the third, the thermal wax printer.

Thermal wax printers are similar to dye-sublimation printers in that both use a thermal or heat process to transfer dyes or inks to receptive paper. Some printers can interchangeably print both dye-sublimation prints and thermal wax prints via a simple change of paper and ribbon. Dye-sublimation prints are continuous-tone, photo-quality images that look like actual chemically produced photographs. Thermal wax prints, although photo realistic, exhibit a dot pattern and are of a comparatively lesser quality. With dye-sublimation printers, the ribbon uses a polyester-based dye that infuses right onto the polyester-coated paper specifically designed for these printers. With thermal wax printers, the ribbon uses a wax-based dye that can print onto any type of paper. Thermal wax prints are less expensive to produce than dye-sublimation prints (see page 45).

Individual printers output images at varying resolutions and at different sizes. In terms of the printed page, resolution is referred to as dots per inch (dpi). In terms of digital images, resolution is referred to as pixels per inch (ppi). But dpi and ppi are often used interchangeably, and their numbers are equivalent. For example, 300 dpi and 300 ppi indicate the same resolution.

In order for you to obtain the optimal performance from a printer, the file size and resolution of the image should correspond. Most dye-sublimation printers output at 300 dpi. For the image to reach maximum quality with tones having a smooth gradation, the image size should be 300 ppi as well. But this isn't true for laser printers, Inkjet printers, and Imagesetters.

To make matters a bit more confusing, resolution in traditional printing is calculated in lines per inch (lpi).

When you figure out what the resolution of your digital images should be, keep in mind that the general rule of thumb is twice the line screen to be used. General newspaper type prints at a line screen of around 85 lpi, while the glossy, high-quality stock used for magazines prints at 200 lpi. For example, if an image is destined for a magazine cover, its image size should be 400 ppi.

INKJET PRINTERS

Images from inkjet printers are generated by ink being jettisoned at high speeds through very thin glass tubes onto a receptive paper. The printer sprays each individual separation color—cyan (C), magenta (M), yellow (Y), and black (K)—back and forth onto the paper where the ink is absorbed. The amount of the ink being sprayed controls the density of the color. The difference in quality is also a result of both the way the ink is sprayed onto the paper and the type of ink used.

Inkjet printers come in all shapes, sizes, and quality ranges. Prices for these printers run the gamut from a few hundred dollars to several thousand dollars. Some of the less expensive desktop models from such manufacturers as Hewlett-Packard, Apple Color, and Epson, to name just a few, are capable of a range from 300 dpi to 1,440 dpi and are sheet-fed on a roll. The resolution of a printer helps determine the quality of a print. The more dots per inch laid down on a page, the finer the detail and the better the print is going to look. The difference is comparable to painting with a fine or small-head brush or with a wide or large-head brush suitable for painting a house. While the Epson printer is capable of 1,440 dpi and the Iris printer is capable of 300 dpi, the Iris printer produces better-quality images. This is because it uses a finer micro-spray technology (see below).

Iris Printers

This type of inkjet printer, capable of 300 dpi, produces photo-realistic images because the dots are sprayed so close together that they merge and appear as a continuous-tone print. So the human eye perceives the resulting image as 1,800 dpi. Iris printers are often used as a prepress proofing device or a fine-art printer. They

The Epson Stylus is a 720 dpi inkjet printer capable of printing an 8 mb file in just over 5 minutes (above). In the enlarged area of an Epson inkjet print made at 720 dpi, the ink dots are visible (right), but at a normal viewing distance, the illusion

The Apple Color StyleWriter 1500 inkjet printer is a 360 dpi printer (above). The enlarged view of a print made with this printer shows a visible dot pattern (right).

use the four process colors of cyan, magenta, yellow, and black. Print sizes from Iris printers range from the standard 8½ x 11-inch page to the tabloid size of 11 x 17 inches, to 14 x 21 inches, to 21 x 28 inches, to 34 x 47 inches, and up to 8 pages in length.

Wide or Large-Format Poster Printers

These large inkjet printers, made by such companies as Hewlett-Packard, ENCAD, Laser Master, and Textronics, among others, produce poster-size images. These prints can be 5 feet wide by 200 feet long or however long the roll of paper is. While the standard Laser Master uses four heads to spray the four process colors (cyan, magenta, yellow, and black), some models, such as one manufactured by Design Winder, come with eight print heads: one for black, one for yellow, three for magenta,

and three for cyan. These extra heads help increase detail in the middle tones and shadow areas. A poster printer has a resolution of 300 dpi and can use various paper stocks, such as those with glossy or matte finishes.

DYE-SUBLIMATION PRINTERS

The second type of printer, the dye-sublimation or "dye-sub" printer, is a digital or "film-less" (as compared to a match-print) printer. This "dry" proofing system doesn't use film or harmful chemicals. Here, everything is done on the computer, and the print or proof is electronically generated. The wide variety of dye-sub printers on the market range in price from around $400 to more than $20,000, and vary in quality. Prints from the less expensive models are mainly used to give a client a hard-copy proof from a digital file, to check image usage during

Although a high-end Iris inkjet printer technically prints at 300 dpi, it produces a higher-quality print that looks like an 1,800 dpi print. This is because an Iris printer uses micro-spray technology, which sprays very fine drops of ink.

the early stage of design work, and to produce a small batch of prints when it would otherwise be too costly to make a press run.

Dye-sub printers range from 140 dpi to 300 dpi continuous-toned. Printing occurs when there is intimate contact between the internal three- or four-colored ribbon and the receptive color paper. A thermal head heats the ribbon to transform the color dyes into a gassy state, which then adhere to the receptive paper, to form a continuous-toned image. The thermal head varies the intensity of the heat according to the density of the file. Skin tones receive a medium amount of heat, while shadows receive a great deal. Each color of the ribbon is laid on top of the preceding one until a four-color proof is obtained.

The largest sheet size available provides an 11 x 17-inch printable area. The paper is sheet-fed. Two models, for example, the Pictura 310 and PhotoFun dye-sublimation printers manufactured by Fargo Electronics, produce photo-quality prints of 4 x 6 inches up to 11 x 17 inches that are Postscript-compatible with a 300 dpi resolution. (Postscript is a printing language used for creating shapes and type on a page, and tells the printer exactly where each dot and each color is to be placed.) But PhotoFun 4 x 6-inch prints at 203 dpi aren't Postscript-compatible for several reasons. There isn't any demand for it by consumers, the printable area is quite small, and the pictures are primarily for home use so there is no need for graphics.

Some of the more expensive dye-sub printers, such as those that Kodak and Imation, a spinoff of 3M, manufacture, are used as prepress proofing devices. This is when clients want to see what their product will most closely resemble before going to film. Keep in mind,

however, that even top-of-the-line dye-sub printers can never exactly duplicate what will come off the press. This is because dye-sublimation prints are continuous-toned while paper off the printing press is composed of halftone dots. Since more and more jobs are done digitally, proofing the image as early in the design process helps to eliminate costly redo's later, thereby speeding up the whole printing process. One of the most widely known dye-sublimation proofing systems is the Rainbow, marketed by Imation.

When a proof needs to be as accurate as possible, a match proof is made. Match proofs are considered to be

A matchprint is used as a way to make an accurate appraisal of what the final print will look like before going to press. Matchprints serve as a "contract" between the client and the printing house that what is seen on the matchprint is what will come off the press.

Kodak's 8650 dye-sublimation printer produces continuous-toned prints for a photo-realistic quality (above). An enlarged portion of a dye-sub print (right) lacks the visible dot pattern of a print made with an inkjet printer.

Rainbow printers, long the industry standard for proofing, use dye-sublimation technology to produce photo-realistic 300 dpi prints (above). Rainbow proofs are four-color, continuous-tone prints (right).

Fargo's 310 dye-sublimation printer, which prints at 300 dpi, can use both thermal dye-sub and thermal wax-print technology (above). The largest printable area is about 12 x 18 RGB. This dye-sub print, made with a Fargo 310, has been enlarged to show the printer's continuous-tone capability (right).

conventional proofs instead of digital proofs because they use film while making the print. Match proofs are a guarantee, or "contract," between a printing house and its clients that what they see is what they'll get. Because match prints are made up of halftone dots, which are what come off the press, they are really the best way to predict the outcome of what will be printed (see below). They can show possible problems in registration, unwanted moiré patterns, and trapping. This is a technique in which adjacent colors are purposely overlapped slightly to minimize the potential for out-of-register plates on the printing press and the possible misalignment of the four separation colors (cyan, magenta, yellow, and black).

Before a match proof is made, the digital file needs to be sent to an imagesetter, where separate pieces of film are made. These proofs are generated from film, one sheet each for cyan, magenta, yellow, and black; these sheets are sandwiched together. Light is then transmitted and exposed through them onto light-sensitive paper. Next, the paper is processed to make the proof.

Several companies market match-proof technology, including Fuji, Agfa, and 3M. Match prints, the trade name for proofing technology manufactured by Imation, has long been considered to be the industry standard for creating a contract proof for clients.

Thermal Wax Printers

A close relative to the dye-sublimation printer is the thermal wax printer. Thermal wax printers operate similar to the way dye-sub printers do: by transferring colors from different colored ribbons containing waxes, which adhere to paper when heated. Thermal wax prints can be printed on a dye-sublimation printer: the same technology is used; it is just a matter of replacing the ribbon and paper. Prints from thermal wax printers are less expensive than dye-sub prints, but they are of lesser quality, print at a lower resolution, and use a lower grade paper to print on.

Thermal wax prints are an economical way to check image usage while still in the designing stage. These prints use the same technology as dye-sublimation prints, but at a lower cost and, subsequently, lower quality.

GALLERY

CAPTURING COLOR AND DETAIL

Les Jorgensen Photography

This was a series of images done for the Phase One Corporation as part of its 1997 promotion calendar, showcasing my images taken with the Phase One digital camera. I was given free reign over the project—something that doesn't happen very often. The different textures of the subjects were all produced by applying a variety of paint colors to their surfaces and allowing them to create interesting effects. A 1K (1,000-watt)/2K (2,000-watt) spotlight and Fresnel tungsten lights were used. The project took several days to complete. Computer work consisted of increased saturation and minimal cleanup and retouching.

EQUIPMENT
Camera: Phase One 4 x 5
Lens: Schneider 210mm
Line time: 1/15 sec.
F-stop: 16
Lights: One 575-watt HMI
File size: 10 mb RGB

CHECKING DETAIL AND IMAGE QUALITY VIA A TEST SHOT

Lightspeed Studios, Inc.

In 1993 we needed a self-promotional image to illustrate how our digital system would compare to film. To do this, we created an image with a broad range of color, texture, and contrast to give an example of the many capabilities of digital photography. In the image of the flowers, we accomplished this and were able to convey our message better than we could have by means of a more straightforward catalog shot.

With the Leaf DCB, color shots are created in three exposures with an RGB filter wheel and reassembled almost instantly by the camera's software. Any subject movement during the exposure will show up as three different colors, one for each color. Because of the snail's low but constant movement, we were forced to shoot it in black and white, color it, and add it later to the final full-color image.

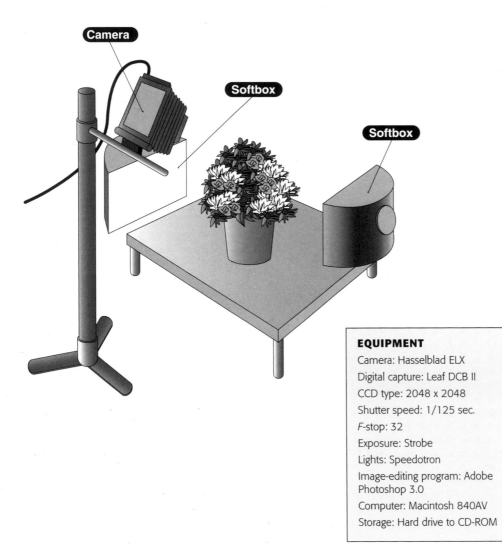

EQUIPMENT

Camera: Hasselblad ELX

Digital capture: Leaf DCB II

CCD type: 2048 x 2048

Shutter speed: 1/125 sec.

F-stop: 32

Exposure: Strobe

Lights: Speedotron

Image-editing program: Adobe Photoshop 3.0

Computer: Macintosh 840AV

Storage: Hard drive to CD-ROM

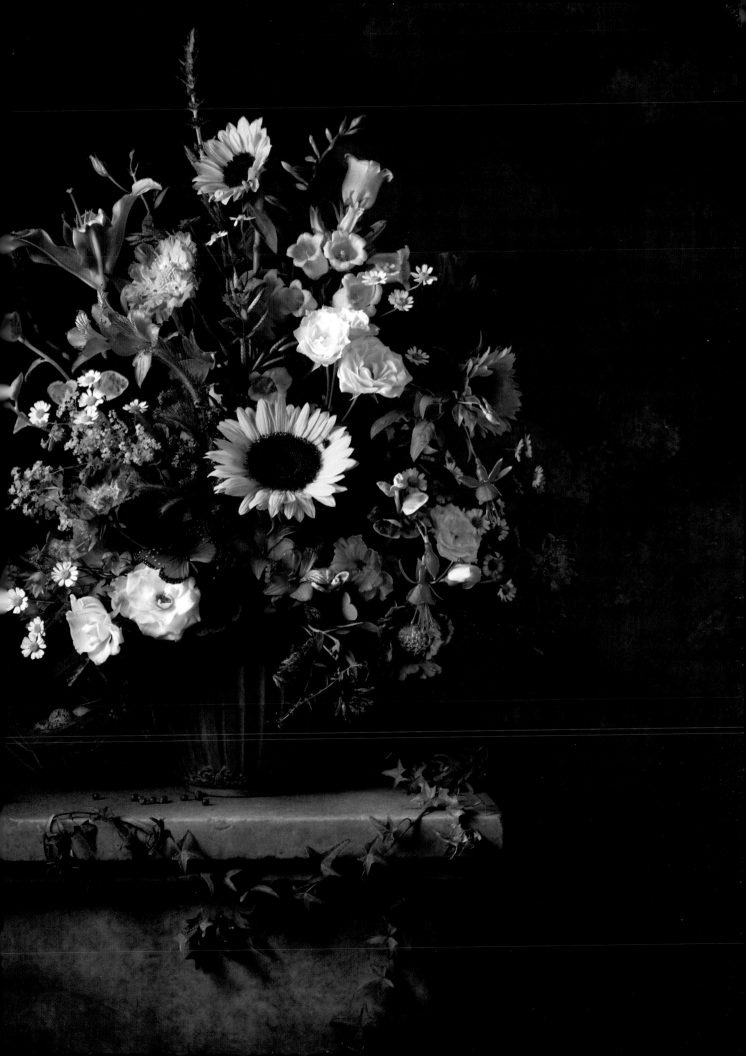

ACHIEVING DETAIL AND ACCURATE COLOR

Butkowski Photography

I enjoy working with small, simple subjects. The peppers were one of these. The bright colors and texture would reproduce well. This would help show clients the high quality my digital camera is able to capture. When I began to photograph the peppers, I placed them next to each other and cut one pepper in half to give the picture a balanced look. Next, I did a prescan and added a black card across the back. This card blocked the light from the scrim, causing the background to go black. This helped the peppers separate from the background.

Little computer work was done to this image, just some slight removal of blemishes. I wanted the colors to stay as vibrant as the real vegetables. I adjusted the levels to increase the contrast, and special attention was given during conversion to make sure the colors didn't lose their saturation when changing from RGB to CMYK.

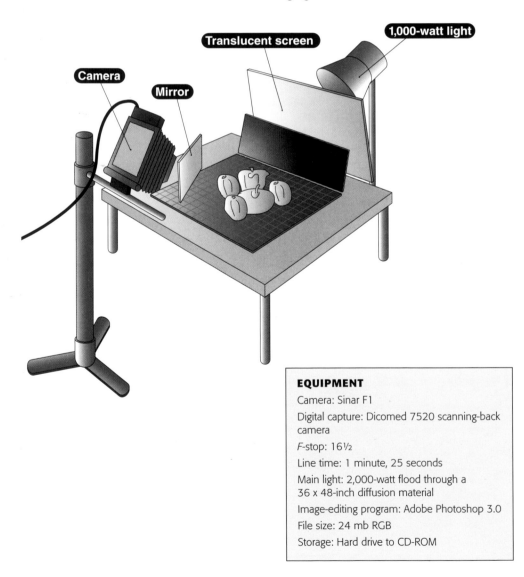

Camera **Mirror** **Translucent screen** **1,000-watt light**

EQUIPMENT

Camera: Sinar F1

Digital capture: Dicomed 7520 scanning-back camera

F-stop: 16½

Line time: 1 minute, 25 seconds

Main light: 2,000-watt flood through a 36 x 48-inch diffusion material

Image-editing program: Adobe Photoshop 3.0

File size: 24 mb RGB

Storage: Hard drive to CD-ROM

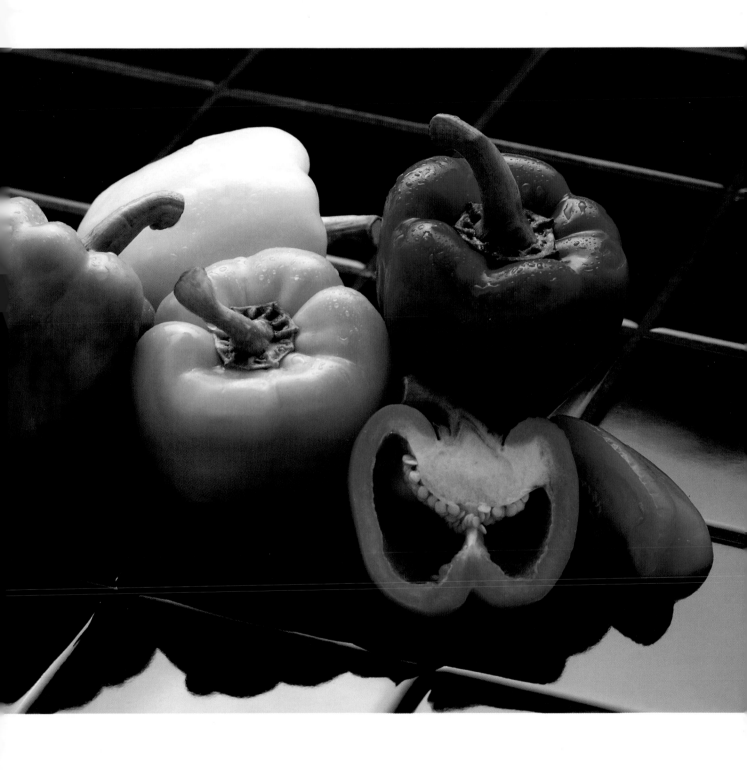

SHOWING DETAIL
IN A STUDIO SHOT

Stephens Photography Inc.

The client, Jadvick Enterprises, provides specialty kits and supplies for the arts-and-crafts industry. This setup was shot on transparency film for a trade ad, and on the DCS 460 as a test to see how the resolution and color would hold up on a large table-top arrangement with lots of detail. This was done very soon after I got the DCS camera, so it wasn't the primary photograph but rather simply part of my "learning curve" and testing. There were no special techniques used in the studio or on the computer.

The set was lit with two softboxes, with the emphasis on light coming from the upper right. Then, to add more contrast and modeling to the subjects, I put a 7-inch hard reflector unit in front of the most powerful softbox. You can see the hard-edged shadow from that light.

After "cleaning up" the image—making color adjustments, removing any unwanted marks, and sharpening the image—in Photoshop, I had the client's printer do a 7 x 10-inch Kodak Approval Proof of the image. It blew me away! I'll reproduce it as one of the images in a promotional piece I'm planning.

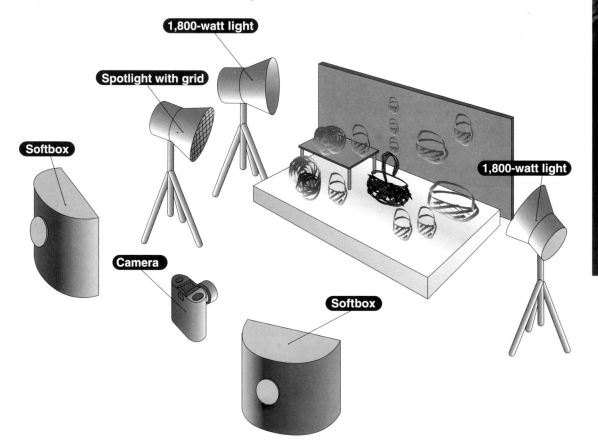

EQUIPMENT

Camera: Kodak DCS 460

Shutter speed: 1/125 sec.

F-stop: 16

Main light: 24 x 36-inch softbox

Background light: Two White Lightning 1800 strobes

Accent light: Strobe with 40-degree grid light

Image-editing program: Adobe Photoshop

Computer: Apple Power Mac 8500

Storage: PCMCIA card in camera, to Zip disc

File size: 18 mb

CAPTURING HIGHLIGHT DETAIL

Stafford Photography

This image was also part of a test done for Dicomed, Inc. Both this image and that of the lemon in bubbles (see page 67) were used internationally for promotional purposes to show the capabilities of the BigShot 4000. The subject was chosen again to show the camera's integrity. Sweat on the model's face could potentially pose problems with the same type of RGB artifacts in the highlight areas. Once again, we didn't see any of that, even when enlarged to poster size, which both this image and the bubbles image were. Both images were run through a color-managing software program to get optimal-quality photographs. They were shot full frame for a 48 mb file size at 8 bits per color channel.

EQUIPMENT

Camera: Hasselblad 553 ELX

Digital capture: Dicomed BigShot 4000

Shutter speed: 1/60 sec.

F-stop: 16½

Main light: 24 x 36-inch softbox with 5,000-watt strobe

Background light: 5,000 watts bounced off back wall

Accent light: Fill card

Image-editing program: Adobe Photoshop

Computer: Apple Power Mac 8500

Storage: Jaz disc to CD

File size: 48 mb

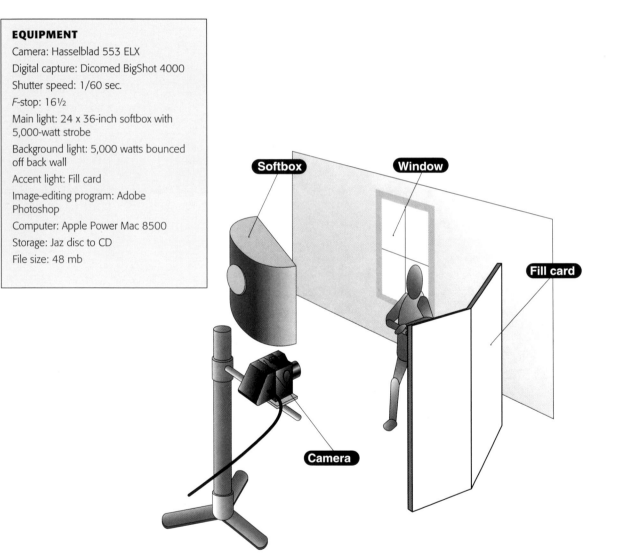

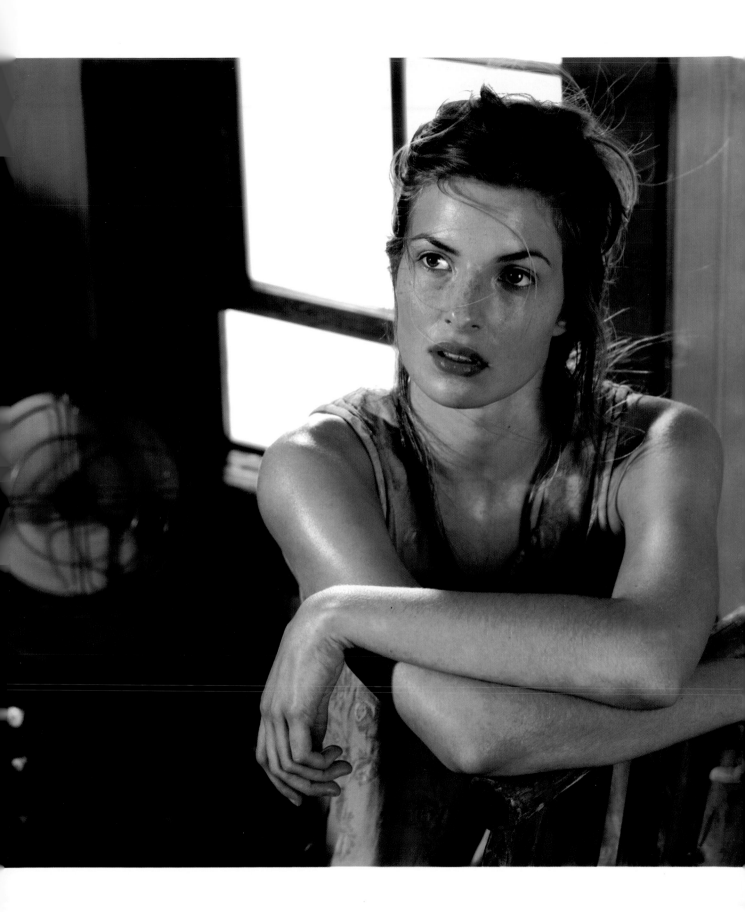

DOING A TEST SHOT

Access Technology Photographer Midge Bolt

I did this test shot to check detail and image quality. Potted flowering plants were placed close together on the floor. The main light coming from the upper left corner simulated the late-afternoon sun. The banklight on the lower right was used as fill with only two of the six bulbs turned on. The two large white cards also added fill to the shadows. I found that with both the Dicomed scanning back, which has a flat or large, dynamic range, and the fluorescent lights I used, which have less contrast than tungsten lights, I had to illuminate the subjects with more contrast to get the sunny-day effect I wanted.

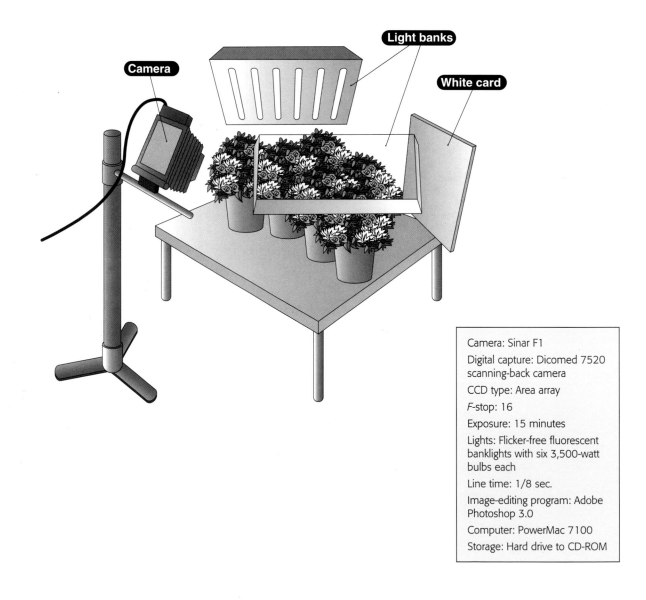

Camera: Sinar F1

Digital capture: Dicomed 7520 scanning-back camera

CCD type: Area array

F-stop: 16

Exposure: 15 minutes

Lights: Flicker-free fluorescent banklights with six 3,500-watt bulbs each

Line time: 1/8 sec.

Image-editing program: Adobe Photoshop 3.0

Computer: PowerMac 7100

Storage: Hard drive to CD-ROM

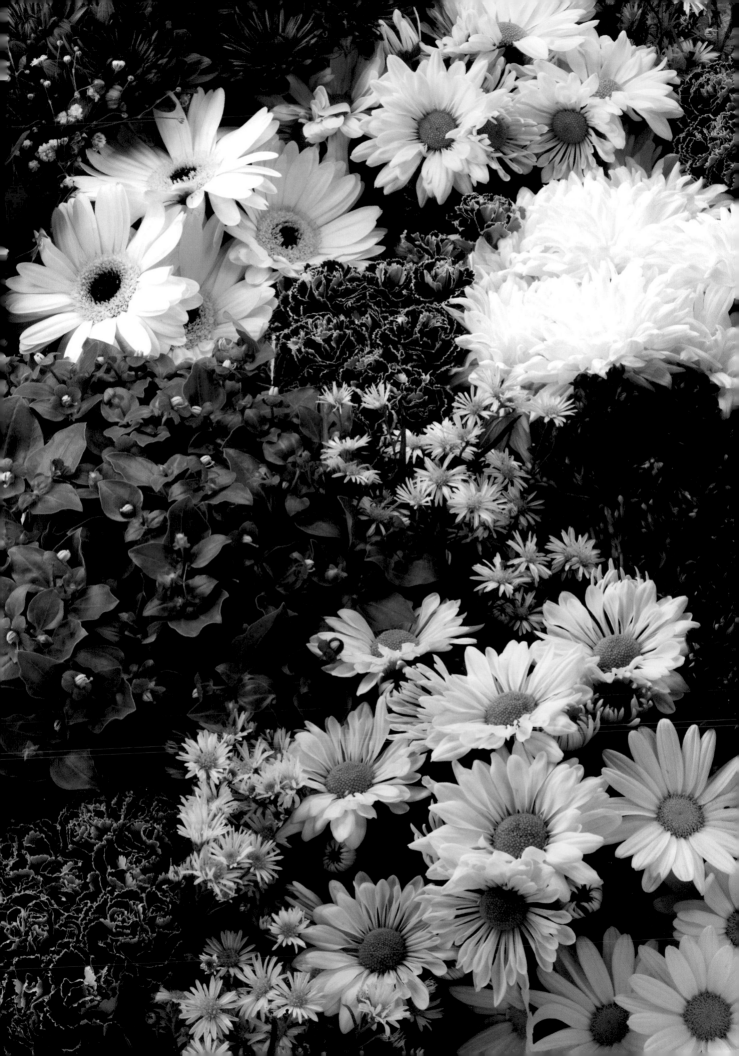

PHOTOGRAPHING PEOPLE

Stephens Photography Inc.

This was a backup/test shot made with my Kodak DCS 420. The primary image was done on transparency film for Sportime International, an institutional provider of athletic and recreational equipment. It was a straightforward product shot with a model, done on my studio "cyc" wall ("cyc" is short for "cyclorama," which is a wall that curves where it meets the floor to create a seamless effect). The lighting included three softboxes (top, main on left, and fill on right), a 7-inch hard reflector unit in front of the main softbox for added contrast and modeling, and two hard-light units on the cyc to bring it up to "white."

In Adobe Photoshop, I worked on the image's individual RGB color curves. I think that this allows greater color control than using other slide-type color-correction tools also in Photoshop. All this enhances the image's appeal. I then selected each of the beanbags and increased color saturation using the Hue/Saturation menu. I also worked on skin tones, which became too red. The child's freckles made this somewhat more difficult.

Since I am one of the very few photographers who has a professional-level digital camera able to capture moving subjects, such as people, I stress that in my promotions. I used this image in a trade ad with the headline/text, "If you think digital cameras are limited to still life . . . YOU DON'T KNOW BEANS!"

EQUIPMENT

Camera: Kodak DCS 460

Shutter speed: 1/125 sec.

F-stop: 16

Main light: 36 x 48-inch softbox

Overhead light: 12 x 48-inch strip light

Accent light: Strobe with 40-degree grid light

Image-editing program: Adobe Photoshop 3.0

Computer: Apple Power Mac 8500

Storage: PCMCIA card in camera, to Zip disc

File size: 18 mb

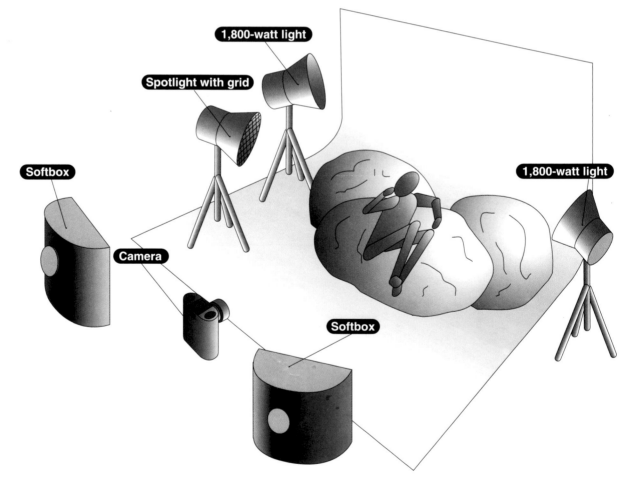

SHOOTING PORTRAITS

Andra Van Kempen

I really wanted to take a picture demonstrating that even though I was using a scanning-back camera, live objects could be photographed—they just couldn't move. And, of course, who better to take a picture of than my beautiful son, Noah (I'm not biased; I'm a mother). This shot was attempted on one occasion beforehand, but he wouldn't cooperate by going to sleep. The second time around my luck wasn't much better: no sooner would I get him to sleep before he would awaken, and I'd have to start all over.

I did manage to take three scans before Noah woke up for good. At first, the image wasn't what I was hoping to get, but the more I looked at it the more I liked it. I love the peacefulness of his face. The image has a nice, soft feel.

Some computer work was necessary because even though Noah was sleeping and was as still as could be, his slight breathing created an almost imperceptible motion that the camera picked up. So I airbrushed parts to smooth out any scan lines that Noah's movements produced. To increase the dreamy quality of the image, I applied a watercolor filter while working in Adobe Photoshop.

Camera: Sinar F1

Digital capture: Dicomed scanning-back camera

F-stop: 8

Exposure: Approximately 3 minutes

Lights: Tungsten

Line time: 1/40 sec.

Image-editing program: Adobe Photoshop 3.0

Computer: Apple Quadra 950

Storage: Hard drive to CD-ROM

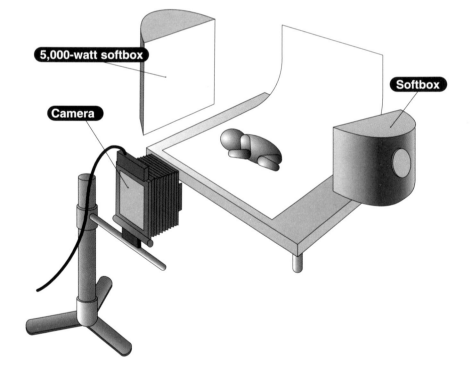

5,000-watt softbox

Softbox

Camera

CAPTURING A MOVING SUBJECT IN THE RAIN

Butkowski Photography

The assignment was to photograph three children coming out of a bus in the rain. This was a perfect example of how digital photography can cut production time. The photograph had to be shot after 3 P.M. and in the hands of the art director the next day. To make matters worse, it was the month of November in Minnesota. It doesn't rain in November; it snows. So this left few options. The client asked if this shot could be done digitally. I looked into the possibility of using the Leaf Catchlight, which works with strobe lighting, and was able to rent one for a day. I was also able to get a new school bus for the picture.

The shoot was going to take place in a vacant space next to the studio, and I went to work setting up the shot. The bus was brought in, and a sidewalk was built alongside it. The tricky part was figuring out how to simulate rain. I began by lighting the set and shooting test images. The client and my assistant sat at the computer while I was at the camera, photographing and directing the models.

Each time I photographed the scene, the image appeared almost immediately on the monitor screen for the client to view. After 15 to 20 shots we would stop, review all of the shots so far, and delete any unsatisfactory ones. We did this for about two hours: shooting, moving models around, and checking the captures on the screen. Upon completion of shooting, the client, art director, and myself reviewed all the stored images, and chose four of the best. The images then needed to be processed by the camera's software and were computer-ready the next morning.

The images were processed using the camera's software and the files interpolated from 6 x 6 inches at 300 ppi to 9 x 9 inches for final size. The CMYK file conversion was done, and little color correction was needed.

Camera: Hasselblad ELX500

Lens: 150mm

Digital capture: Leaf Catchlight

Main light: Two 4 x 6-foot banklights with four 2,000-watt-second strobes each

Back light: One 2 x 3-foot softbox with one 2,000-watt-second strobe

F-stop: 16

Shutter speed: 1/125 sec.

Image-editing programs: Leaf Image Processor; Adobe Photoshop 3.0

File size: 12 mb RGB

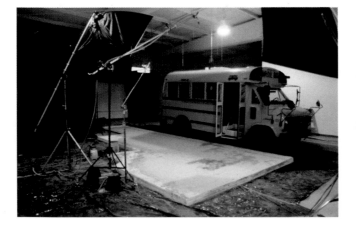

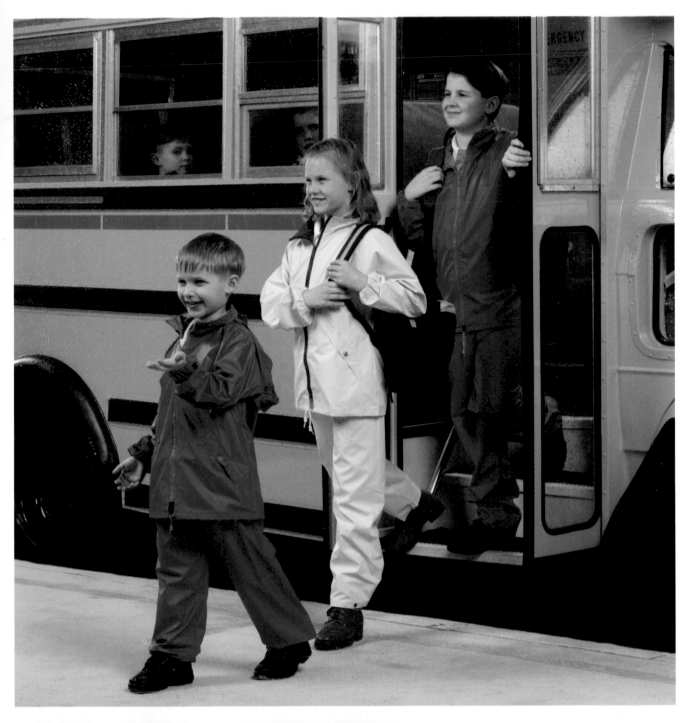

STOPPING ACTION

Stafford Photography

The lemon in bubbles was done as a test shot for the camera manufacturer of the BigShot, Dicomed, Inc. It was a simple subject meant to show the integrity of the camera. Because the camera uses a striped array chip, such artifacts as the "Christmas Tree effect," also known as "blooming," have been known to occur in highlight areas with other similarly configured cameras. This is where the RGB pixels appear as individuals in the white highlight areas of an image.

The bubbles in this image showed a lot of specular highlight in a small area and would be a perfect subject to look for the Christmas Tree effect. We didn't see any of that. Dropping the lemon also showed the camera's ability to stop action. The great part about digital photography is the camera's ability to preview images right after the shutter is clicked. We could tell right away if the shot was a keeper. With this particular image, the second shot was the winner.

EQUIPMENT

Camera: Hasselblad 553 ELX

Digital capture: Dicomed BigShot 4000

Shutter speed: 1/60 sec.

F-stop: 32

Main light: 12 x 48-inch strip light with 5,000-watt strobe inside

Background light: 4,000-watt light with green gel

Image-editing program: Adobe Photoshop

Computer: Apple Power Mac 8500

Storage: Jaz disc to CD

File size: 48 mb

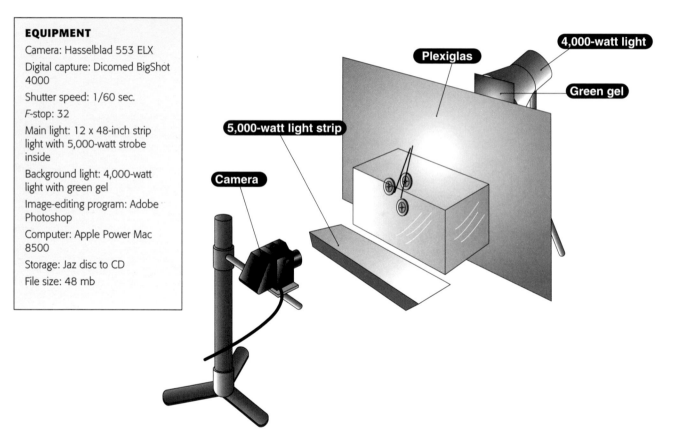

4,000-watt light

Plexiglas

Green gel

5,000-watt light strip

Camera

SHOOTING FOOD

Stafford Photography

Both of these shots were part of a photo shoot done for General Mills for the Hamburger Helper line of products. The images were to be used in a free-standing insert placed in newspapers and at grocery stores. There was a total of 10 to 11 different shots—you see just 2 of the 11 here—done for General Mills; the shoot took seven days to complete because of the various themes. Lighting for both shots was similar, with a main sidelight for specular highlights and a bounced light used to fill in the shadows to give a natural look to the photograph. Each shot had its own theme, and a prop stylist purchased different props for the two themes.

All of the images were shot full frame for a 48 mb file image at 8 bits per color channel. They were shot large for layout flexibility and saved in three different file sizes: one high-res color-corrected file; one 25 percent above crop file size; and one low-res file used in layout placement. The pictures were shot with the BigShot mounted on a Hasselblad body using a 180mm lens with an 8mm extension tube and set at f/22-f/32 to maintain focus throughout.

EQUIPMENT

Camera: Sinar P2

Digital capture: Dicomed BigShot 4000

Shutter speed: 1/60 sec.

F-stop: 32

Main light: 3,200-watt strobe inside 12-inch reflector

Accent light: Two fill cards

Image-editing program: Adobe Photoshop

Computer: Apple Power Mac 8500

Storage: Jaz disc to CD

File size: 48 mb

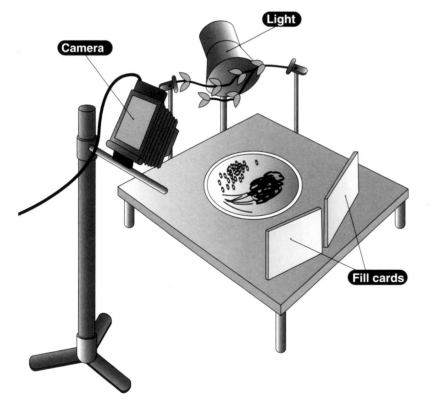

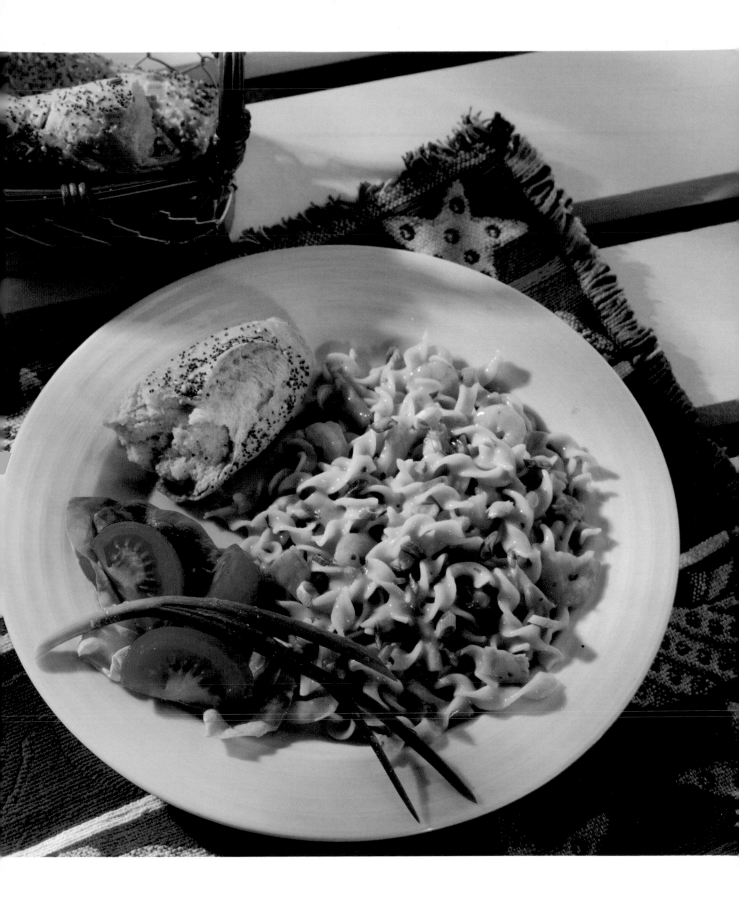

USING FLUORESCENT LIGHTS

Access Technology Photographer Midge Bolt

This set was placed on the floor because I needed the camera up high (8 feet). This way I could fill the entire scan area for maximum resolution and size. Maintaining freshness was the major factor. All lighting and prescans were done with stand-ins. In fact, I scanned from the top down and was, therefore, able to add certain elements that were lower in the set while the top portion of the image was being scanned. This is one advantage to a scanning-back camera. These types of challenges pushed me to be innovative and creative in developing new ways of shooting.

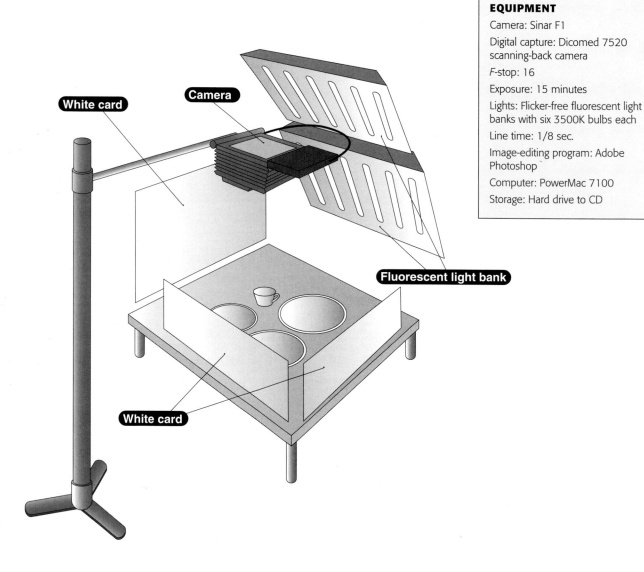

EQUIPMENT

Camera: Sinar F1

Digital capture: Dicomed 7520 scanning-back camera

F-stop: 16

Exposure: 15 minutes

Lights: Flicker-free fluorescent light banks with six 3500K bulbs each

Line time: 1/8 sec.

Image-editing program: Adobe Photoshop

Computer: PowerMac 7100

Storage: Hard drive to CD

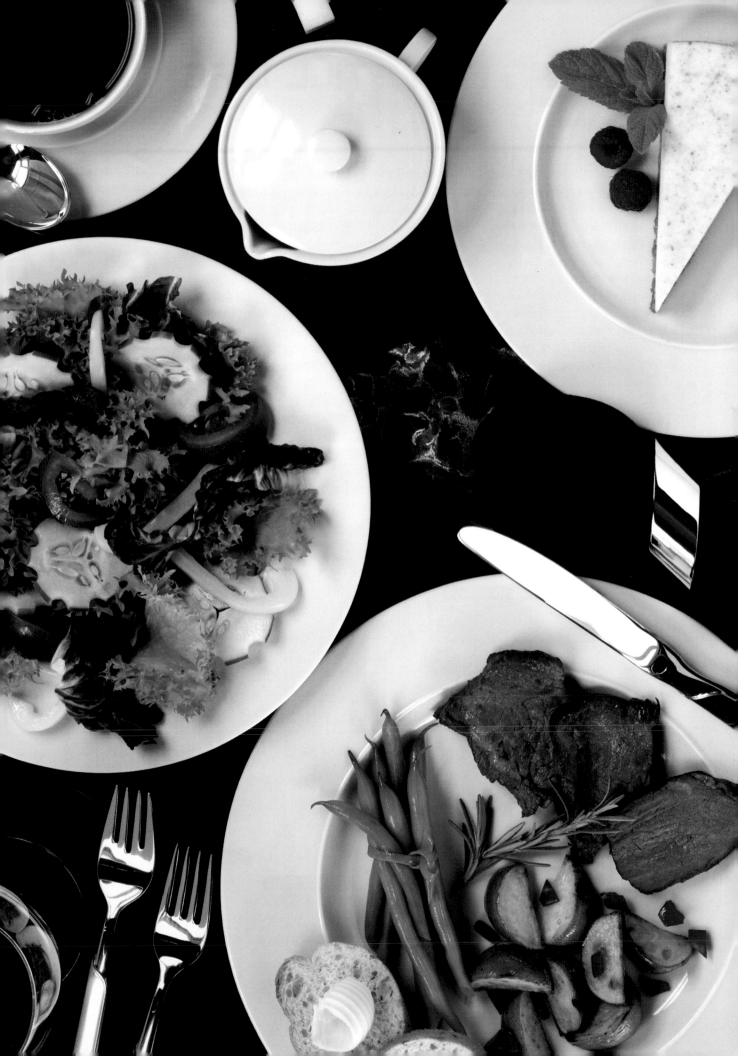

LIGHTING FOR STILL LIFE

Andra Van Kempen

This image was done on self-assignment. I wanted to use a different perspective: showing fruit through a frame, and making the frame appear to be hanging from thin air. What was nice about shooting it digitally was that I could see exactly what the camera was seeing moments after previewing the image. The human eye compensates so efficiently from shadow areas to highlight areas that sometimes it is hard to predict how the lighting actually will reproduce. I tried lighting the fruit a number of ways, finally settling on a softbox positioned on a 5K (5,000-watt) tungsten light with a 2K (2,000-watt) light with a softbox as fill. For the background, I used a 2K tungsten light shining through a foamcore board with a slit cut out of it to create a shaft of light. An orange-colored gel was used with this light to cast a warm, golden glow.

One of the challenges here was to hang the frame. This was accomplished by attaching two rods with duct tape to the back of the frame and then inserting the rods into a stand. Once the frame finally held, which took a few times, I didn't dare move it for fear it would fall again. I really wish the frame had been smaller.

This image was scanned once normal and once with a heavy diffusion filter covering the lens. The two images were opened in Photoshop, and the soft image was dragged and dropped over the sharp image. Using a large, soft brush, I began to erase the soft layer, allowing the sharper, background image to come through. This was done mainly to the fruit to put more emphasis on them. I also had to remove the poles sticking out on either side by using the cloning tool. Some slight saturation was added as well.

EQUIPMENT

Camera: Sinar F1

Digital capture: Dicomed 7520 scanning-back camera

CCD type: Area array

F-stop: 11

Exposure: Approximately 3 minutes

Lights: Tungsten

Line time: 1/12 sec.

Image-editing program: Adobe Photoshop 3.0

Computer: Apple Quadra 950

Storage: Hard drive to CD-ROM

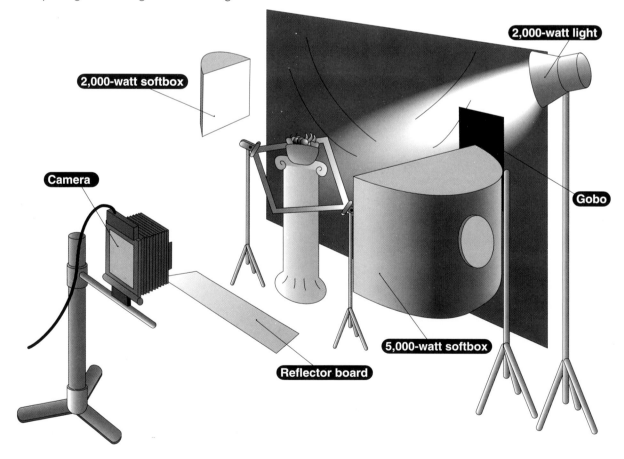

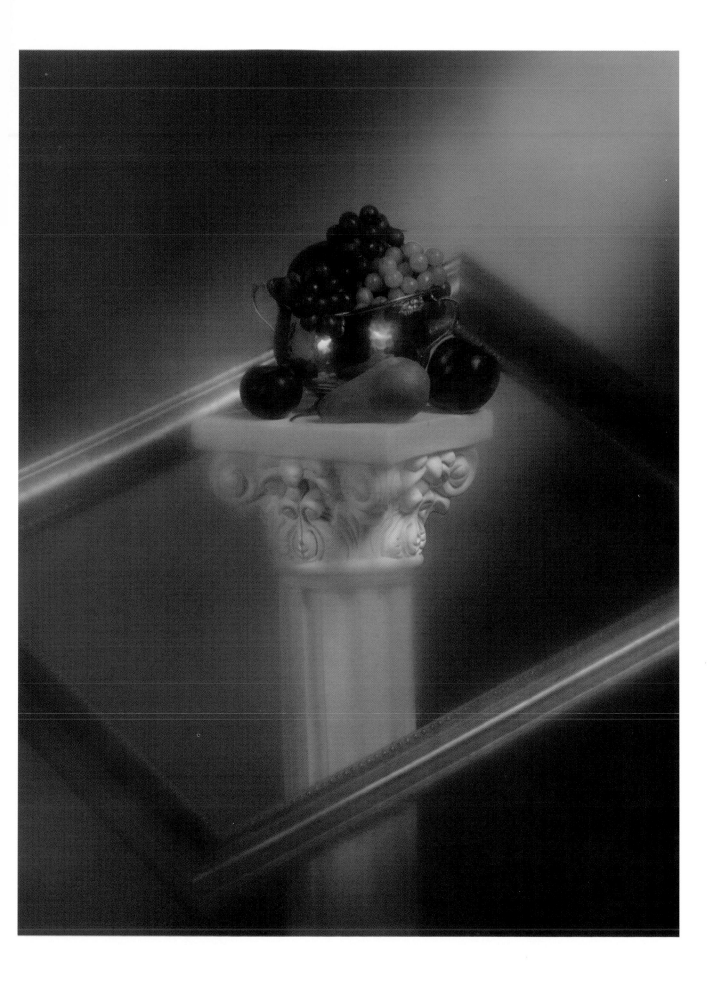

WORKING WITH LARGE SUBJECTS

Butkowski Photography

I had the opportunity to shoot a new snowmobile for a friend. This image would be a good way to show that my Dicomed scanning back is capable of large-product shots. I began by setting up the shot with the toplight using six 1,000-watt Lowell Tota lights. I used a 2,000-watt floodlight for the background to produce separation of the snowmobile seat. I placed a 1,000-watt spotlight in front to lighten the area around the ski shack. Another 1,000-watt light was used to lighten the back seat area of the sled. After doing a couple of prescans, I turned off two of the 1,000-watt lights over the hood to even out the exposure difference between the black of the seat and the white hood, keeping detail in both.

I knew this image would be a long horizontal and I would be removing the background, so to gain more light and depth I lowered the top banklight to just more than 1 foot from the top of the snowmobile. This gave me an additional half stop of light. I did a couple of more prescans and then the final scan, which was about 50 mb.

The second shot was much simpler: it consisted of only one 5,000-watt tungsten light in a 36 x 48-inch softbox. I let the background go to black. I would use this as the background of the illustration.

The files of these photographs are 50 mb to 60 mb each, so doing any computer work on them is a little slow because of my older Quadra 950. My Photoshop software program is optimized for files around 32 mb. I did only minor correction work on the two files, removing scratches in the plastic bumpers and skis. The profile shot was taken out of the background and resized to fit into the background photograph.

EQUIPMENT

Camera: Sinar F1

Digital capture: Dicomed 7520 scanning-back camera

F-stop: 16½

Exposure: 3 minutes, 45 seconds

Main lights: Six 1,000-watt lights in a 6 x 12-foot softbox and one 5,000-watt Fresnel in a 36 x 48-inch softbox

Backlight: One 2,000-watt floodlight in a 24 x 36-inch softbox

Image-editing program: Adobe Photoshop 3.0

Computer: Apple Quadra 950

File size: 60 mb RGB

White fill cards

Softbox

1,000-watt light

Camera

CONTROLLING DETAIL IN REFLECTIVE METAL

Butkowski Photography

I was asked to shoot a series of stamping parts for a new corporate brochure. The shots all had to be consistent in lighting, but the number of parts per shot would vary. I started with the largest group and proceeded to the smallest. The Dicomed scanning-back camera and some other cameras let you set-crop the scan in the camera's software. This allows you to crop each photograph, increasing or decreasing the resolution and crop size without moving the camera. This saves time moving the camera, resizing, refocusing, and dealing with depth of field issues. You set-crop for the largest object, and as the subject gets smaller you increase the resolution size to keep the file size the same.

The lighting for this photograph was simple. A 48 x 48-inch smooth white board was used to reflect the light from the 2,000-watt tungsten main light. This produced a graduated reflection on the glass surface. A second 1,000-watt light was used to add a highlight to the left side. Finally a white reflector was added to the front underneath the camera.

I didn't do much computer work on this image. I took out any dusk that had settled on the glass since the last cleaning and evened out some of the highlights in the brass pieces. This would make them more uniform with the image.

EQUIPMENT

Camera: Sinar F1

Digital capture: Dicomed 4 x 5 scanning-back camera

F-stop: 22

Exposure: 1 minute, 15 seconds

Main light: One 2,000-watt tungsten Fresnel

Sidelight: One 2,000-watt Fresnel

Fill light: One white card

Image-editing program: Adobe Photoshop 3.0

File size: 5 mb to 35 mb RGB

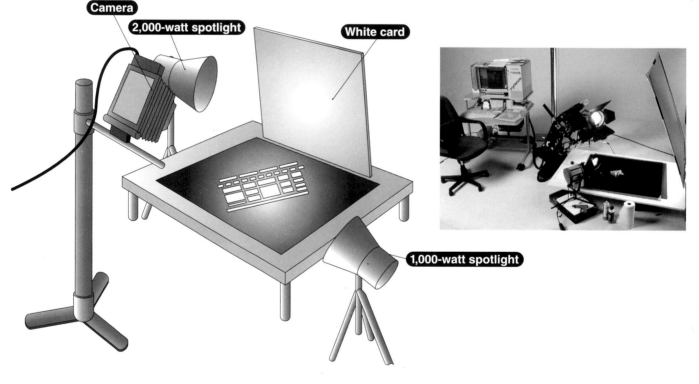

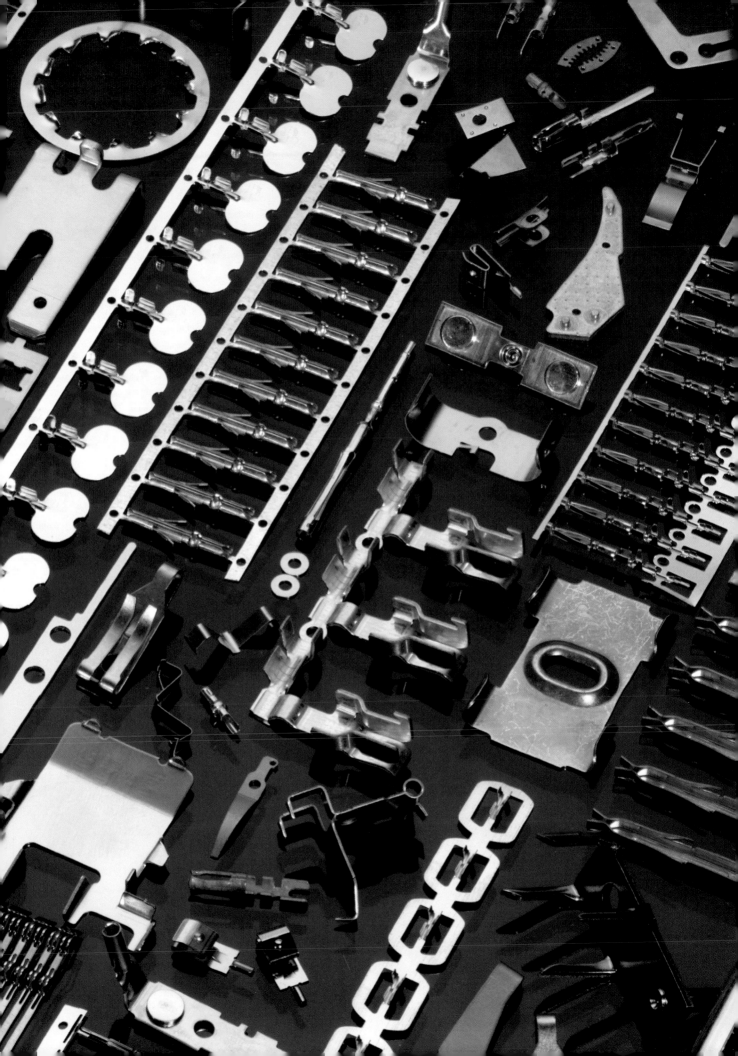

SHOOTING A MULTIPLE-PURPOSE IMAGE

Butkowski Photography

This image was created as part of an advertising campaign for a client's floral department. The image needed to be simple, say "flowers," and be visually appealing. Also, the client didn't want the image limited to any particular season. I could have used any type of flower, but roses are available throughout the year, and I liked the repeating curves inside the flower petals.

The camera was set up first because I didn't want the heat from the lights to wilt the flowers. Next, a 2,000-watt Fresnel light was used for the main light and was placed to the left. This would be my "sun." Several of the roses were put into place along with some of the greenery. After a couple of prescans—my versions of electronic Polaroids—I added a second 1,000-watt light closer to the flowers and aimed it at only the dark green leaves to lighten them. All the flowers were then added and bunched together. The lights were adjusted a little more, and a couple of new prescans were done.

The client was going to use the photograph for many purposes, including large in-store displays, point-of-purchase displays, and a mailer. So I had to keep the image loose and easy to crop. I needed a lot of depth of field to keep the flowers all in focus; I was able to get around f/22 on my camera's lens. With the combination of only 3,000 watts of light on the subject (to keep the roses from wilting) and the need for extensive depth of field, my only option was to increase my line time (shutter speed). I increased it to 1/10 sec., which made the scan time around 5 minutes. Although this was a little longer than I like—the longer the scan, the more movement can occur—it was the only way to keep everything in focus.

Like all living things, the roses weren't picture perfect, so I did some computer work on the image. The edges of the petals were cleaned of splitting ends. Not all of the ends were removed, just the really bad ones. In Adobe Photoshop, I applied a watercolor filter to the leaves and baby's breath, leaving the smooth rose petals alone.

Camera

2,000-watt light

Mirror

EQUIPMENT

Camera: Sinar F1

Digital capture: Dicomed 4 x 5 scanning-back camera

F-stop: 22

Exposure: 5 minutes, .05 seconds

Main light: 2,000-watt Fresnel

Sidelight: 1,000-watt Fresnel

Line time: 1/10 sec.

Image-editing program: Adobe Photoshop 3.0

Computer: Apple Quadra 950

File size: 32 mb RGB

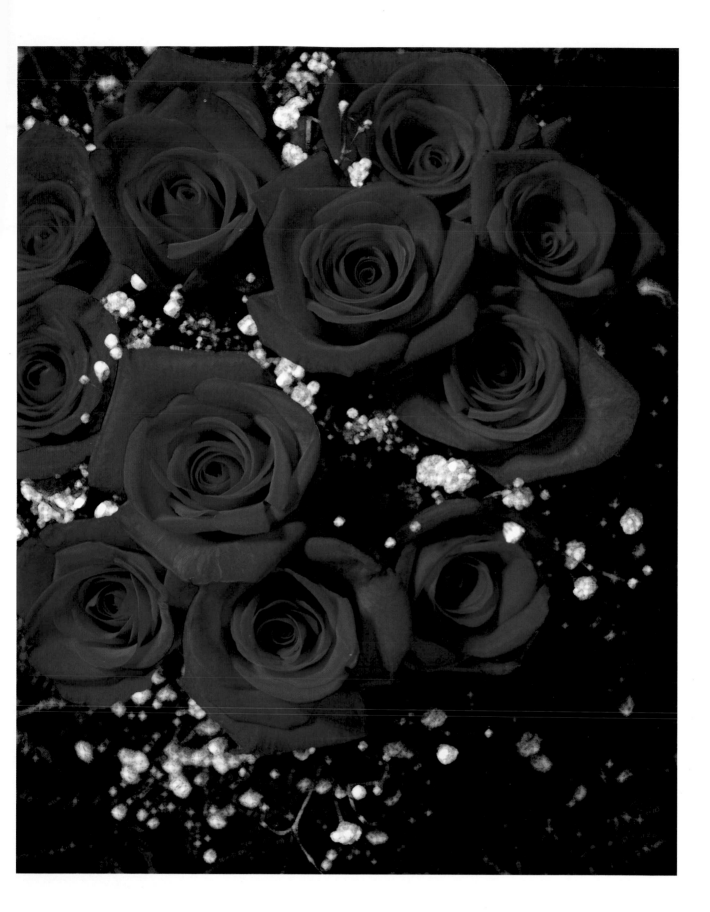

SHOOTING A BIRD'S-EYE VIEW

Stafford Photography

This set was placed on the floor because we needed the camera up high (8 feet). This way we could fill the entire scan area for maximum resolution and size. Maintaining freshness was the major factor. All lighting and prescans were done with stand-ins. In fact, we scanned from the top down and were therefore able to add certain elements that were lower in the set while the top portion of the image was being scanned. This is one advantage to a scanning-back camera. These types of challenges pushed us to be innovative and creative in developing new ways of shooting.

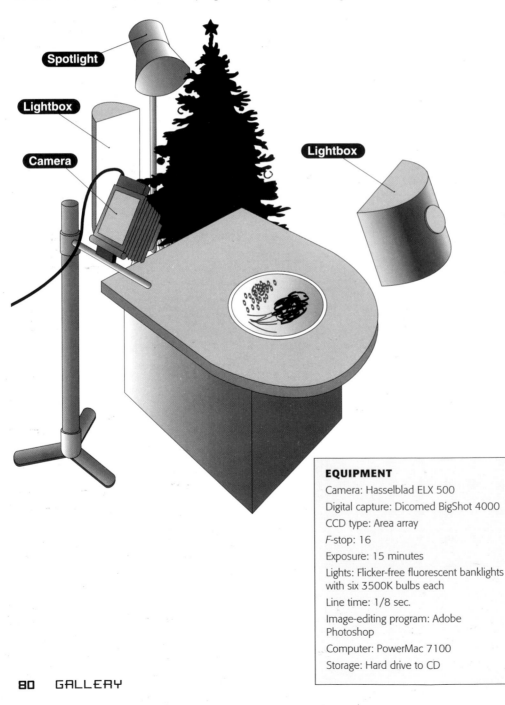

EQUIPMENT
Camera: Hasselblad ELX 500
Digital capture: Dicomed BigShot 4000
CCD type: Area array
F-stop: 16
Exposure: 15 minutes
Lights: Flicker-free fluorescent banklights with six 3500K bulbs each
Line time: 1/8 sec.
Image-editing program: Adobe Photoshop
Computer: PowerMac 7100
Storage: Hard drive to CD

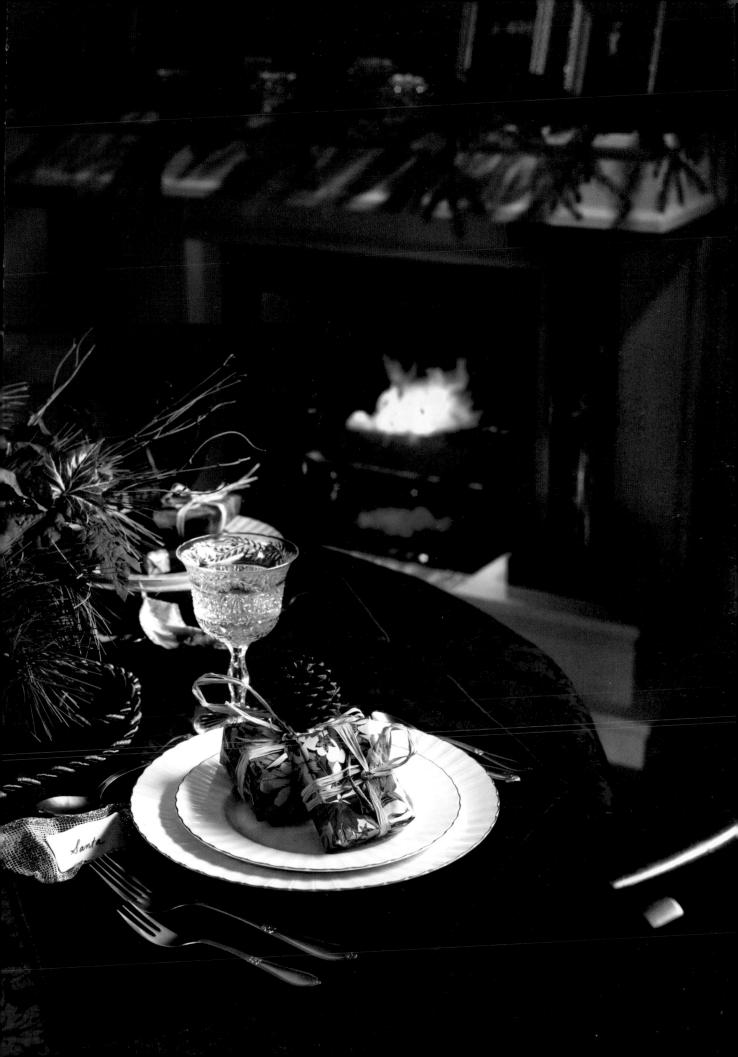

USING PHOTOSHOP FILTERING

Butkowski Photography

I was asked to help illustrate a custom line of handbags and business products for a new client. I started by first setting up the composition and then lighting the subjects. Initially, the main light was on the left of the subjects with the idea that I could spotlight each subject. But after doing a couple of scans, I changed the lighting completely around. Lighting each item was too involved and complex for the subject. Simple lighting was the answer.

I began by setting up a 5,000-watt light in a large softbox to illuminate the whole scene. I added a background light and a small accent light to bring attention and detail to the leaves in front. I had four separate product groupings to do, so this basic lighting setup let me concentrate on the design and placement of the products.

I imported the images into a program called "Painter" from Fractal Design. I used the program to give the effect of a painted image. I then took the original file and the new simulated painted file and merged them using Photoshop. The two images were on separate layers. Using the erase tool, I removed portions of the top, painterly version, thereby allowing the original sharp version to come through. This produced a dreamy, surreal quality to the image.

EQUIPMENT

Camera: Sinar F1

Digital capture: Dicomed 4 x 5 scanning-back camera

F-stop: 16½

Exposure: 3 minutes

Main light: 5,000-watt floodlight in a 24 x 48-inch softbox

Background light: 2,000-watt Fresnel

Accent light: 150-watt mini spotlight

Image-editing programs: Adobe Photoshop 3.0; Fractal Design Painter 4.0

Computer: Apple Quadra 950

File size: 65 mb

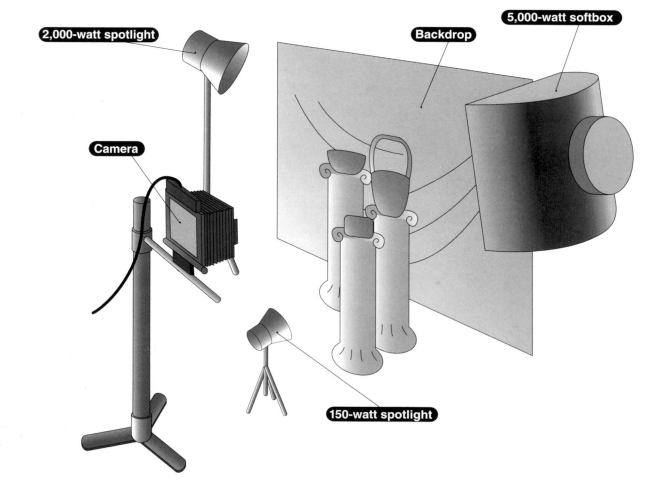

2,000-watt spotlight

Backdrop

5,000-watt softbox

Camera

150-watt spotlight

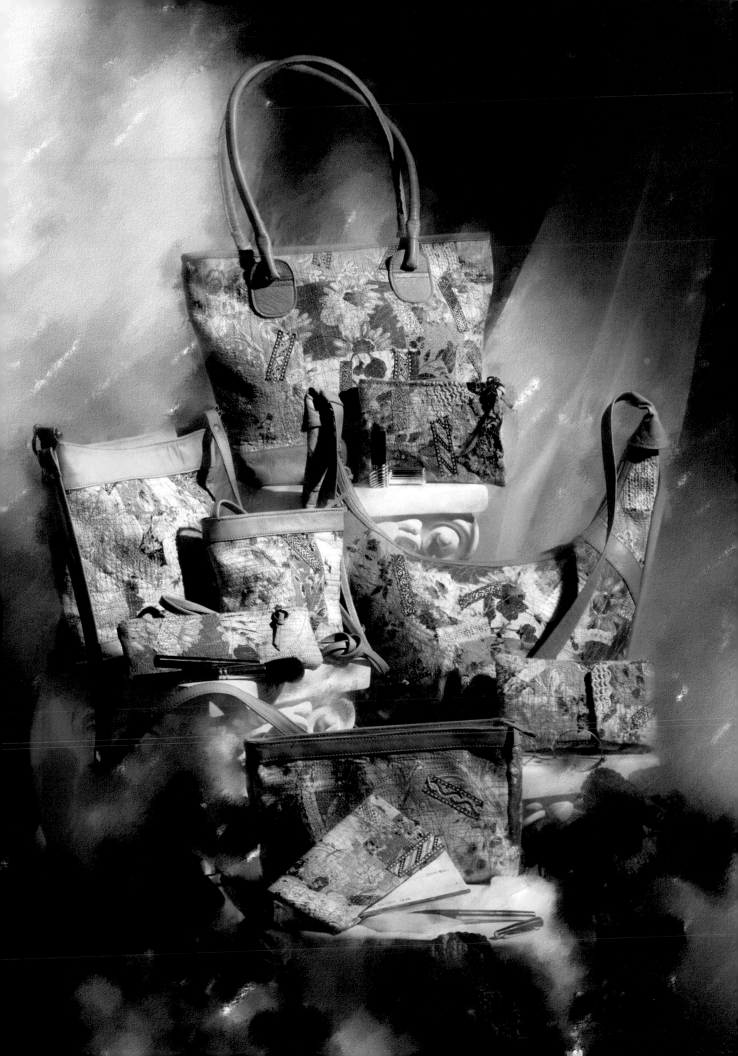

CREATING SPECIAL EFFECTS

Holt Photography

This photograph was done as part of an advertisement for a magazine to advertise a hatchet lure. Shooting this piece digitally worked well because of the ability to remove unwanted elements in the picture. The first part of the photograph entailed suspending the lure with a minnow inside the aquarium. This was done by attaching them to a monofilament secured to the bottom, which were later retouched out in Adobe Photoshop.

The challenge here was to keep the minnow from going belly up. The walleye used in the photograph was actually outside of the tank and mounted from underneath. It was aligned with the tank in such a way as to give the appearance of being free-floating in the tank. The lighting was done by an overhead softbox combined with a cookie, which is a card with holes or irregular patterns cut into it, to create shadows.

EQUIPMENT

Camera: Hasselblad 553 ELX

Digital capture: Megavision TI

Shutter speed: 1/60 sec.

F-stop: 16

Main light: 36 x 48-inch softbox with 3,200-watt strobe inside

Background light: 2,000-watt light

Image-editing program: Adobe Photoshop

Computer: Apple Power Mac 9500

Storage: Optical disc to CD

File size: 48 mb

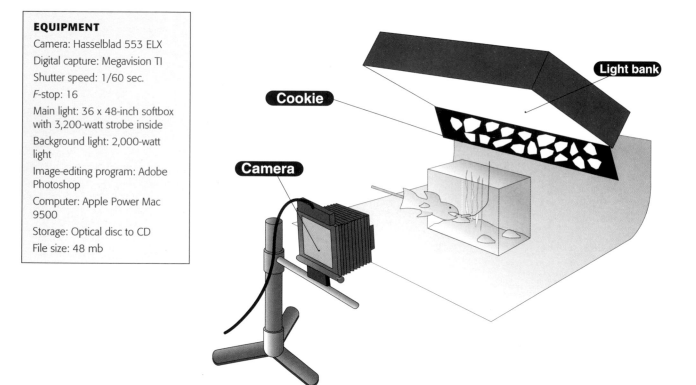

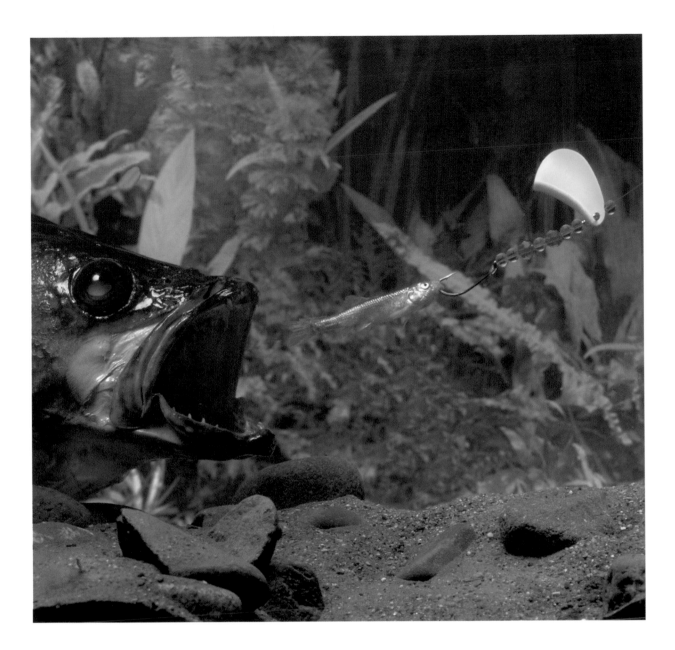

USING FLASH AND BURN TECHNIQUES

Christensen Carver Digital

This image was photographed for the cover of a hip-hop compilation CD series for B & G Records, a division of Capitol Records. Freeland Griffith Associates, a Los Angeles agency, wanted a New York-based studio to create a strong cover to launch the series. Both of the agency principals flew in from Los Angeles to attend the shoot of Spinderella and her brother. Because the agency had never used digital photography before, both film and digital cameras were used: Hasselblad and Ektachrome, and Hasselblad and Leaf Catchlight.

Within the first hour of shooting, the client fully appreciated the creative control and flexibility that the digital system offered with its instantaneous 7-inch color previews. We would shoot for 20 to 30 minutes and then review that portion of the shoot on the monitor using Leaf's contact-sheet software. First we would look at the creative aspects of the shoot, then while set and lighting changes were being made, we would make a rough edit.

My partner, Paul Christensen, and I (Douglas Carver) worked as a team to continually expand the creative variations available to the client. We mixed strobe and tungsten light. Strobe captured the sharp part of the image. And using tungsten with a slow shutter speed captured the blurred and ghosted portion.

The immediate control of both the creative and technical aspects of the shoot enabled our studio to put our subjects and clients at ease. The agency creatives knew exactly what they were getting as the shoot progressed. In fact, they selected the cover image before any film was even sent to be processed.

EQUIPMENT

Camera: Hasselblad 553 ELX

Digital capture: Leaf Catchlight

Shutter speed: 1/60 sec.

F-stop: 16

Main light: 800-watt strobe inside 8-inch reflector

Background light: Two 200-watt lights with gels

Accent light: 450-watt light with snoot

Image-editing program: Adobe Photoshop

Computer: Apple Power Mac 8100

Storage: Hard drive to CD

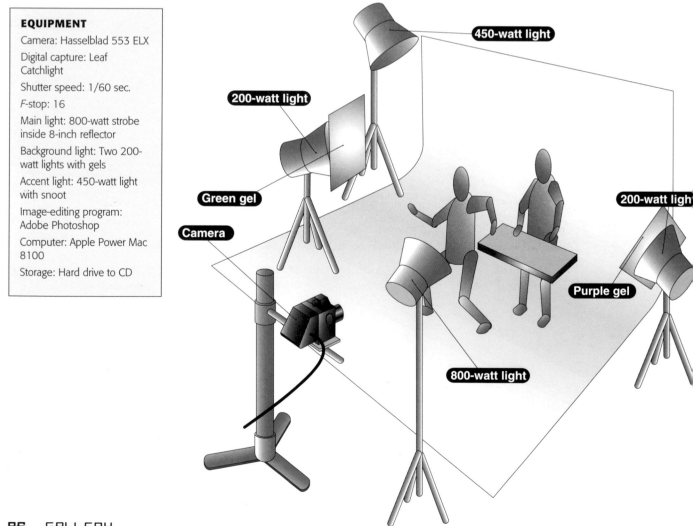

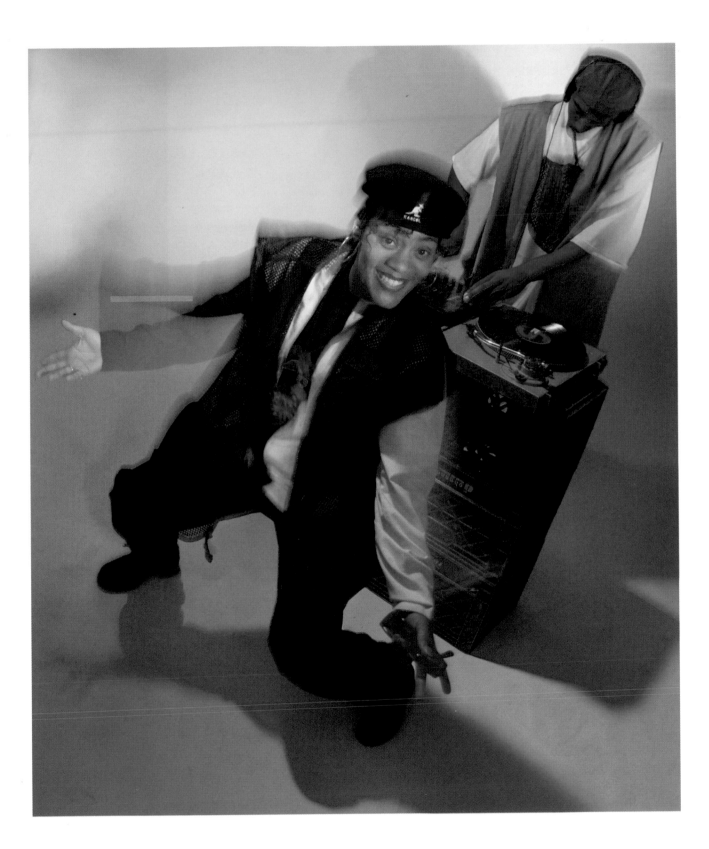

EXPLORING LOCATION POSSIBILITIES

Stephens Photography Inc.

I'm passionately fascinated with steam locomotives, and I travel to see and photograph them wherever possible. I sell art prints of steam trains at train shows around the eastern United States, but don't see my digital camera as contributing directly to that part of my business. When 16 x 20 color prints are your goal, you don't start out with 35mm slide film—or digital cameras, either. The picture quality isn't adequate for commercial print sales.

I did shoot this on the Kodak DCS 460 for a reason, though. I plan a campaign of direct-mail pieces hitting hard at the concept that I can do action—or, really, almost anything—with my digital camera, not just the studio still life that others offer. After all, that is why I selected the Kodak camera over the other choices available. So this action picture was shot with that in mind. I also intend to use the image as a Graphics Image Format (GIF) or Joint Photographers Expert Group (JPEG) on my future Web page, dedicated to promoting digital photography and sales of train prints.

I was positioned at this picturesque railroad crossing waiting for the train. The camera was on a tripod, prefocused and set for a pretested exposure. So although it is an action picture, it was done in a very deliberate way. I've been successful with many other action pictures shot handheld using autofocus and autoexposure, so the careful approach isn't absolutely necessary. On another tripod nestled just to the left, my trusty 4 x 5 Speed Graphic captured the same view on Kodak PRN color-negative film for my print sales.

This shot of Rock Springs Crossing was done of the same train, using the same techniques on the same day and for the same purposes as "4501 - Factory." This image was used in the second trade ad in my series (following "Beanbag Boy"—see page 60) with the headline/text: "If you think digital cameras are limited to the studio . . . YOU'RE ON THE WRONG TRACK!" I'll also probably use the picture in a promo printed piece.

As with the other train picture, I captured the view on 4 x 5 color-negative film for making prints for sale. I think this is an important concept for people considering a digital camera: Even though the Kodak DCS 460 can shoot almost anything anywhere, it might not be the best or even the most cost-effective medium for everything. It won't totally replace film.

EQUIPMENT

Camera: Kodak DCS 460

Shutter speed: 1/250 sec.

F-stop: 16

Main light: Sun

Image-editing program: Adobe Photoshop

Computer: Apple Power Mac 8500

Storage: PCMCIA card in camera, to Zip disc

File size: 18 mb

RECORDING A SUNSET ON A REFLECTIVE SURFACE

Butkowski Photography

The warm light of the sunset always looked great on the granite and blue glass of the building. I set out to see if I could capture that look digitally. The warm color of the sun's rays off the structure and graphic lines of the building made it a great subject. The building was a couple of years old, and there was a bank housed inside. A lot of signs were located on the exterior walls of the building and on drive-up teller lanes, which I knew could be removed later using the computer.

First, I set up, composed, and focused the camera. I took a prescan, color-balancing off of a white, gray, and black card using an Apple PowerBook laptop computer and the camera's software. I realized that by color-balancing the image, I would lose the amber cast of the setting sun's light; the scanning back's software would compensate for the warm color by adding blue. Although this would give me a perfectly color-balanced photo, it wasn't the end result I wanted. So I added a light blue filter over the lens and recolor-balanced. Because the camera would add yellow and red to compensate for the blue filter, this would produce a warm-looking light to the image. I took three scans, and during two of them, cars drove through the camera's viewing area. The last one was a clean scan, with no interruptions. Soon after the third scan, the sun went below the horizon line, making shooting nearly impossible.

Using Adobe Photoshop, I took out all of the signs in the teller's windows, the exterior bank signs, and the ATM. There were some unwanted reflections from nearby signs in the building windows, which were removed as well. I spent between three and four hours removing all of the signs and reflections. Another hour was spent adding more leaves to the trees and cleaning some dead grass out of the foreground.

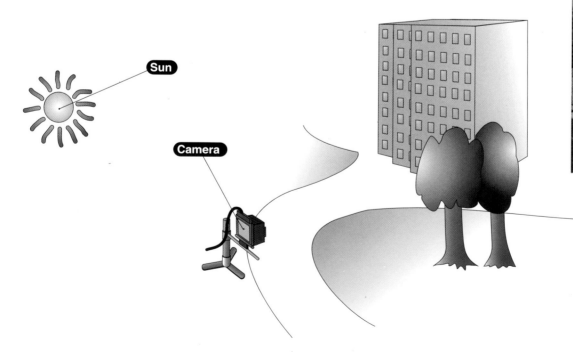

EQUIPMENT

Camera: Sinar F1

Digital capture: Dicomed 7520 scanning-back camera

F-stop: 22½

Exposure: 30 seconds to 2 minutes

Main light: Evening sun

Image-editing program: Adobe Photoshop 3.0

Computer: Apple Quadra 950

USING THE SUN FOR INTERIOR SHOOTING

Butkowski Photography

One summer evening, I came through the back door of my house and observed the sun streaming through the mini-blinds. Its rays were hitting my daughter's magnetic letters on the refrigerator, making the fluorescent colors glow. Not having a 4 x 5 camera at home, I decided that on the next sunny day I would photograph the letters. The following day was perfect.

I set up my Dicomed scanning back and my 4 x 5 camera, and played with the blinds to shape the way the light struck the letters. I composed the image and using my Apple PowerBook 160, I took prescans to determine correct exposure. I color-balanced using a white piece of paper. I had to use the quickest scan time possible because I was unsure at the time if the sun's movement would cause exposure shift. With scanning backs, the camera is scanning line by line. While the camera's scanning element was moving, the sun was moving, too.

The human eye doesn't notice the almost imperceptible movement of the sun, but I was somewhat concerned that the slight movement would show up in the scan. I had no reason to worry: experience has taught me that scan times as long as 4 to 5 minutes rarely create any problems. In between my daughter's inquisitiveness and getting in the way with her bouncing ball, I managed to take three scans of the letters using different contrast levels and exposures.

Sunlight through window

Camera

In terms of computer work, I opened up all the scans and selected the best one. I brought it into Adobe Photoshop, setting the levels to achieve as much shadow detail as I could while still retaining detail in the highlights. This was accomplished by setting the black point (the blackest area) and the highlight point (the point where no detail would show). This increased the contrast in the image. I then added saturation to the overall image to give the image more color and snap. Some cleaning was done to correct for any imperfections in the plastic letters, and I played around with the cropping to enhance the image's appeal.

EQUIPMENT

Camera: Sinar P2

Digital capture: Dicomed 7520 scanning-back camera

Main light: Late-afternoon sun

F-stop: 16

Exposure: 1 minute, 30 seconds

Image-editing program: Adobe Photoshop 3.0

Computer: Apple Quadra 950

File size: 20 mb RGB

USING A LAPTOP COMPUTER FOR LOCATION SHOOTING

Butkowski Photography

I was going on a location shoot to photograph an antique John Deere farm tractor for an equipment calendar. The shoot was on 4 x 5 transparency film, but I also brought my digital camera and Apple PowerBook 160 along. The owner drove the tractor out to a nearby field. While the tractor was being cleaned, I set up for the shot, getting my camera into position. I started with a high angle, exposed a couple of sheets of film, and then moved to a low angle. Using a low angle and looking up at the subject gave the tractor more prominence and authority. The tractor looked powerful and ready to tackle the field. The high angle of the sun helped to define the tractor and bring out the green color. I used a long lens, a 240mm, which allowed me to drop the background out of focus, helping to keep the attention on the tractor. I did a couple of scans, exposed some more film, packed up, and headed home.

To enhance the tractor even more, I selected the background and blurred it with the Gaussian blur filter found in Adobe Photoshop. I also increased the saturation of the yellow on the tractor. This yellow color looked a little flat and green. This could have been caused by the white board that I used to check the color balance—it might not have been as white as I thought, or it could just be an idiosyncrasy of the camera.

EQUIPMENT

Camera: Sinar P2

Lens: Rodenstock 240mm

Digital capture: Dicomed 7520 scanning-back camera

F-stop: 22½

Exposure: 1 minute, 28 seconds

Line time: 1/40 sec.

Main light: Afternoon sun

Image-editing program: Adobe Photoshop 3.0

CREATING A FINE-ART DIGITAL PHOTOGRAPH

Stephen Johnson

This image is part of a book project called *With a New Eye: The Digital National Parks Project*. This is a digital-landscape-photography look at American national parks. Each of the images for the book was taken using a Dicomed scanning-back camera, a Sinar 4 x 5 camera, and an Apple PowerBook 540c. This combination of digital capture, camera, and computer gives me a completely portable digital photography system with images of very high quality. The Dicomed is able to scan in black-and-white, infrared, and color with extremely high resolution and dynamic range (6,000 x 7,520 pixels/ around 130 mb files with more than 8 bytes per color), resulting in, for example, a 20 x 25-inch scan at 300 ppi.

This tree photograph was made during a gentle rain in the fall of 1994 in Shenandoah National Park. I huddled under a nearby tree for shelter and set up my 4 x 5 camera, Apple PowerBook, and the Dicomed 7520 scanning-back camera. Asserting control over the color balance on this image was particularly gratifying since I know how blue film would have rendered the scene. The light passing through the clouds and the rain would have made the color temperature of the sun's rays bluer.

The images were previewed in the field, on screen, in order to determine appropriate contrast, exposure, and color balance, as well as to check composition and focus. The full-resolution photograph was then opened to inspect the results, bringing to the photographic experience an immediacy and confidence never before present in landscape photography.

EQUIPMENT

Camera: Sinar P2

Digital capture: Dicomed 7520 scanning-back camera

F-stop: 22½

Exposure: 1 minute, 28 seconds

Main light: Afternoon sun

Line time: 1/40 sec.

Image-editing program: Adobe Photoshop

Computer: Apple 165 laptop

Storage: Camera's own hard drive to computer's hard drive, to CD

File size: 32 mb

SHOOTING WITH MINIMAL FOCUS

Butkowski Photography

This started as a shot for a client's promotional piece. After the client left, I started to play with the lighting on the flower. I don't get to play very often, so this was a treat. I wanted to try some new color-balance techniques. I began by using the camera's software to alter the color balance of the scan. The Dicomed controls allow a person to set a color balance for different types of lights being used: daylight, HMI, and tungsten.

I was using a 2,000-watt tungsten spotlight to illuminate the flower. I started by using the daylight-balance setting. I took a prescan and saved the results. I did this for the six different color balances the camera has. After they were all taken and saved, I compared them to see the differences in color balance. If I used the daylight balance while using tungsten lights, I would get a warm, yellow cast, much like late-afternoon sunlight streaming in through a window.

After choosing a color balance I liked, I began to play around with camera angle and focus. I started by focusing on only the center of the flower using an aperture setting of f/8 to give me a shallow depth of field. This kept the emphasis on the flower head and petals while letting the rest of the flower and the pot below go out of focus.

I wanted a more three-dimensional look, so I cut out the flower, duplicated it, and added a drop shadow (which can't be done with camera software). I did this to the other parts as well. To give the overall image more pizzazz, I added a new border using the PhotoEdges program. I also added a new background using a Photoshop filter called "Swirl." The working file on this image was about 175 mb to 200 mb, which included about six layers.

EQUIPMENT

Camera: Sinar F1

Digital capture: Dicomed 7520 scanning-back camera

F-stop: 8½

Exposure: 30 seconds

Main light: 2,000-watt tungsten spotlight

Line time: 1/40 sec.

Image-editing program: Adobe Photoshop 4.0/PhotoEdges/ Black box filters

Computer: Apple Quadra 950

Storage: Hard drive to CD-ROM

File size: 50 mb

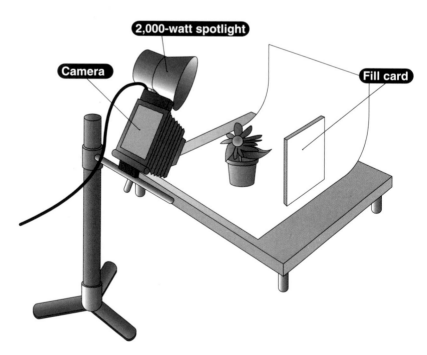

2,000-watt spotlight

Camera

Fill card

ADDING COLOR TO A MONOCHROMATIC IMAGE

Butkowski Photography

This was the first time I'd shot a motorcycle digitally. This was going to be a challenge, and its being a black cycle made it more so. Black soaks up a lot of light. I didn't have the time or the electrical power to just use another 10,000 watts of light, so I had to use what little power and lights I did have wisely.

First came the top light. I have a custom 6 x 12-foot banklight built for strobes, which don't give out a lot of heat. Now I was going to use 6,000 watts of tungsten light, which produces a lot of heat. I opened the side walls and added a small fan to move the air through the banklight, which did the trick.

After solving the problem of heat, I moved the bike into position and set up the camera. Next, I added the light over the front tire. An additional 5,000-watt light was placed in the front and directed into a reflector to help disperse the light. This filled in the front of the bike and gave a nice highlight to the tail pipe and engine. A smaller, 2,000-watt light was positioned to the back to lighten the seat and highlight the rear fender. To add the color background, I first masked out the entire motorcycle using Adobe Photoshop. I then used the airbrush tool to paint multiple colors lightly around the bike onto the gray background fabric. I also smoothed out the softbox reflections on the fuel tank.

EQUIPMENT

Camera: Sinar P2

Digital capture: Dicomed 7520 scanning-back camera

F-stop: 16½

Exposure: 3 minutes, 15 seconds

Main light: Six 1,000-watt Lowell Tota lights

Backlight: 2,000-watt floodlight in an 18 x 24-inch softbox

Frontlight: 5,000-watt Fresnel light

Accent light: 2,000-watt light in an 18 x 24-inch softbox

Image-editing program: Adobe Photoshop 3.0

Computer: Apple Quadra 950

File size: 50 mb RGB

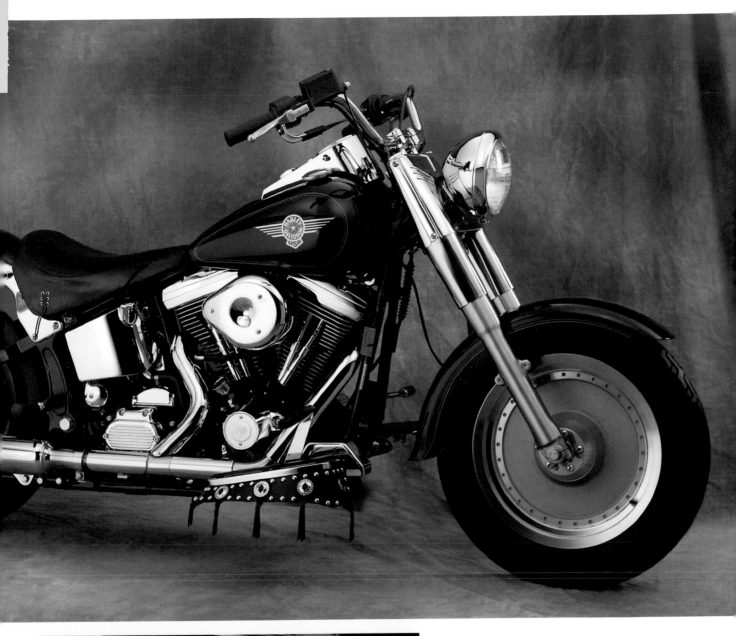

USING IMAGING FILTERS

Butkowski Photography

Sometimes the simplest subject can be the hardest. I was given an orthopedic foot pad to shoot for a trade-show graphic. First, I had to do some thinking on how to illustrate the use and features of this pad. I came up with the one I thought would work. I then shot the pad. Simple lighting was used: one light from the top and one a little stronger from the left side. This light would bring out the texture of the pad.

I did a series of three shots: one a little higher, one level, and one lower. This gave me some options later in image composition. Next, I set up with the same lighting for the foot shot. My assistant really didn't want her foot photographed, nut after a little reassurance that the blur would hide her imperfections, she agreed. When all the scans were complete, the rest of the work was up to me and Adobe Photoshop.

After opening the images and taking out the background of each on my computer, I went to work on creating the image. I first scanned a transparency of clouds for the background, cleaned up some dust marks, and then added the foot pad to the lower half of the image. The foot file was then input and resized to fit the pad. At this time the foot looked too big; it was dominating the illustration. I used a combination of filters on the foot image to recreate a photographic blur, and I changed the opacity of the foot layer to add to the blur and to achieve this visual effect.

EQUIPMENT

Camera: Sinar P2

Digital capture: Dicomed 7520 scanning-back camera

Main light: 2,000-watt floodlight

Fill: White fill card

F-stop: 16½

Exposure: 1 minute, 45 seconds

Image-editing program: Adobe Photoshop 3.0

Computer Apple Quadra 950

File size: 18 mb RGB

ADDING MOTION TO ILLUSTRATE AN ACTION

Holt Photography

The purpose of this shot is to show a flow of Froot Loops cereal through an acrylic, cylindrical flow meter. Trying to capture an actual flow on film would have been too hard since there is no way to regulate the flow, spacing, or density of the Froot Loops. Also, dust from the cereal is a problem in this type of flow situation. Far easier is a digital capture where Froot Loops are spray-mounted on a clear plastic sheet that is inserted into the plastic tube. A still capture is then made and a motion blur applied for the selected tube. In this case a vertical direction with a blur of 45 pixels was used—simple and quick. A blur could have been applied to a film scan but that would have taken a couple of days and been more costly.

By using digital capture, I could shoot open in Adobe Photoshop and see the final effect only minutes after I took the shot. Also, a side benefit of a three-exposure, digital-capture camera, such as the MegaVision T2 or the Leaf DCB, is the ability to have a spot in the background that can be covered on any combination of one and/or two flashes. This gives the photographer a selection of very intense and pure colors.

EQUIPMENT

Camera: Omega 4 x 5 view camera

Digital capture: MegaVision T2

Shutter speed: 1/60 sec.

F-stop: 32

Main light: 24 x 36-inch softbox with 4,800-watt strobe to left side

Accent light: 2,000-watt light with gel

Image-editing program: Adobe Photoshop

Computer: Apple Power Mac 8100

Storage: Hard drive to 2.6 gb optical

File size: 12 mb

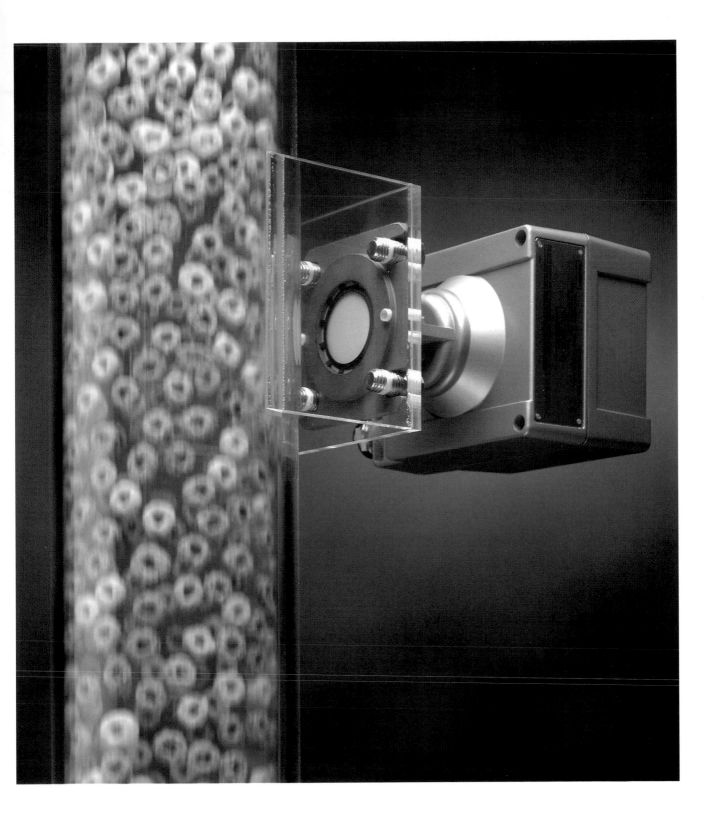

CREATING A HOT-FOIL ILLUSION

Studio Fineman

We were hired by a printing firm to help illustrate a technique known as "hot foil stamping." To fulfill this rather unusual request, we had to shoot two separate images that we later assembled into an image of the mask. To make the mask look "hot foiled," we covered a Japanese kabuki mask with crumpled aluminum foil. We then illuminated the mask from three different directions with a different-colored gel over each light source. The DP light sources enabled us to focus our concentrated colored light beam into exactly the area that we wanted. We could also judge the way the color overlapped from section to section.

Once we'd captured the master image, we then photographed the same image. But this time we removed all the aluminum foil, and we used only white light. Then, having a clean version of the face, image and design specialist Ray Rodriguez used Photoshop's layering tool to add just enough of the "human face" to bring life to our mask.

After we were done composing the images in Photoshop, I then moved the combined image to Live Picture. This picture-editing program had some features that at the time I couldn't find in Photoshop. It allowed us to "drag the edges" of the mask to make it appear to have some smoke rising from it. This helped convey the feeling of "hot foil."

EQUIPMENT

Camera: Sinar P2

Digital capture: Dicomed 7520 scanning-back camera

F-stop: 16½

Exposure: 3 minutes, 15 seconds

Main lights: Three 1,000-watt spotlights with blue, magenta, and orange gels

Line time: 1/15 sec.

Image-editing program: Live Picture

Computer: Apple Power Mac 9500

Storage: Zip disc to CD

File size: 50 mb

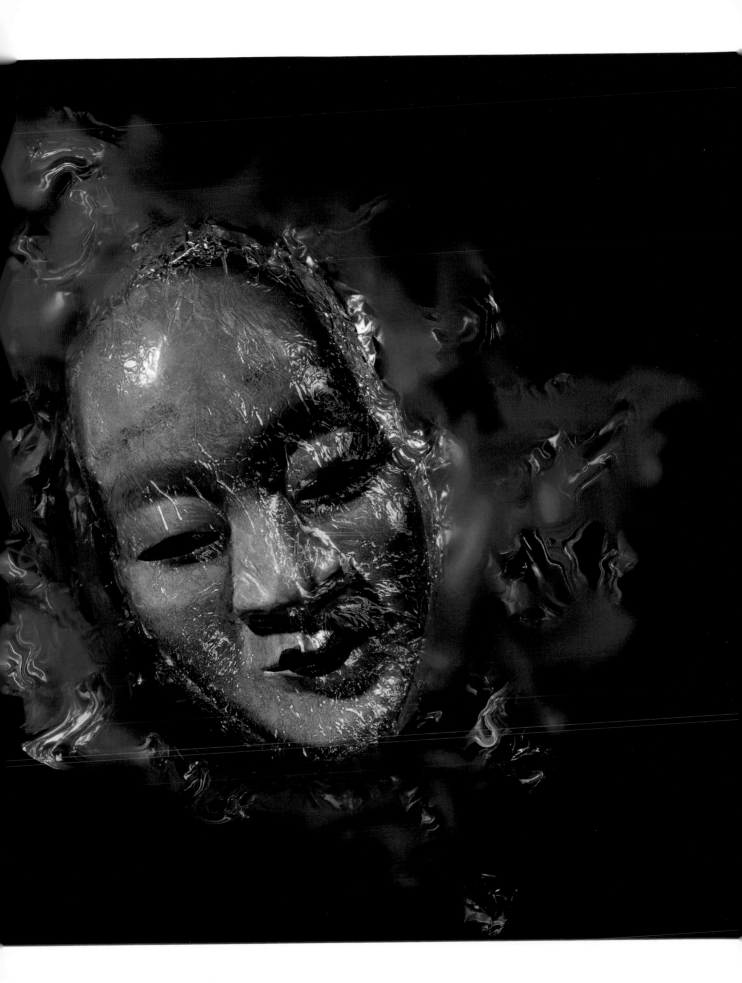

ACHIEVING AN AUTHENTIC LOOK

Studio Fineman

CNN was about to introduce itself to the Latin American marketplace. The concept was "CNN interviews the world." The globe and the podium were photographed separately. The podium shot needed to have the feeling of being in one of CNN's broadcast centers. In order to have the podium look correct, I tracked down a sound man who worked in the White House. Needless to say, the podium looked very official.

The background was illuminated by shooting through "cookies." These are patterns cut into metal and then inserted into the front of a light source. They created the exact random pattern that we wanted.

The globe needed to having a feeling of floating in space while being interviewed. The globe was illuminated equally on both sides. This helped to create the dark center that our client wanted. We had to retouch out the hard edges that this particular globe had, and we also added a motion blur to help give the image a little energy. Both images were later composed in Photoshop. After we'd completed the assignment, the client asked our image and design specialist Ray Rodriguez to add the "CNN I.D. tags" to all the microphones. He created all the images in Photoshop as well.

EQUIPMENT

Camera: Sinar P2

Digital capture: Dicomed 7520 scanning-back camera

F-stop: 16

Exposure: 3 minutes

Main lights: Four 1,000-watt Tota lights through diffusion materal

Line time: 1/25 sec.

Image-editing program: Adobe Photoshop

Computer: Apple Power Mac 9500

Storage: Magneto optical to CD

File size: 32 mb

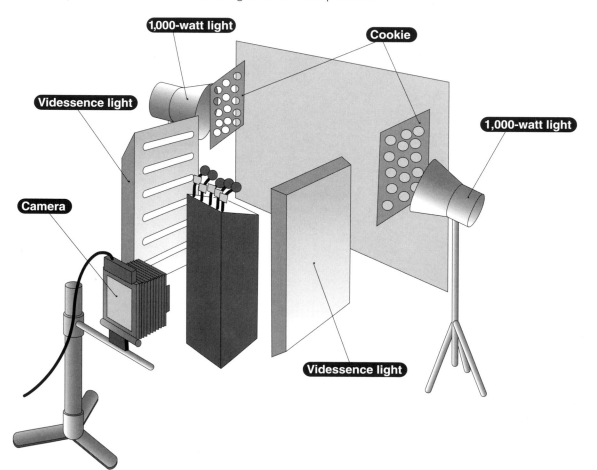

1,000-watt light

Cookie

Videssence light

1,000-watt light

Camera

Videssence light

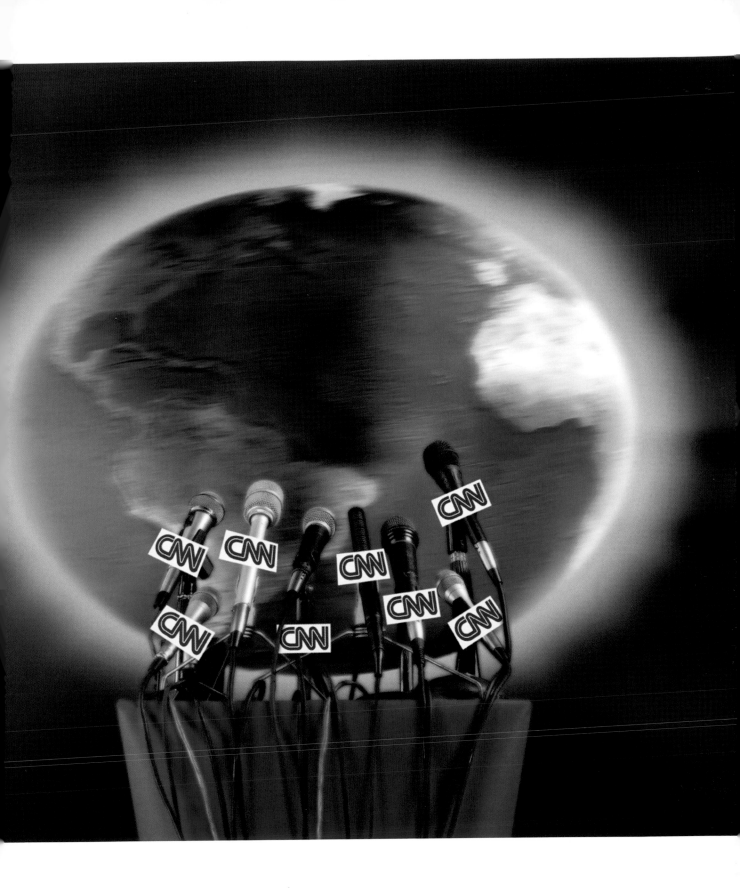

PRODUCING A LARGE, SHARP IMAGE

Studio Fineman

This was a promotional piece for the studio. People have always said that digital photography wasn't sharp and that the images were small. The original capture of this setup was a 218 mb file. We produced a poster that was 24 x 36 inches. Needless to say, no one would comment that this image isn't sharp.

This is a totally created image; the floor is really painted canvas. All the "details" were rented to help convey the feeling of an old garage. The motorcycle is a $45,000 Harley soft tail that won second place at Bike Week in Daytona Beach, Florida. The greasy stain walls were really aluminum siding that was purchased at a local hardware store. We then used rags to dab on shoe polish to create the aged look we desired.

The lighting consisted of mixed color temperature sources. The bike itself was illuminated with only Videssence lights. The background was illuminated using ellipsoidal spotlights. This enabled us to make the shafts of light that were on the background appear like normal light from the sky. The chrome on the motorcycle posed another problem. By its very nature, chrome is a mirror reflecting everything that it "sees." Our job was to tell it what to "see." So we built a white wall that was 12 inches high and wide. We cut a hole in the wall to position our camera and illuminated the wall. By lighting the wall, we were actually lighting the chrome.

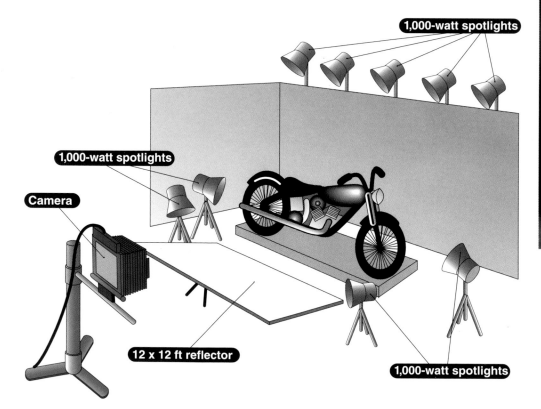

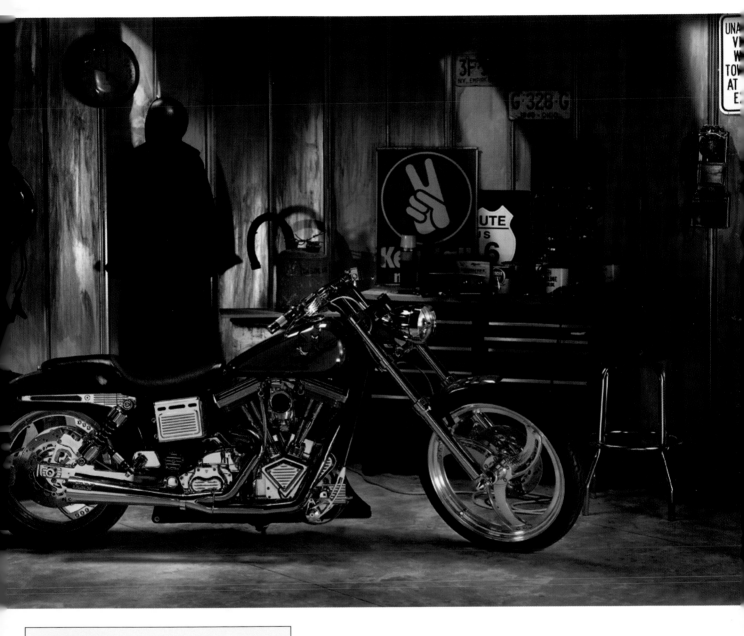

EQUIPMENT

Camera: Sinar P2

Digital capture: Dicomed 7520 scanning-back camera

F-stop: 22

Exposure: 5.05 minutes

Main light: Four 1,000-watt lights

Line time: 1/10 sec.

Image-editing program: Adobe Photoshop

Computer: Apple Power Mac 9500

Storage: Magneto optical to CD

File size: 50 mb

CAPTURING ACCURATE COLOR

Studio Fineman

This assignment was done for a printing company. Normally a printer will show beautiful images of its press and its facility. We not only photographed the food, but Ray Rodriguez, our image and design specialist, designed the brochure as well. His thinking was "Let's show the color of printing." After all, that is what their real business is about. The brochure turned out to be a six-course meal with recipes.

This particular photograph of the lobster was shot from directly overhead. What we were selling was lobster bisque. The lighting was rather simple to emphasize the texture of the food. That is why we chose a simple sidelight arrangement with small fill cards to emphasize areas that were too dark for our taste. Visually textureless food has no appeal, and we wanted people to think the food was good enough to eat. If they did, this meant that the quality of the printing came through.

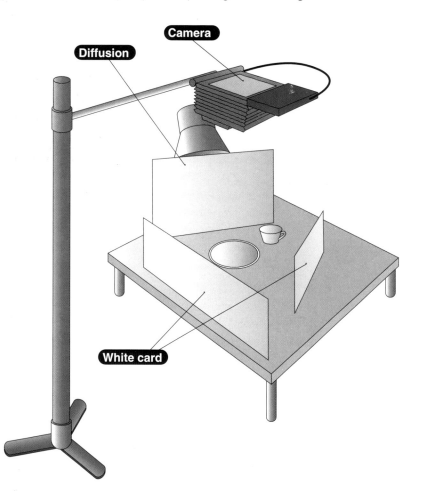

Camera

Diffusion

White card

EQUIPMENT

Camera: Sinar P2

Digital capture: Dicomed 7520 scanning-back camera

F-stop: 22

Exposure: 2.5 minutes

Main light: One 1,000-watt light through diffusion material

Line time: 1/12 sec.

Image-editing program: Adobe Photoshop

Computer: Apple Power Mac 9500

Storage: Magneto optical to CD

File size: 50 mb

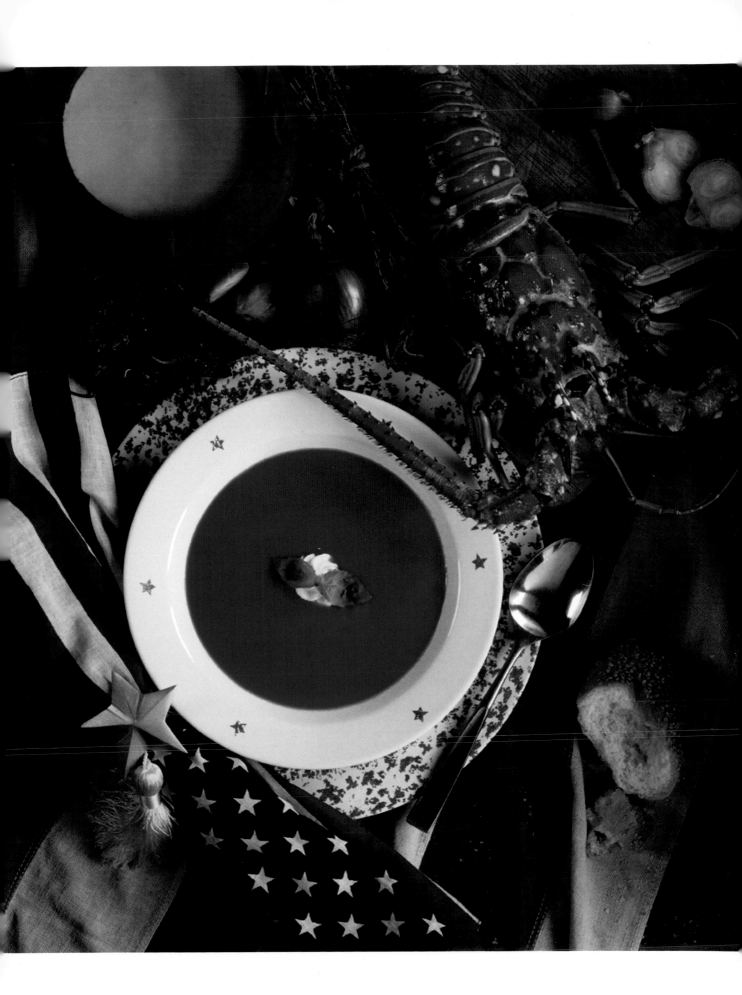

MAKING A MULTIPLE-IMAGE COMPOSITE FOR DISPLAY

Eddie Tapp

The assignment was to create a point-of-purchase image for a coffee-flavor dispenser. The client brought in a coffee cup, coffee beans, and the measurements of the display window (approximately 2 x 8 inches). We first shot the coffee cup with the hand holding the flavor drops and then the mountain of coffee beans with the Kodak DCS 460 camera. The background was borrowed from a stock image.

The images were composed in Adobe Photoshop in layers. As a final touch, I added a yellowish glow behind the cup to suggest a morning sunrise. As usual, the image was needed immediately to meet product production deadlines. The image took four hours to produce from concept to sending press-ready files to the printer.

EQUIPMENT
Camera: Kodak DCS 460
Shutter speed: 1/60 sec.
F-stop: 16
Main light: 36 x 48-inch softbox
Accent light: Strobe with 40-degree grid light
Image-editing program: Adobe Photoshop
Computer: Apple Quadra 950
Storage: Hard drive to CD
File size: 18 mb

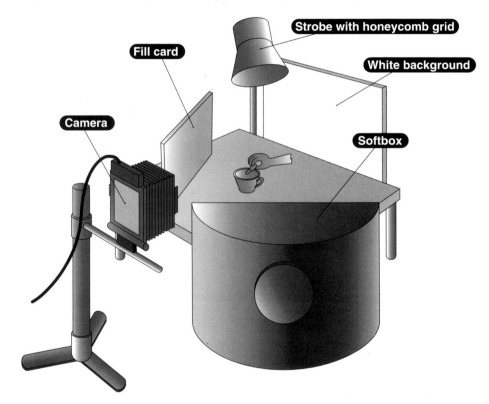

USING MULTIPLE EXPOSURES AND COMPOSITING

Les Jorgensen Photography

This image was done as part of an ad for Internet magazine-Mecklermedia. The client wanted a graphic representation of the Internet. Different elements, such as the key, and type were used to represent the various components of the Net. There were two exposures for this image to make up the background and foreground. During the exposure for the background, the camera was shaken to simulate a flash-and-burn effect. A 1K (1,000-watt) tungsten light covered by a red gel was used as the light source to create the glow. The foreground exposure was illuminated by various spotlights. These two images were then combined in Adobe Photoshop.

A Gaussian blur was applied to the background file. This file was then placed on top of the foreground image, and the two were blended using layer masks.

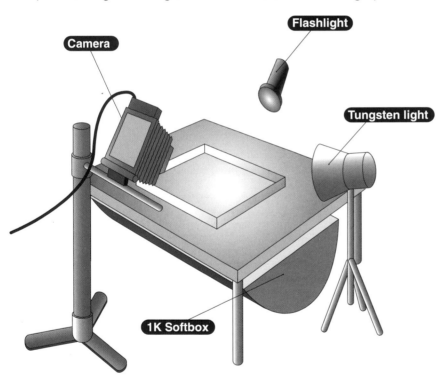

EQUIPMENT

Camera: Linhof 4 x 5

Lens: Schneider 210mm

Digital capture: Phase One Power Phase

Line time: 1/60 sec.

F-stop: 16

Lights: 1K Tungsten light and spotlights

File size: 55 mb

TYPES OF DIGITAL CAMERAS

Digital cameras come in many different shapes and sizes, and there seems to be a million to choose from. So buying a digital camera is like buying a breakfast cereal: the supermarket aisle is filled with a mindboggling variety. The array of digital cameras can be daunting. To simplify the selection process, keep in mind the following when you begin your search. You first need to ask yourself, "What will I use the camera for?"

If you plan to use the camera only for family snapshots, or for downloading documentary photographs onto your computer and either using them on the Web or for small enlargements, low-end consumer models in the 350,000 to 1 million pixel range will suffice. These cameras look just like conventional point-and-shoot (P&S) cameras and cost anywhere from several hundred dollars to more than a couple thousand dollars. As their name suggests, you just point and shoot; their limited features are fairly automatic. Most models have fixed-focal-length lenses or have minimal zoom capabilities, and the lenses aren't interchangeable.

If you intend to use your images for high-end catalog or print, you'll need a digital camera with much higher resolution capacities, the ability to generate a larger final picture size, and better-quality images than most P&S cameras can deliver. High-end cameras have more professional features, and the price rises according to the image quality that the individual camera achieves. The cost can exceed $10,000 for a 35mm-based professional cameras, like those photojournalists use, altered to incorporate a CCD chip and can go even higher for larger-format digital cameras. If you buy a high-end digital camera, you might need to consider financing, which you can spread over a period of several years. But if you are able to land a couple of catalog jobs, you'll be able to pay for the camera very quickly.

You can choose from four types of digital cameras. The consumer P&S models, which look, feel, and respond like traditional film-based automatic cameras, have been specifically designed as digital cameras and are geared to consumers on a small budget who don't require high-resolution images. Usually priced below $1,000, these cameras are perfect for recording family events and sending the images on the Internet, as well as for Web pages, documentation, and company newsletters—in fact, for any use that doesn't call for very large final images.

The second type of digital camera, the SLR cameras, consists of purposely built 35mm format cameras and modified cameras containing a digital sensor capable of capturing usually more than a megapixel. This sensor, or CCD chip, replaces conventional film. These cameras are more expensive than consumer P&S models, ranging in price from a couple of thousand dollars to more than $15,000. Although these SLR cameras can be used for the same consumer-camera reasons discussed above, they're used primarily for business applications that require higher-resolution images and for purposes that involve tight deadlines, such as photojournalism.

The third digital camera category comprises removable digital camera backs using an area or matrix CCD chip and made to fit on existing medium-format cameras or 4 x 5 camera, thereby replacing traditional film backs. These cameras are used for high-end digital capture, such as for images used in brochures, catalogs, and fashion and food photography.

The last category is made up of scanning-back cameras that are ordinarily used in conjunction with 4 x 5 cameras, but not always. Scanning-back cameras differ from instant-capture cameras primarily in exposure duration and chip configuration. The area-array cameras use a matrix configuration to capture color data, while linear-array cameras scan one line of an image at a time. They're used to capture large file sizes for large prints, such as those intended for display or posters.

CHOOSING A CAMERA

Before you begin to shop for a digital camera, you first need to know a little bit about what you're looking for. Purchasing a camera is like cooking. Before you can prepare an elaborate dish, you must be familiar with the ingredients the recipe calls for and understand the amounts and measurements required. The more you know about digital cameras, the better prepared you'll

be to make an intelligent decision when you go to buy one. Keep in mind the following factors when considering the different features of specific cameras. The cameras described within the main categories here are representative of each group.

Resolution

Camera resolution, or the amount of detail a CCD chip can capture, is measured in pixels per inch (ppi). Pixels are the minute photo sites of the CCD chip and are the digital equivalent of the grains in film. The pixel count of the chips varies with the sophistication level of the camera. A low-end consumer camera captures an image size of roughly 640 x 480 pixels, while a high-end camera can capture an area up to 6,000 x 7,500 pixels. This pixel count determines how much information a chip is able to·capture and at what resolution an image can be printed at to produce a high-quality print.

When deciding what size CCD chip will work for you, think about the size of the final output or the print, as well as what it will be printed on. Image resolution refers to the pixels or dots per inch (dpi) that the imagesetter uses to print the image. This amount can fluctuate according to the printing requirements or the final usage. Most dye-sublimation printers operate on a standard 300 dpi setting to generate a photo-realistic print. For example, suppose that your final output needs to be an 8½ x 11-inch photograph printed at roughly 300 dpi. This means that you would need a camera with a pixel resolution of 2,550 x 3,300 (8½ x 300 = 2,550; 11 x 300 = 3,300). If, however, you plan to primarily use your photographs for the screen, Web pages, and/or multimedia presentations (which requires only 72 dpi), cameras that produce images in the 640 x 480 pixel range would be just fine. With this resolution, you could make 2 x 2½ inch prints. (It is also the standard VGA resolution of a 15-inch computer monitor and fills the monitor's screen.) If printed at 200 dpi, a CCD chip with a pixel count of 640 x 480 would produce a 3.2 x 2.4-inch photograph.

As the pixel count increases in the CCD chip, the image-output capabilities also increase. A high-end scanning-back digital camera with a pixel count of 6,000 x 7,500 would be capable of producing a final image size of 30 x 37½ inches when printed at 200 dpi. As you make your camera selection, it is important to note if the final image size is actual size or is the result of computer interpolation.

CCD Configuration/Sensor

As you look at digital cameras, you must also consider whether the objects you'll be photographing will be static or moving. Most digital cameras use an area array CCD, which is capable of capturing the full subject in an instant. But to build up full color information, some area array CCDs use a three-shot method via which three separate exposures are made using a color filter wheel; each exposure captures its own color data of red, green, and blue. Because matrix array CCDs are more expensive to manufacture, especially in large sizes, the images they are able to produce are often smaller than those possible with a scanning-back digital camera.

Remember, most low-end P&S models are capable of capturing an image size of 640 x 480 pixels; midrange P&S cameras, about 800 x 1,000 pixels; modified 35mm cameras, such as the Kodak DCS 420, about 1,000 x 1,500 pixels; professional medium-format scanning-back digital cameras using a matrix array, upwards of 2,000 x 2,000 pixels; and high-end scanning-back digital cameras, such as Dicomed's 7520, about 6,000 x 7,500 pixels, thereby producing a much bigger file than matrix-array cameras. Scanning-back cameras, which scan one line of information at a time, require objects to be stationary, as well as a constant light source.

CCD Sensitivity/Exposure

This refers to the camera's light sensitivity and is measured in terms of its equivalent ISO rating or film speed. This number indicates a film's specific sensitivity to light, which varies according to pixel size, color filtration over the pixels, and the design of the CCD in terms of acceptable signal-to-noise ratio. CCDs register overall light intensity, but because they are more sensitive to the red portion of the light spectrum, an infrared filter is placed in front of the chip to reduce the amount of exposure in that area.

Amplification of each charge at the various photo sites (pixels) might produce "noise," whereby a small background charge—if the charge produced by the light exposure isn't greater—will show up as incorrectly colored pixels. The maximum ISO rating that can be used in setting exposure time and still producing an acceptable image is determined by the signal-to-noise ratio. When the charge or signal produced by the light exposure isn't significantly higher than the background charge or noise, inaccurate readings result, which, in turn, produce "noise."

Unlike films, which you can switch according to the needs of the lighting situation, CCDs aren't interchangeable. You can, however, make them respond like pushed film. When you push film, you intentionally underexpose it and then compensate by overprocessing it in order to achieve acceptable images. With the CCD, the signals that form from the accumulated charge at each photo site are amplified.

With professional 35mm, 120mm, and 4 x 5 digital cameras, you can dictate which settings to use in order to achieve the desired exposure. With area-array cameras capable of using flash, you set the exposure by changing the f-stop and aperture, just like film cameras. With the 4 x 5 scanning-back cameras, which scan over a period of time, you manipulate the f-stop using traditional methods; however, you control the shutter speed, or the length of the exposure, via the camera's software. This is called line time, and equals the length of time each line of the image is exposed during the scan.

For example: if you have a line time of 1/25 sec. and you're scanning 2,000 lines, the scan time would be approximately 1 minute, 20 seconds. If you increased the line time to 1/15 sec. per line, the exposure time for 2,000 lines or pixels would change to 2 minutes, 13 seconds. So to prevent images with unwanted blur, scanning backs are limited to shooting stable objects. Also, a constant light source is required for the duration of the scan. Any light fluctuations will be apparent in the final image as variations in color balance or as static.

Dynamic Range

This is a term that photographers often use to determine how much information can be captured from one f-stop to another, keeping detail in both the highlights and shadow areas. Any value outside of the dynamic range will be recorded as either black or white. Dynamic range refers to the maximum tonal range that film, photographic paper, or CCD chips can record. Photographers also often use the term it indicate the f-stop range.

Slide films can capture a dynamic range of only 6 to 7 f-stops, so proper exposure is more critical than it is with negative film, which is more forgiving and can capture more than 9 f-stops of information. A trilinear CCD chip can record between 9 and 11 f-stops of information. (Consumer P&S and midrange cameras can deliver about the same amount of or slightly less information as negative films.)

Dynamic range also refers to the number of different levels of gray that a digital camera can capture. Film-based cameras have only 32 different levels of gray, whereas most professional-level cameras digital have in excess of 256 different levels of gray. Color models are composed of 24-bit images, to produce 16 million colors. The higher the number of gray levels or colors, the smoother the gradation between tones.

Storage

If your digital camera is tethered to a computer via an SCSI cable, image storage might not be a big issue. But if location shooting is a requirement, then internal memory is important. Most consumer P&S cameras capture images in two separate resolution modes before you have to download the images onto your computer: high-resolution files and standard-resolution files. The number of files that can be stored varies from camera to camera. Some cameras have a high-quality mode of about 1,024 x 768 pixels. Because these cameras have only 2 to 6 mb internal flash ROM storage, this mode might allow you to shoot only 16 to 32 images, depending on the camera.

Professional and many P&S 35mm cameras enable you to store captures on removable PCMCIA cards or PC cards. You use them like a roll of film, loading a card into the camera and swapping it for an empty card when it is full. PC cards come with different memory-storage capabilities, ranging from a couple megabytes of information to more than a couple hundred megabytes. You then download a full card to a host computer by way of a piece of hardware called a PC card reader. Some larger-format cameras have their own hard drive that is capable of storing more than a gigabyte of information, which can then be imported to the computer.

Removable storage Type I PC cards can store around 2 mb of information. Depending on the kind of camera used, Type II cards will store between 2 mb and 20 mb if you use Compaq flash cards with an adaptor; otherwise, these cards store between 2 mb and 85 mb. Type III cards vary greatly in terms of storage capacities as well, ranging from around 85 mb to 340 mb. The cost of the cards ranges from about $370 for a Type III Integral 260 mb card to about $5,070 for a Sandisk 220 mb Ruggedized card.

Computer Requirements

Most likely you have a computer, but you need to find out if it is good enough to operate your camera. If you have a consumer-targeted camera, your one- or two-year-old computer is probably just fine. These P&S cameras don't require great amounts of RAM or processing power because the image files are small and the computer can easily work with them.

As you climb to the next level to professional 35mm SLR digital cameras, more computer processing power and RAM are necessary. The minimal computer-system requirements for a camera like the Minolta RD 175 (which captures a 5 mb file) are 25 MHz CPU or higher, 20 mb RAM or higher, and 30 mb hard disc space or more for storage. With other camera systems, the requirements are much greater. Some manufacturers suggest a 150 MHz CPU, an additional 150 mb or RAM, and more than 1 gigabyte (1,000 mb) of hard disc space.

Additional Software Requirements

Many cameras need some additional software in order for you to view the images on the computer monitor. This software is included with all P&S cameras, and might be included with other cameras; most manufacturers suggest the additional purchase of photo-editing or image-viewing programs. But these programs, which include Adobe Photoshop, Adobe Photo Deluxe, FotoLook, FotoTune, MacSoft PhotoMaker, and Corel Draw, are a bit pricey. A fully featured program like Adobe Photoshop can cost more than $600. If your camera doesn't require all of the bells and whistles, a program like MacSoft's PhotoMaker, which costs less than $30, is adequate for extensive retouching capabilities, such as those that Photoshop offers.

Transportability

With most P&S and SLR digital cameras, transportability isn't a problem. But tethering a camera to a computer limits the camera's range of motion to just a few feet from the computer. This arrangement could also restrict shooting to the studio. You can work with some tethered digital cameras on location by using a laptop computer to operate the camera software. In this case, storage is a consideration if the camera doesn't provide enough battery power for the laptop.

Lens Multiplication

The standard focal length lens of a 35mm camera is a 50mm lens, which is the approximate diagonal measurement of 35mm film. The standard lens for a medium-format camera is an 85mm, and the standard lens for a 4 x 5 camera is a 150mm. When film—whether for a 35mm, medium-format, or 4 x 5 camera—is replaced by a CCD smaller than its traditional dimension, a phenomenon known as focal-length magnification occurs. This means that only the central area of the image is captured by the CCD chip. If this area is enlarged to fill the traditional film format completely, it would look as if it had been photographed with a longer focal-length lens. This can be misleading: while it seems on the surface that the image was captured with a longer lens or that the focal length of the lens used was doubled (as if it was used with a teleconverter), in actuality, it is just the angle of view that has changed. This means that a smaller portion of the subject as seen through the viewfinder was captured.

Some digital cameras have managed to simplify this by modifying the image viewed through the camera to match what is actually recorded, or by offering a masking guide to match the image area captured. Some matrix arrays use CCD chips that are consistent in terms of size to the film format replaced so that little or no lens magnification occurs. If the lens' focal length is doubled, this is considered a magnification ratio of 2 to 1, or a magnification factor of two. The more closely the CCD chip matches the film format that it is replacing, the less magnification that occurs.

But the chips used in digital photography aren't the size of 35mm film; they are smaller, so the standard doesn't apply. Instead of inventing new lenses, digital-camera manufacturers use a lens multiplication factor. For example, a 50mm lens on a digital camera with a multiplication factor of two is a 100mm lens (50mm x 2 = 100mm). If the chip is larger, the multiplication factor is smaller and closer to the 35mm standard: a 50mm lens on a digital camera with a multiplication factor of 1.25 is a 62.5mm lens (50mm x 1.25 = 62.5mm).

CONSUMER POINT-AND-SHOOT MODELS

Agfa ePhoto 307

The Agfa ePhoto 307 is ideal for home and office use to create real-estate sell sheets, Web pages, greeting cards, and newsletters—to name just a few. The 307 looks and feels just like a regular 35mm P&S camera. It has a bit depth of 10 bits per color, and a digital sensor with two resolution options of 640 x 480 pixels for high quality and 320 x 240 pixels for standard quality. The camera's internal memory can store 36 high-resolution images or 72 standard-resolution digital images. The images are high-quality, 24-bit images with the potential for millions of colors.

The camera features include: a built-in auto flash with a coverage range of 3 to 10 feet, a fixed-focal-length lens that covers from 2 feet to infinity (equivalent to a 43mm lens on a 35mm camera), and a 10-second self-timer.

Agfa ePhoto 307

Epson PhotoPC 500

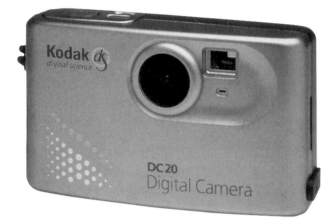
Kodak Digital Science DC20

Kodak Digital Science DC50 Zoom

The camera's sensitivity is equivalent to ISO 125. The 307 electronically operates a shutter speed ranging from 1/8 sec. to 1/10,000 sec. and runs off four AA alkaline batteries.

The 307 camera is Windows 95 and Macintosh (running system 7.0 or higher) compatible, and requires the computer to have at least 12 mb RAM and 50 mb available hard-disc space. Agfa PhotoWise and Adobe PhotoDeluxe software are included with purchase. You can use the PhotoWise software to transfer images from the camera to the computer and manage them once they are there. The PhotoDeluxe software comes with image-editing tools, including activities and templates, that let you create calendars, brochures, greeting cards, and more.

Epson PhotoPC 500

Epson's PhotoPC 500 looks like most other P&S cameras on the market, but an optional CCD panel for image preview, playback, and closeup picture-taking is available. The PhotoPC 500 enables you to capture 640 x 480 pixel images in 24-bit color easily and quickly for home or business use to display in business letters, presentations, greeting cards, and invitations, or to be sent via e-mail and used on the Web. The camera utilizes an advanced processing system for true colors and a ClearOptics system for sharp detail. The camera's exposure sensitivity is equivalent to an ISO 130. It uses an electronic shutter ranging from 1/30 sec. to 1/10,000 sec. and a two-step aperture of f/2.8 and f/8.

The camera's internal memory is capable of storing 30 high-resolution images or 60 standard-resolution images. You can expand the memory to 100 high-resolution images or 200 standard-resolution images by snapping in the optional PhotoSpan module that Epson offers. The lens is focus free from 2 feet to infinity and accepts most 37mm camcorder accessory filters and lenses for increased flexibility.

Another option available for the PhotoPC 500 is a snap-on LCD monitor capable of preview, playback, and displaying pictures as they're taken, allowing them to be deleted if they aren't what you want. The LCD also permits you to shoot closeup images—from 8 inches to infinity—without the use of a macro lens. The built-in flash facilitates shooting in low-light conditions with an option for red-eye reduction.

The PhotoPC 500 is compatible with both standard Windows 3.1 or higher systems and Macintosh 7.5 or higher systems. The camera requires at least 8 mb RAM and 25 mb available hard-disc space. Other requirements include a CD-ROM drive, a serial modem or printer port, and a VGA monitor with at least a 256-color display.

Kodak Digital Science DC20

This pocket-sized P&S camera provides an inexpensive introduction into digital photography for novices. The DC20, designed for personal picture-taking and home-computer use, is capable of capturing 24-bit color images with a resolution of 493 x 373 pixels. The fixed-focus lens ranges from 19 inches to infinity. The camera, which doesn't have a built-in flash, has an exposure sensitivity equivalent to ISO 800 or ISO 1600, depending on the amount of light available. The DC20 automatically determines which setting to use.

The camera's 1 mb internal memory can store 8 high-resolution images or 16 low-resolution images, making the DC20 perfect for sharing pictures online with family members and friends. You can do this easily by using Kodak's Digital Science Picture Postcard Software, available at no cost through Kodak's Web site. This software helps you make your own postcards and even add text. These postcards can then be sent and received electronically, and viewed and saved. You can also use DC20 images for business applications to jazz up a company newsletter or document. The PhotoEnhancer Special Fun Edition Software from PictureWorks Technology, Inc., which comes with the camera, enables you to create personalized greeting cards, calendars, and invitations.

Kodak Digital Science DC25

The DC25 is an improved version of the DC20, offering additional features to expand its use from personal home use to business applications. This compact digital camera uses an optical viewfinder for composing and framing pictures, which makes easier and also helps to lengthen the life of the batteries. The DC25 offers a color LCD display for picture review, you can scroll images forward or backward for viewing any time. You can look at images immediately to ensure that you are happy with the shots and individually erase any that you don't want to keep; this frees up space for more pictures. The camera's 2 mb internal memory stores either 14 high-resolution images or 29 low-resolution images. Like its predecessor, the DC25 can capture 493 x 373 pixel images in 24-bit color. The shutter speed is automatically set between 1/30 sec. and 1/4000 sec. The aperture ranges from f/4 to f/11, depending on lighting conditions.

The DC25 camera's built-in flash extends its use to varied lighting conditions. The DC25 also gives you the option of using removable CompactFlash memory cards. These cards look like credit cards and can be readily swapped once they become full, just like rolls of film. This added portability permits taking pictures on the go. You can download images through a standard serial cable connected from the camera to an IBM PC, an IBM PC-compatible, or a Macintosh computer. The camera requires at least 6 mb of RAM.

Kodak Digital Science DC50 Zoom

The DC50 looks like a pair of binoculars and weighs 22 ounces (including batteries). It has a motor-driven lens that is capable of going from wide-angle to as much as three times the magnification for shots that call for a tighter image simply by pressing a button. Images are viewed through a real-image viewfinder, thereby making framing easy—except when you're shooting closeups. The camera lens can focus at distances from 19 inches to infinity.

The automatic shutter fires at speeds from 1/16 sec. up to 1/500 sec. Aperture settings range from f/2.6 to f/16 and are also set automatically. While automatic exposure enables you to shoot pictures at the press of a button, you can also override automatic exposures if necessary. You can select three compression quality options for every shot from "good" to "better" to "best" as the end use dictates.

The DC50 has a resolution of 756 x 504 pixels and 24-bit color. The 1 mb internal memory is capable of storing 7 high-resolution images, 11 medium-resolution images, or 22 fair-resolution images. You can also store pictures on removable PCMCIA cards. To transfer images from the camera, you can insert cards into a laptop computer or through a standard serial interface cable hooked to a Window PC, a Macintosh computer, or a laptop computer with at least 8 mb RAM and 10 mb hard-disc space available. Like other DC models, the camera ships with PhotoEnhancer software.

Kodak Digital Science DC120 Zoom

This is one of the first P&S digital cameras to offer unmatched high-quality imaging and ease of use for less than $1,000. The DC120 has a high-resolution CCD sensor of 850 x 984 pixels that interpolates up to an image size of 1,280 x 960 pixels, for a total image resolution of 1.2 million pixels. The camera is equipped with a motor-driven lens capable of zooming from a wide angle of view to three times as close. The lens' focal-length range is equivalent to that of a 38–114mm lens on a 35mm camera.

You can view images on the 1.6-inch color LCD one at a time or in groups of four or nine. You can also individually delete unwanted images, thereby making room for additional pictures. Images can be stored on removable compact flash memory cards, available in

2 mb, 4 mb, and 10 mb capacities, which supplement the camera's 2 mb internal memory. Depending on the compression of the images, the DC120's internal memory can store up to 20 pictures. When you use the camera's default setting, you can store 12 images. You can shoot images in four modes: uncompressed, best, better, and good.

The DC120 has a built-in flash that is automatically activated when available light levels fall below a certain level. The camera's exposure-sensitivity equivalent is ISO 160. Four AA lithium batteries typically power the camera, but it can also be operated off an optional external AC line adapter or used with other AA batteries.

Camera applications can be used by desktop publishers, insurance adjustors preparing claims out in the field, real-estate agents, law-enforcement officials, and military and government personnel. The DC120 software includes PhotoEnhancer by PictureWorks Technology, Inc., Picture Transfer software by Kodak Digital Science, a TWAIN-acquire module for Windows systems, and Adobe Photoshop plug-in software for Macintosh and Windows 95. The camera is both Macintosh- and PC-compatible. Computer requirements for PCs is Windows 3.1 or later software or Windows 95, a minimum 486 microprocessor, a 33 MHz microprocessor, 8 mb or more RAM, 30 mb hard-disc space, a CD-ROM drive, and an available serial port. A color-display monitor with 800 x 600 pixels and 24-bit color is recommended.

For Macintosh computers, System 7.1 or higher is needed. Systems operating with a 68020 or higher processor require 8 mb or more RAM, 30 mb hard-disc space, a CD-ROM drive, and an available serial port. Once again, a color-display monitor with 800 x 600 pixels and 24-bit color is recommended.

Nikon Coolpix 100 and 300 Models

The Nikon Coolpix 100, which is slim enough to fit into a pocket, is a uniquely designed camera built on a PC card developed for users on the go and business applications where information might need to be quickly downloaded to meet tight deadlines. The Coolpix 300 operates as a multimedia Digital Video Assistant (DVA) for digital still image recording, as well as sound recording and handwritten memo recording. The Coolpix 100 has a resolution of 512 x 480 pixels, and the Coolpix 300 has a resolution of 640 x 480 pixels. Both models use a fixed-focal-length lens and a fixed aperture of f/4, which are the equivalent of a 44mm lens in the 35mm format.

You transfer images from the Coolpix 100 to a notebook simply by inserting the PC card. The PC model is capable of storing 42 normal-mode images and 21

fine-mode images. The multimedia model can store 131 normal-mode images and 65 fine-mode images. Digital information is downloaded from the Coolpix 300 to a computer through either an SCSI (small computer serial interface) or a serial interface cable. Each camera is powered by four AA alkaline batteries. The Coolpix 100 is equipped with a removable battery pack, but is also able to run off a computer while plugged in. The camera can also run off an optional AC power adapter. The length of the battery life depends on how much flash was used and if the LCD panel was used to display images.

Obsidian IC/100

The Obsidian IC/100 is a programmable camera equipped with a 486 microprocessor and operating system. This processor enables the camera to utilize in-camera image naming, as well as authenticating the image against future tampering. (Before photographing, you specify account names, identification codes, and a starting image number. This information is then written to the image file, as well as the time, date, and the serial number of the camera used.) Obsidian Security secures an image in the camera before it is written to a PC card. Authentication, watermarking, and encryption are three types of security used for images. Other software programs, such as SmartPictures, permit images to be tagged, either individually or as part of a group, for their predetermined destination and to be automatically color-corrected.

The IC/100 features interchangeable C-mount and 35mm lenses with a C-mount adaptor, as well as through-the-lens (TTL) viewing similar to traditional 35mm SLR cameras. (With ubiquitous C-mounts, a lens is attached to the camera body via the matching up of two lines or dots and turning the lens in the shape of a "C" to securely join the lens and camera.) You can use the built-in flash in either automatic or manual mode, with a multiple-flash option for optimum exposure. The CCD is capable of capturing 768 x 494 pixel resolution images in 24-bit color for a total of 16.7 million colors. Images can be stored on PC Type II removable cards and PC Type III cards. Type II cards can store approximately 20 images, while Type III cards can store approximately 1,600. An LCD control panel lets you keep track of the number of pictures you've taken; the amount of storage space, flash life, and battery life remaining; and the mode settings. The camera is powered by a DC adaptor or standard camcorder lithium-ion batteries.

Olympus D-200L and D-300L Models

Like other P&S cameras, the Olympus D-200L and

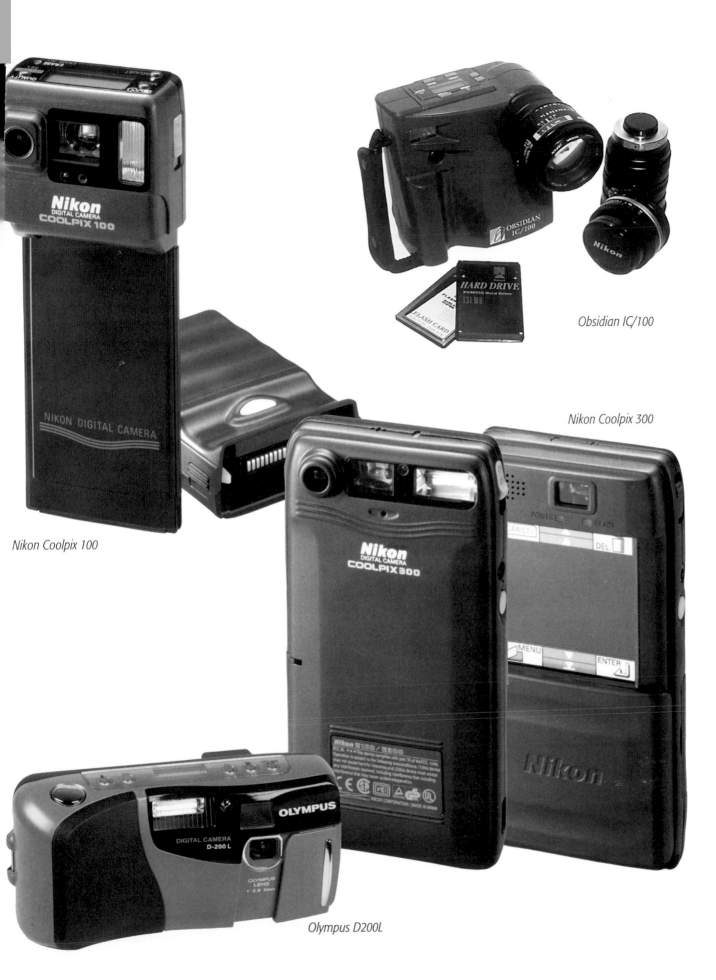

Obsidian IC/100

Nikon Coolpix 300

Nikon Coolpix 100

Olympus D200L

D-300L capture images in an instant. The D-200L comes equipped with a digital sensor capable of an image resolution of 640 x 480 pixels in 24-bit color. The D-300L has a digital sensor with an image resolution of 1,024 x 768 pixels, also in 24-bit color. The cameras use an f/2.8 high-resolution aspherical lens to reduce image distortion. Both the D-200L and the D-300L give you the choice of taking pictures with the lens set for a wide angle of coverage or set on macro for getting in close to the subject. Both models have on-camera flash capabilities, including one for reducing red-eye.

The cameras operate on full automatic TTL metering, using a center-weighted average metering system. The D-200L has aperture settings of f/2.8, f/5.6, and f/11, and shutter speeds ranging from 1/8 sec. to 1/1000 sec. And to ensure the image is what you want, Olympus designed the cameras with a built-in LCD screen that enables you to preview the image before you press the shutter and afterward to give you the option of deleting it if you don't want to keep it. The D-300L allows for 120 pictures in standard-quality mode and 30 pictures in high-quality mode. With the D-200L you can take and store 80 standard-quality and 20 high-quality images. Both the D-200L and the D-300L models use an equivalent of ISO 130. The D-300L camera runs off four AA alkaline batteries. You can download images to either your Windows PC or Macintosh computer via an external connector. (Olympus has recently introduced four new models, the D-220L, D-320L, D-500L, and D-600L.)

35MM CAMERAS

Canon EOS-DCS 1

The Canon EOS-DCS 1 handles like the professional 35mm EOS-1n camera, utilizing all of the features photographers have come to love and depend on to capture award-winning photographs. The 6 million pixel sensor has a 3,060 x 2,036 pixel area at 12 bits of color per RGB channel to create 4,096 different shades per channel. The EOS-DCS 1 is compatible with all Canon EF-mount lenses to produce finely detailed images. It has a 5-point autofocus system and shutter speeds ranging from 1/30 sec. to 1/8000 sec. to stop even the fastest action. The camera's high-capacity 16 mb buffer memory allows for continuous shooting for up to two exposures in approximately 1.7 seconds when you use shutter speeds greater than 1/250 sec.; the flash syncs at a speed of 1/250 sec. or slower.

You can store up to 26 images on PC Type II removable cards; use 170 mb PC Type III hard-disc cards; or transmit directly to a computer via an SCSI cable.

Computer requirements for a Macintosh include 8 mb RAM, 32-bit QuickDraw software, and Adobe Photoshop. For IBM computers and IBM-compatibles, the requirements are 8 mb RAM and TWAIN-compliant application software.

Canon EOS-DCS 3

The EOS-DCS 3 combines Canon's top-of-the-line EOS-1n with the latest DCS technology Kodak offers. Geared for working professionals with strict deadlines, the DCS is fully compatible with all Canon EF lenses to take advantage of the optics they offer. In addition, it can use most of the EOS accessories. The DCS 3 is able to make the most of standard features offered by the EOS-1n body, including autoexposure modes, compensation, and bracketing to ensure properly exposed images, as well as autofocus modes using the five spot-metering position indicators.

The camera's 1.3 megapixel CCD sensor captures a pixel-image area of 1,268 x 1,012 pixels with 12-bit color per RGB channel. The DCS 3's exposure sensitivity for equivalent film speeds is ISO 200-1600 for color images, and ISO 400-6400 for monochrome and infrared images. Shutter speeds range from 1/30 sec. to 1/8000 sec. A 16 mb buffer memory permits continuous shooting of up to 12 exposures for 2.7 images per second.

You can store images to a PC Type II removable card; you can also store more than 120 images on a 170 mb PC Type III hard-disc card. The PC cards can record notes or voice messages for up to 25 seconds at a time for captioning as well. Another option is to transfer images to a PC via an SCSI serial cable. Computer requirements for both Macintosh and IBM computers are at least 8 mb RAM. The DCS 3 is powered by a rechargeable nickel-metal-hydride (Ni-MH) battery pack.

Canon EOS-DCS 5

The EOS-DCS 5, like the EOS-DCS 3 and EOS-DCS 1, is built around the Canon EOS-1n body. The difference is the size of the CCD chip. The DCS 5's chip can capture a 1,012 x 1,524 pixel image area for a total of 1.5 million pixels, with the image area being marked right on the screen. The DCS 5 offers the same flash-metering and available-light-metering patterns that the other DCS-series cameras do, as well as accepts all EF lenses, including TS-E Tilt-Shift Series lenses. The camera's sensitivity is equivalent to ISO 100-400 for color images and ISO 200-800 for monochrome images.

The DCS 5 can capture 2.3 fps with bursts of 10 images in 4 seconds. File sizes are 1.5 mb RAM and

4.41 mb RGB. You can store up to 100 images on 170 mb PC Type III hard-disc storage cards. The camera also has voice-recording capabilities for caption information. You can download images to Macintosh and IBM computers. The camera is powered by built-in, rechargeable Ni-MH batteries.

Fuji DS-300

Offered by Fuji Photo Film U.S.A., Inc., this digital camera is equipped with an optical viewfinder, so what you see is what you get. The camera has a fixed (unremovable) 3X zoom lens. The DS-300 incorporates a vacancy-transfer (VT) technology CCD sensor with a resolution of 1,280 x 1,000 pixels. It is able to capture an image size of 1.3 million pixels. An optional extension unit offers a continuous-shoot mode that enables the camera to capture 4.5 fps, making the camera ideal for fast action or sporting events. The CCD sensor's exposure sensitivity equivalent ranges from ISO 100 to ISO 400.

The camera is fully operational on automatic for exposure, focus, and flash, freeing you up to concentrate on taking pictures. Its 3X lens has a focal-length range that is equivalent to a 35-105mm lens on a 35mm camera, and shutter speeds between 1/4 sec. and 1/1000 sec. You can set the camera to single-shot, self-timer, and continuous mode.

When the DS-300 is connected to an LCD monitor via a video out jack, whether a laptop or a television screen, you can check the composition of instant previews before shooting a frame. Images can be recorded in either TIFF or JPEG format, and can be easily transferred via the use of Type I or Type II memory cards or downloaded to the computer by way of a serial cable. The extension unit includes an SCSI connection for faster downloads or direct connections to Fuji printers.

Fuji Fujix DS 515 and 515A Models

The Fujix DS 515 and 515A were built on the Nikon F4 chassis, incorporating many camera features offered by Nikon technology. The camera has the same auto and manual capabilities for both aperture and shutter control. It has an electronically controlled focal-plane shutter with speeds of 1/8 sec. to 1/2000 sec. The DS 515 can shoot at bursts of 3 fps for up to 7 consecutive pictures. The 1,280 x 1,000 pixel resolution CCD sensor captures 24-bit images, which can be stored on a image memory card. The camera's effective sensitivity is equivalent to ISO 800 and ISO 1600. The DS 515 runs off a dedicated nickel-cadmium (NiCad) battery/external power supply.

The Fujix 515A has the look and feel of a conventional SLR camera and, like the 515, uses Nikon technology and

Canon EOS·DCS 5c

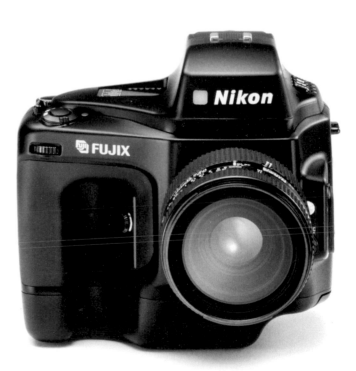

Fuji Fujix DS 515

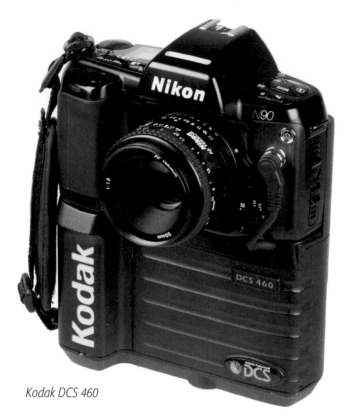

Kodak DCS 460

N90 accepts all F-mount lenses and uses the same traditional SLR operation. Both the DCS 420 and the DCS 460 come with all of the standard meter modes available.

The DCS 420 provides a 1.5 million pixel image captured with its 1,012 x 1,524 pixel area CCD in 36-bit color. The camera has equivalent settings of ISO 100-400 for color images and ISO 200-800 for monochromatic images. It has a burst rate of 2 fps for 5 consecutive pictures. You can record approximately 1,000 images per battery charge. Images are stored on PC Type II removable cards or PC Type III hard-disc cards. The DCS 420 is both IBM- and Macintosh-compatible and requires at least 8 mb RAM.

The DCS 460's exposure sensitivity is equivalent to ISO 100. The camera, which costs about $20,000, produces single-exposure images with a resolution of 6 million pixels. The DCS 460 CCD sensor has an image size of 2,036 x 3,060 pixels in 36-bit color which produces an 18 mb file. You can capture 300 images per battery charge with the 460 model, which requires at least 32 mb RAM in the host computer.

Minolta RD-175

This camera uses a 3-CCD sensor system to capture approximately a 1.75 million pixel resolution. This system captures an image area of 1,528 x 1,146 by diagonally shifting each CCD pixel to get the highest resolution possible. The 3-CCD uses a dual-green sensing system of G, G, R/B to capture color more accurately with 8 bits per channel. One CCD captures both red and blue color data, while the two other CCDs capture green color information with 8 bits of information each.

The Minolta RD-175 offers both the performance and versatility that the Minolta AF SLR series of cameras provides, and has the same autofocus, aperture-priority, shutter-priority, manual, and program-exposure modes as those film-based cameras. Shutter speeds range from 1/2000 sec. to 1/2 sec. A built-in flash comes standard for greater flexibility. Flash sync is at 1/90 sec. or slower. The camera has an exposure sensitivity that is equivalent to ISO 800.

Images are stored on PC Type II removable cards or PC Type III cards, and information can be downloaded to either an IBM, IBM-compatible, or Macintosh computer through an SCSI-2 interface. RAM requirements are 20 mb or higher for a Macintosh, and 16 mb or higher for an IBM with 30 mb of additional free memory required in order to successfully view and manipulate images using the Adobe Photoshop software that comes with the RD-175. Minolta software for image processing is also provided, as is catalog software.

F-mount lenses. It features an optical viewfinder that captures 98 percent of the image scene, so composing with this camera is as natural as using a traditional 35mm camera. The 515A has an effective exposure sensitivity of ISO 3200 for low-light situations of fast-action sports. It is capable of capturing 3 fps for a burst of 7 frames, just like the 515. An optional rechargeable battery is available, which captures up to 1,000 images per a single charge.

With the 515A model, images are recorded using Fuji's High Data Compression Techniques in JPEG format, keeping file sizes to 160 mb without experiencing loss of quality. Small file sizes mean fast transmission. You can store images on PC Type II removable cards available in 5 mb and 15 mb.

The 515A's improved 1.3 million pixel CCD uses VT technology for a resolution similar to the line density of high-definition television (HDTV). The camera has an auto white balance mode for the precision required to capture fine detail. The camera's automatic color-balance feature can operate under various lighting conditions, ranging in temperature from incandescent to sunlight.

Kodak DCS 420 and 460 Models

The Kodak 420 and 460c were built on the Nikon N90 chassis, using Kodak CCDs and digital storage. The Nikon

Nikon E2 and E2N Models

Because the Nikon E2 and E2s are based on the Nikon F4 chassis and electronics, working with them is as easy as working with a standard film-format Nikon. In addition, you have the same choice of Nikon lenses, flash units, and other accessories. Both the E2 and E2s use a 2/3-inch CCD with a resolution of 1,280 x 1,000 pixels that can capture 1.3 million pixels at 24-bit color depth.

Features include autofocus and a metering system that provides three choices: matrix metering, center-weighted metering, and spot metering. For flexible exposure control, the cameras offer program (P), shutter-priority (S), aperture-priority (A), and manual-exposure (M) modes. You can also manually set the aperture via the command dial from f/6.7 to f/38. The camera's sensitivity ranges from an equivalent ISO 800 when set on standard mode to an equivalent ISO 1600 when on high mode.

The E2 is capable of capturing images at approximately 1 frame per second (fps), and the slightly larger E2s can capture images at approximately 3 fps for up to seven consecutive shots. You can shoot images in four different quality modes—high, fine, normal, and basic—and then store them on PCMCIA ATA data-storage cards. The E2 and E2s are IBM- and Macintosh-compatible. The IBM setup requires 5 mb RAM and 4 mb available hard-disc space; the Macintosh setup calls for 2 mb RAM and 5 mb available hard-disc space.

The Nikon E2N and E2Ns cameras have an increased exposure sensitivity of ISO 3200 when in high-sensitivity mode, a flash mode to be used with high-powered studio lights balanced for daylight at 5700K, and a preview mode to confirm images on the computer monitor before capturing the final image. Both the E2N and the E2Ns models can shoot at 3 fps.

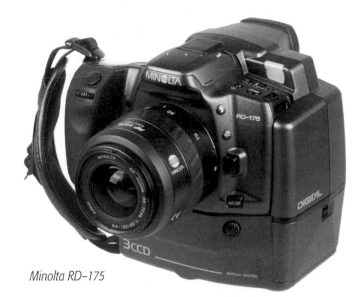

Minolta RD–175

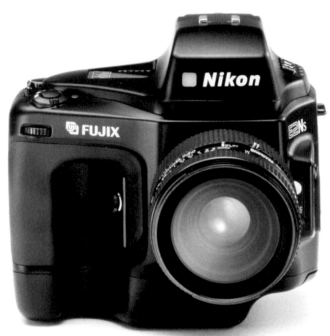

Nikon E2Ns

Polaroid PDC 2000

This PDC 2000 has a comfortable and functional body shape, and a built-in flash with a range of 15 feet. The camera's F2.8 11mm lens, which is equivalent to a 38mm lens on a 35mm camera, is standard; an optional 17mm lens, which is equivalent to a 60mm lens on a 35mm camera, is available. The PDC 2000 automatically controls the shutter speeds, which can range from 1/25 sec. to 1/500 sec. You can shoot about 5 images per minute with flash and 7 images without.

ISO 100 is the film-speed equivalent for the CCD chip. A 1 million pixel CCD sensor can produce either a super-high-resolution, 1,600 x 1,200 pixel, 24-bit uncompressed, interpolated image or a high-resolution, 800 x 600 pixel,

Polaroid PDC 2000

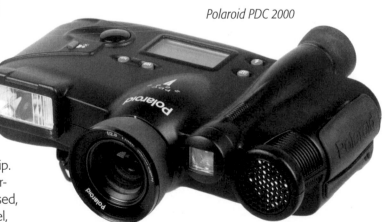

24-bit image. The file sizes are 5.6 mb and 1.4 mb respectively. Software for the PDC 2000 includes a direct utility for the camera. Adobe Photoshop plug-ins and drivers are also included for both Macintosh and Windows operating systems. The PDC can be used for a number of purposes, including real-estate transactions, documentation, company newsletters, and brochures.

You have three models to choose from. The PDC-2000/40 stores 40 images on the camera's internal hard disc. The PDC-2000/60 holds 60 image files. The PDC/T tethered version enables you to use a host computer for image storage.

MEDIUM-FORMAT CAMERAS

Dicomed BigShot 1000, 3000, and 4000 Models

The BigShot 4000 instant color capture camera boasts the largest single chip available so far for commercial medium-format cameras. The chip is a whopping 2¼ x 2¼ inches square, for more than a 4,000 x 4,000 pixel capture area; this can generate a 12 x 12-inch photo-quality image printed at 300 dpi. At 12 bits per RGB channel, the color and shadow detail are great. Because of the camera's CCD array chip, the back can use strobe lights, tungsten lights, HMI lights, or daylight. This enables you to use the BigShot 4000 for still product shots or images of moving subjects, such as in fashion photography.

The BigShot 4000 produces a 48 mb file in its 8-bit form, and a 96 mb file in its native 12-bit form. Of course, you can't run this on a 386 PC or a Macintosh Classic; the BigShot 4000 needs 150 mb RAM for the program, and additional RAM to operate the system and other programs. A 180 MHz or faster CPU for speed is recommended. At 48 mb per shot, a 1.2 gb hard drive won't get you far. Dicomed recommends a 4 gb drive with a PCI slot accelerator for fast transfer from camera to computer to disc.

The BigShot 4000 currently fits on a Hasselblad 6 x 6cm camera, but plans to make it compatible with 4 x 5 camera systems are in the works. The BigShot is also available in other models, such as the black-and-white, single-shot 1000 capture camera, which captures only monochrome images instantly. The BigShot 3000 model uses a three-shot approach that involves a color-filter wheel.

Kodak DCS 465

The Kodak DCS 465 digital camera back lets you capture high-resolution digital images with a CCD area array of 2,036 x 3,060 pixels, for more than a 6 million pixel resolution at 12 bits per color channel. You can shoot an image about every 12 seconds and can store images on the host computer's hard drive or on 105 mb Type III PC removable cards. The DCS camera back fits Hasselblad and Mamiya cameras, as well as 4 x 5-inch view cameras when equipped with an appropriate adapter. The back has an equivalent exposure sensitivity of up to ISO 100 and can be used with standard professional flash systems. Capable of producing 18 mb image files, it is compatible with Macintosh II, Powerbook, and Quadra computers, with a minimum recommended memory of 32 mb RAM. The acquire module is an Adobe Photoshop Software Plug-in.

Leaf CatchLight

This digital camera back uses a 1.2 x 1.2-inch CCD chip with an integrated mosaic filter, providing a final color image of 1,920 x 1,920 pixels. This can generate a 6.4 x 6.4-inch image at 300 ppi. In the CatchLight's native HDR (High Dynamic Range) format, for use in Leaf's optional Colorshop/HDR software, the back delivers 16 bits per pixel, per color channel of RGB. The CatchLight also has an 8-bit per color TIFF format for use in such photo-editing programs as Adobe Photoshop. Depending on the computer's CPU speed, you can make an exposure about every 10 to 15 seconds; after each shot the image appears on the monitor. Once the shooting is complete, you can edit the images using an additional contact-sheet program and keep only the final ones you want. A batch-processing program then converts the chosen files from the native file format to an 8-bit TIFF format for use in other imaging-editing programs.

The dynamic range is more than 9 stops. The CatchLight also has a patented anti-blooming feature to preserve highlight detail. The back is available for Hasselblad, Mamiya, and Fuji medium-format camera systems, as well as Sinar, Camerz, and Cambo 4 x 5 camera systems. It is compatible with most studio lighting equipment, whether it is strobe, HMI, or tungsten lighting. The CatchLight has an exposure-sensitivity equivalent of up to ISO 100, and operates with shutter speeds from 1/1000 sec. to 1 sec. It is designed for any Power Mac from the 8100 model and up, as well as the DayStar Genesis MP computer. The CatchLight requires an open Nubus or PCI slot for the Leaf interface card, and a minimum of 72 mb RAM.

Leaf DCB II

The Leaf DCB II digital camera back records three exposures: one red, one green, and one blue through a moving gel filter wheel. The three exposures are then

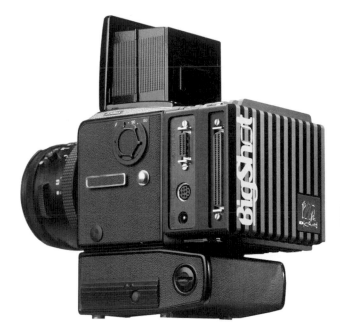
Dicomed BigShot

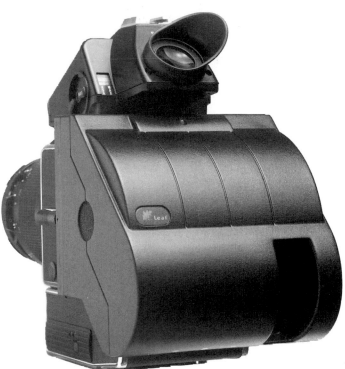
Leaf DCB II

combined in the camera's software to form the final high-resolution image file. The Leaf DCB II uses a 1.2 x 1.2-inch CCD chip and enables you to capture three-exposure color images or single-exposure black-and-white images.

The back offers 11 stops of dynamic range for great tone gradations. It also has a 2,048 x 2,048 pixel CCD with a patented anti-blooming feature; this helps prevent an image's highlight areas from blowing out and losing detail. The DCB II is compatible with most lighting equipment, including electronic strobe lights, tungsten lights, HMI lights, and daylight. For black-and-white exposures, the DCB II has an equivalent exposure sensitivity of up to ISO 200. For color exposures, its sensitivity is equivalent to ISO 25, and it operates with shutter speeds from 1/1000 sec. to 1 sec.

You can use the Leaf DCB II with many popular medium- and large-format cameras, including the Hasselblad, Mamiya, Fuji, Sinar, and Cambo models. To run this camera back, you need an Apple Quadra, a Power Mac 8100, or higher versions. You also need 64 mb RAM free for the camera and camera-control software, which allows for picture-taking, tonal control, and image cropping. Additional software called Leaf Colorshop gives you more control over file conversion, unsharp masking or sharpening, and image scaling.

MegaVision S2

This professional high-resolution camera back uses an array chip dyed with alternating colors of red, green, and blue to capture single shots of images instantly. The CCD area array can capture an interpolated 12 mb file of 2,048 x 2,048 pixels or a 6 mb native file. The CCD sensor has an exposure sensitivity equivalent to ISO 64. The S2 provides shutter speeds ranging from 1/2 sec. to 1/500 sec.

The lightweight, removable S2 back is compatible with medium-format bodies, such as Hasselblad and Mamiya's 645, RB67, and RZ cameras (compatibility with Bronica and Rollei cameras is in the works). The S2 connects to a Power Mac or PC system and is ideal for many applications, including fashion, portraiture, and interior and product shots, just like traditional medium-format cameras. You can also use the S2 with a belt-mounted power pack and a removable disc drive for location work, providing up to 4 hours of remote shooting.

The S2 can sync to studio strobes, and when tethered to a computer is able to capture an image every 1.8 seconds; when used on location with the BatPac, the S2 can capture color images at 1 fps. The BatPac is a belt-mounted power pack with 64 mb RAM, a removable disc drive, and an Ni-MH battery. Computer requirements for a tethered S2 are model 7200/120 with 64 mb RAM, a

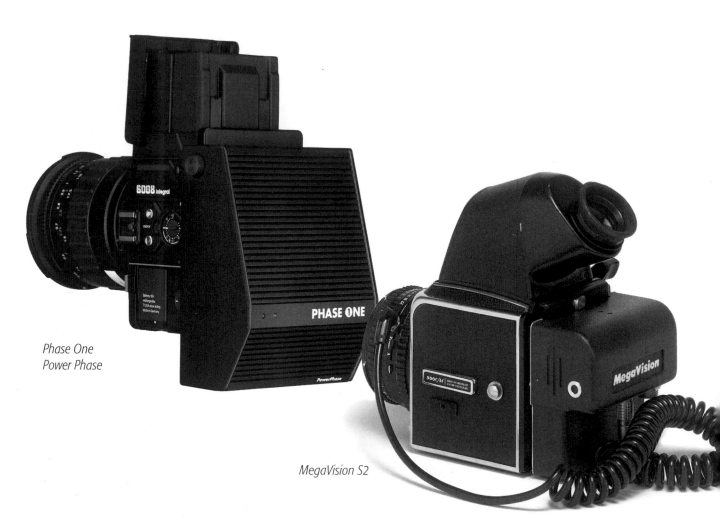

Phase One
Power Phase

MegaVision S2

1 gb hard drive, and a 17-inch monitor with an 800 x 600 pixel, 16-bit color display.

The MegaVision Software used to capture, develop, and store pictures taken with the S2 stores images in TIFF, which can be opened by any program reading that format. In order to for the software to capture images, you must put it into camera-ready mode. When on, the software responds immediately to images captured by the S2 and stores them as a thumbnail image to a proof sheet. You can edit images on the proof sheet, as well as delete any unwanted ones.

Phase One Power Phase

The Power Phase, which is intended for use with Hasselblad and other popular medium-format cameras, promises a digital quality that matches traditional film. It is designed for high-resolution images with a 7,000 x 7,000 pixel capture area, for a total of 49 million pixels. This produces a file size of more than 140 mb, so you'll need good storage capacity.

The Power Phase is designed for users requiring extremely high-resolution images that will be output to large printed material or high-quality stock, such as

magazines. The high resolution enables you to output to print a 22 x 22-inch image printed at 150 lines per inch, and to a 23 x 23-inch image printed at 300 dpi. Another bonus of the high-resolution file is being able to obtain an extensive depth of field by physically moving the camera farther away from the subject yet still being able to capture enough information to produce a letter-size print. All this is based on a CCD sensor made to match the Hasselblad medium-format camera perfectly. As such, you can use Hasselblad's existing lenses. This is without any lens magnification factors.

The Power Phase comes with flicker-suppression technology that permits you to use low-wattage tungsten, quartz, or fluorescent lighting systems. The camera's exposure sensitivity is equivalent up to ISO 1600, which reduces the need for heavy and expensive lighting equipment.

The Power Phase's image-capture software can go both ways; it is Power Macintosh-compatible, and is available for Windows 95 and Windows NT 3.51 as a fully implemented 32-bit application. For the Mac, you need a minimum of 10 mb RAM, 80 mb free space, and a 16-bit graphical adapter.

4 X 5 CAMERAS

Dicomed Field Pro and Studio Pro

The Dicomed Field Pro, formerly the Dicomed 7520, was one of the first scanning backs for any camera using conventional 4 x 5 film holders. (The studio version of the 7520 is now called the Dicomed Studio Pro.) The Field Pro boasts such features as automatic gray balance, a 2 mb preview, and user-definable scan areas. Its dynamic range is equal to 8 stops, which is 1 to 2 stops more than that of traditional transparency film. The camera delivers a 129 mb, single-pass, RGB scan; scan times vary from 1/8 sec. to 50 seconds per scan line. The back's 6,000 x 7,520 pixel scan area is the largest area currently available for 4 x 5 cameras; this scan can generate a 20 x 25-inch image at 300 dpi. In addition, the Field Pro's compact design, low host-computer requirement (it needs only a Powerbook), and optional batteries make it a good choice for field shooting.

HMI lights, tungsten lights, daylight, and daylight-balanced fluorescent lights are all compatible with the Dicomed Field Pro. The studio model doesn't have the standard 12-volt battery and aluminum travel case.

Leaf Lumina

The Leaf Lumina is truly a scanning camera. Within its wide aluminum body are the CCD chip and the UV filter, which are necessary for all scanning cameras or scanning backs. You can connect a large selection of Nikon lenses via the Nikon bayonet mount on the front of the Leaf Lumina. The camera can generate a 2,700 x 3,400 pixel image, which is equal to 600 ppi on 4 x 5 output and 300 ppi on 8 1/2 x 11. The camera has a 2,700 element, 3-line, RGB single-pass CCD. The image area is 28.5mm x 35.5mm, which is a little larger than a standard 35mm film frame. Lighting options for the Lumina are tungsten, HMI, or daylight-balanced fluorescent lights.

The Leaf Lumina can yield up to a 26.1 mb file. This is with typically fast scan times of under 3 minutes. You manually set f-stops on the lens, and set the line time, image cropping, and other functions in the software. Camera control is through an Adobe Photoshop Plug-In for Macintosh.

MegaVision T2

The MegaVision T2 was designed primarily for prepress photography, thereby enabling users to scale the image to the target size for end use. The T2 was built mainly with medium- and large-format camera users in mind and is designed to work with standard studio equipment.

Dicomed Studio Pro

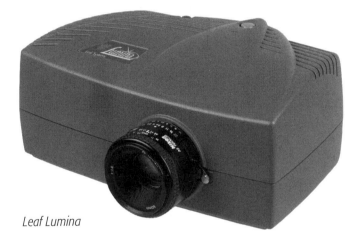

Leaf Lumina

It is 4 x 5 format-compatible with the use of an inexpensive attachment. The area-array sensor has a maximum image-resolution size of 2,048 x 2,048 pixels to produce a 12 mb color image. The three-pass digital camera back uses an internal filter wheel to capture 12 bits per each RGB, with capture times ranging from 5 to 10 seconds. The T2's exposure sensitivity is equivalent to ISO 300 in black-and-white mode and ISO 25 in color mode.

The T2 is both Macintosh- and PC-compatible and requires a minimum of a Macintosh 7200/120 with 64 mb RAM, a 1 gb hard drive, a 17-inch monitor, an 800 x 600 pixel display, and 16-bit color. When tethered to a PC, the T2's minimum requirements are a 90 MHz PCI Pentium, 64 mb RAM, a 1 gb hard drive, a 15-inch monitor with an 800 x 600 pixel display, and 16-bit color.

MegaVision T2

Phase One Photo Phase

The Photo Phase is one of the top 4 x 5 film scanning backs. As you do with others in this class, you insert the Phase One back into the same place you would a standard 4 x 5 sheet film folder. The scan size is 2.7 x 4 inches for a total of 5,000 x 7,200 pixels with one pass trilinear. The Photo Phase can produce more than a 100 mb uninterpolated RGB image file with 36-bit color depth (12 bits per RGB channel) for true detail and color. The Photo Phase can be used with tungsten lights, HMI lights, and daylight-balanced fluorescent lights. It has an exposure sensitivity equivalent of ISO 800.

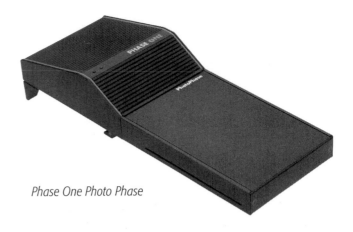

Phase One Photo Phase

Like its siblings, the Power Phase and the Studio Kit, the Photo Phase comes with flicker-suppression technology. This permits the use of low-wattage tungsten lights. Phase One camera control software, which lets you set the highlight and shadow points for complete tonal gradational control, is included. You can save all camera settings for later recall and use. This back is used for commercial photography for catalogs, products, and food. Computer requirements are a 68040 Power Macintosh with 24 mb RAM available for the camera software.

MISCELLANEOUS CAMERAS

Agfa StudioCam

The Agfa StudioCam is a tethered, fully featured digital camera designed to increase work flow and productivity. It was intended for such business applications as creating promotional flyers, direct-mail catalogs, and product brochures. It sports a 35-80mm zoom lens for easy

framing of subjects, as well as a preview capability on the computer monitor to check composition.

The CCD image resolution is 4,500 x 3,648 pixels and can be rotated internally for either portrait or landscape photographs. It uses a one-pass scan to capture 24-bit, 50 mb files and 36-bit, 100 mb files. Prescan time runs 12 seconds with capture times varying from 1/200 sec. line time to 1/30 sec. line time. Actual recording time varies from 1 to 10 minutes. Because scan times run into minutes in length, the StudioCam needs a constant light source. The camera, whose sensitivity equivalent extends from ISO 100 to ISO 400, has a dynamic range of 3.0.

The StudioCam is Macintosh-power PC compatible and requires a minimum of 32 mb RAM and 24-bit video card. The camera is hooked up to the computer via an SCSI serial cable, and the images are imported by way of Photoshop plug-ins.

Agfa StudioCam

GLOSSARY

Accent light: An additional light used to highlight a small area or a specific product feature.

Additive color theory: When the primary colors of light, red, green, and blue, are mixed, white light is produced.

Aperture: The diameter of the opening in the camera through which light passes into the lens. Aperture settings are designated as *f*/8 and *f*/11, for example; the larger the number, the smaller the aperture.

APR: The acronym for "automatic picture replacement." With APR, a high-resolution version of an image automatically replaces a low-resolution image. Scitex first developed the implementation process.

Archive: The long-term storage of graphic material on a computer system for future use.

Artificial lighting: Lighting that is generated from a camera's electronic flash or from lamps and that is used to provide additional illumination when the natural lighting isn't sufficiently bright enough.

Artwork: Artwork and art are the terms used to include all original copy, including type, photographs, and illustrations that are intended to be reproduced.

Available lighting: The natural lighting in a photograph, as opposed to the additional lighting supplied by the photographer. "Ambient light," "existing light," and "natural light" are other terms used quite frequently to describe available lighting.

Backing up: Copying information from a computer hard drive to another data-storage medium to prevent the loss of all material should the original material be lost.

Bank lighting: A number of individual light sources ganged together to provide increased brightness. This type of illumination is often diffused to soften its effect.

Bezier curves: Curved lines anchored by specific points for use in software that is designed for drawing and type rendering.

Bit: The smallest unit of data that can be recorded and stored. It represents a binary value of either zero or one.

Black: One of the four process colors used in printing.

Black and white points: The two end points for the range of tones in an image. The points are set in the "Curves" and "Levels" dialog boxes.

Bleed: The term used for a printed image that extends beyond the trimmed edge of a sheet or a page.

Block: Usually consists of 512 or 1,024 bytes, but sizes vary.

BMP: The acronym for "bitmap." The standard bitmap image format can be saved in either Microsoft Windows or OS/2 format for DOS and Windows-compatible computers. Bit depth, from 1 bit to 24 bits, can also be specified. With 4-bit and 8-bit depth, images might be compressed using Run-Length-Encoding (RLE), which doesn't discard any detail during compression.

BPI: The acronym for "bits per inch." The number of bits of data recorded per inch of tape.

Brightness: One of the three dimensions of color. This is the amount or the intensity of light reflected from the surface being illuminated, independent of its hue and saturation.

Byte: A unit that represents one character of information and consists of eight bits.

Catchlight: Light reflected in a subject's eye.

Chrome: The slang term for an original color transparency.

Coated paper: Paper that has been covered with a coating of clay or other mineral pigment to improve reflectivity and ink holdout.

Color balance: 1) The way film responds to the colors of the subject matter. Different light sources require different film, with each film balanced for use with specific light sources. 2) Altering colors during printing. 3) Maintaining the ratio of cyan, magenta, and yellow ink to produce a picture with the desired colors and without an unwanted color cast or color bias.

Color bars: A strip of the four process colors on a proof that a printer uses as a guide to determine the amount and density of ink required.

Color cast: When one dominant color appears as a trace in all the other colors in a photograph.

Color correction: 1) Adjusting one or more of the process colors to duplicate the original art. In the printing process, this is the combination of colors that produces the final result and causes a hue error that requires

compensation or color correction. 2) Changing an image's pixel colors to achieve a specific result. Brightness, contrast, midlevel grays, hue, and saturation all can be adjusted.

Colored gel: Transparent material used to change the color of the object being highlighted.

Color proof: A proof designed to duplicate the original art and allow for final checks before the actual printing process takes place. 3M Matchprint, DuPont Cromacheck, and Kodak Double Check are examples of color proofing systems.

Color scanner: High-intensity lights, such as a laser, are used to scan transparencies or glossy photographs and to make color-separated negatives.

Color separation: The process by which an image is separated into the four process colors, cyan, magenta, yellow, and black. In four-color printing, a plate is developed for each of the process colors.

Color temperature: The temperature an object that doesn't reflect any light would have to be heated to produce a given color. This number is expressed in degrees Kelvin (K).

Color-temperature meter: The instrument used to estimate the color temperature of a light source. This is typically how a photographer determines the filter required to match the color balance of the light source with the color film being used.

Composite proofs: One form of proof that shows the position and color of all elements of the original art before plates are burned.

Comprehensive: A pencil sketch showing all the design elements that depicts how the finished product will look.

CompuServe GIF: GIF is the acronym for Graphics Interchange Format. This is mainly used for files used on the World Wide Web and other online services that are color-indexed or images in hypertext markup language (HTML). GIF files are compressed for faster transfer times over telephone lines.

Continuous-tone image: 1) An image that shows the difference in tone gradients from black to white. 2) A photographed image before the four process colors are separated and broken into dots.

Contrast: The difference in tone between the lightest and the darkest color or tone areas in a photograph. In a black-and-white photograph with high contrast, there are more black-and-white tones and few gray or middle tones.

Cool: Bluish-green colors associated with snow and ice.

Coverage: In the printing process, the amount of ink (indicated by a percentage) on a page.

Crop marks: Symbols or marks, outside the image area, that indicate to the printer and bindery which areas are to be printed or trimmed.

Curl: An undesirable paper characteristic caused by humidity or mechanically at the paper mill, in storage, or on the printing press. Curl is characterized by a waviness usually at the edge of the sheet of paper.

Cyan: One of the four process colors used in printing. Commonly known as process blue.

Daylight-balanced film: Color film balanced to produce accurate-color photographs when the light source is similar to midday sunlight or with an electronic flash. Rated at 5500K.

DCS: The acronym for "desktop color separations." An extension of files saved in the EPS ("Encapsulated Postscript") format that enables certain programs to read imported files and print color separations. DCS creates five separate files: one for each process color channel and a fifth master file where all channels are combined.

Depth of field: The distance between the closest and farthest points on the subject that remain in focus.

Diffuser: Usually a clear or white frosted plastic or acetate material that is used to soften and evenly distribute an artificial light source.

Diffusion screen: A wooden frame or box constructed to hold white or clear plastic frosted diffusing material. As the light strikes the diffuser, it is evenly distributed.

Digital soft proof: A photograph, text, or data file that is displayed on a color computer monitor.

Dot: The smallest element of a halftone.

DPI: The acronym for "dots per inch." This term refers to the printed page and how many dots are laid down per inch. Most dye-sublimation printers are 300 dpi, continuous-toned photo-realistic printers.

Dylux: A light-sensitive proof that is produced in blue or black.

EPS: The acronym for "Encapsulated Postscript." A type of file format used when the image to be saved includes text.

Feathering: Highlighting with the edge of a light source rather than directly to produce softer, more diffused, and less intense lighting.

Fill board: A reflective surface that light is bounced off to lighten shadows without causing another shadow.

Fill lighting: Secondary lighting used to brighten shadows without creating additional shadows. A fill light usually isn't as strong as a primary light source.

Filter: 1) A tinted material (usually colored glass or plastic film) that either completely or partially absorbs light passing through it. 2) To use a filter to alter the rays of light reaching the subject.

FPO: The acronym for "for position only." This term refers to the inexpensive reproduction of photographs or other art in mechanicals simply to indicate placement and size.

Gobo: A board or some other device used to direct light away from the camera lens or parts of the subject.

Gray card: A card made of material that reflects a known percentage of light. Used to determine exposure readings, the card has a gray side reflecting 18 percent of the light and a white side reflecting 90 percent of the light. Light meters use a gray tone of 18-percent reflectance to determine exposures. A gray card also provides a known gray tone for color work.

Halftone: An image or photograph in which the tones are screened into a pattern of dots that are close together in dark areas and farther apart in light areas. The dots give the illusion of a continuous tone.

Highlight: 1) The brightest area of a photograph, where most of the most light is directed. It becomes the darkest and most dense area in a negative. A highlight is also called a "high value." 2) The smallest dots in a halftone, representing the lightest area of a photograph.

Hue: One of the three dimensions of color.

Imagesetter: A method of transferring data onto photosensitive paper or film by using a high-resolution laser. It can record halftones, line images, and type.

Incident light meter: A meter that determines exposure times by measuring the amount of light falling on a subject.

Inkjet: One of the methods for printing images that use jets to squirt very small amounts of ink onto the surface being printed.

ISO: 1) The acronym for "International Standards Organization." 2) A rating system based on a film's light sensitivity. The higher the rating, the more light-sensitive the film is. For example, an ISO 1000 film is more light-sensitive than an ISO 100 or ISO 200 film.

JPEG: The acronym for "Joint Photographic Experts Group." Images saved in this mode are most commonly used for display over the World Wide Web or other online services. JPEG images work by compressing information and reducing file sizes by discarding data not needed to display the image. JPEG images retain all RGB color information.

Kelvin: The unit of measure used to determine the color temperature of a light source.

Key light: The light source that controls the direction of shadows. It is usually the brightest and most intense source of light in a photograph.

Keyline: A term used for the layout that indicates all the page elements, including type, illustrations, and all other art in their exact shape and position as they'll appear in the final printed piece. A keyline is also known as a "mechanical."

Knock out: The removal of either all the printing dots from a specific area or all the dots surrounding an image.

Layout: A sketch or drawing that shows the proposed size and general appearance of the finished piece. It typically indicates where all the elements will be placed and their relationship to each other.

Magenta: One of the four process colors used in printing.

Main light: This light casts the dominant shadows and helps define the feel of the photograph. It is the primary source of light for studio work. This type of light is also called the "key light."

Mask: An opaque overlay that prevents any part of a photograph or transparency from being exposed to light.

Matchprint: The positive single sheet proofing system that simulates SWOP specifications. Developed by 3M.

Mechanical: A complete page with text, line art, photographs, and crop marks that is ready to be photographed or output to film. A mechanical is also called a "keyline."

Middle gray: A standard gray tone of 18 percent reflectance.

Midtone: The density or tone of a dot that is halfway between the highlight value and the shadow value.

Moire: Objectionable wavy patterns that appear when two or more screen patterns are placed over one another. A moire is usually caused by misalignment, incorrect screen angles, and slippage.

Negative: A piece of film in which the light and dark images are reversed from the original art.

Neutral gray: The gray tone between white and black that doesn't have any apparent color cast or hue.

Nonreproducible colors: Natural colors (some produced through photography) that can't be reproduced using process inks. An example is a very dark, deep, rich, wine red or green.

Overexpose: To expose film or paper to too much light, resulting in light or weak images.

Pagination: 1) The process of numbering pages in order. 2) The process of performing page makeup on a computer.

Paste-up: The manual or electronic process of arranging graphics and text on a page.

PCX format: Established for the Paintbrush software and is most commonly used by IBM PC-compatible computers.

PDF file format: PDF files can represent both vector and bitmap graphics when based on the Postscript Level 2 language. PDF pages are similar to Postscript pages, but they can also contain "Search" and "Navigation" features for electronic documents. This format is used for the Adobe Acrobat application program.

Photoflood: An incandescent lamp with a relatively short life span that is used to produce an intense, very bright light.

PICT file: Used when transferring files between different application programs for Macintosh graphics and page-layout purposes. The PICT file can compress large areas of solid color, which is dramatic for alpha channels that often consist of big blocks of white and black. Different pixel resolutions can be chosen when an RGB image is saved as a PICT file.

PMS: The acronym for "Pantone Matching System." This color-matching system allows exact color selection and matching from a wide range of controlled, preprinted color swatches.

Position proof: A color proof used to verify that the text, photographs, and illustrations are correctly positioned.

PPI: The acronym for "pixels per inch." Refers to an image-capture device or monitor that displays digital information or pixels.

Prepress: All the work that is performed by the printer, separator, or service bureau prior to printing. It typically includes camera work, color separation, stripping, plate-making and the other functions necessary to prepare the job for printing.

Prepress proof: A color proof that is used as a final check before running the job on a printing press.

Primary colors: The colors that form the basis for reproducing all the colors of the spectrum. Cyan, magenta, and yellow are subtractive primary colors; red, green, and blue are additive primary colors.

Process colors: Cyan, magenta, yellow, and black color pigments used in the four-color printing process.

Quarter-tone: An image or photograph in which the tones are screened into dots that are 25 percent of the normal printing dot size, halfway between the highlight and midtone.

Rainbow: A digital, high-resolution, desktop color-proofing system. Developed by 3M.

Reflector: 1) A piece of white cardboard or some other reflective material that is used to redirect light. Often used to soften shadows. A reflector is also called a "flat." 2) A cone or bowl-shaped reflective surface placed behind a lamp to direct more light at the subject.

Reflector board: A shiny, reflective surface used to bounce light back into the subject area.

Registration: The correct positioning and alignment of all the images from each color plate.

Run around: Text or type designed to fit around a photograph, an illustration, or some other piece of art.

Screen ruling: The number of rows or lines of dots per lineal inch on a halftone screen.

Scrim: A screen or some other device made to decrease the amount of light transmitted from a light source.

Service bureau: An intermediary business employed to manipulate and output digital files, usually to a Postscript imagesetter.

Shadows: The dark areas in a photograph. In a halftone image, shadows are represented by the largest dots.

Sharpening: Reducing the size of dots in halftones to make the image clearer.

Shutter speed: The length of time that film in a camera is exposed to a light source.

Snoot: A circular or cone-shaped attachment fitted over a strobe light to define and narrow the beam of light.

Softbox: A light source with reflective sides and back and a translucent front that is used to diffuse light and provide a soft, less intense exposure.

Spotlight: A light source used to provide a narrow, tightly focused beam of light.

Spot meter: A light meter used to determine exposure times. It has a very small angle of view and primarily measures the brightness of a small portion of the subject.

Standard viewing condition: A neutral gray area used for viewing transparencies, photographs, and other printed pieces that is illuminated by a 5000K light source.

Strip light: A softbox that is elongated or rectangular in shape, usually in a 1:3 or greater proportion.

Tenting: A lighting method used primarily on highly reflective objects. The subject is surrounded with large sheets of paper or translucent material so the light reflects off them and not the lamps and camera.

TIFF: The acronym for "Tagged-Image File Format." Used when saving files that will be exchanged between different computer programs or used in separate applications. Files can be saved as either Macintosh- or IBM-compatible. They can also undergo LZW compression, which doesn't discard any data (unlike the JPEG mode).

Tonal compression: The reduction or compression of the tonal range of an original piece of art to one that can be achieved through the normal reproduction process.

Tonal range: The difference in tones, from the lightest to the darkest, in a photograph or some other reflective art.

Tone: One of the three dimensions of color. The different shades or hues one color can exhibit, whether it tends to be light or dark.

Transparency: A translucent material with an image recorded on it that can be viewed by holding up to a light source. A transparency is also called a "slide" or "film positive."

Tungsten film: Color-balanced film used to produce a color photograph or transparency when the light source has a color temperature of about 3200K (like many tungsten lamps). This film is also called "Type B film."

Tungsten lighting: Light emitted from ordinary light bulbs that contain thin tungsten wires that glow or emit light when an electric current is passed through them. This type of lighting is also called "incandescent light."

Ultraviolet light: Part of the color spectrum just beyond violet. It is invisible to the human eye but strongly affects photographic materials.

Value: A term used to express a subject's relative lightness or darkness. Low values represent a dark area, while high values indicate a light area.

Warm: Reddish-orange colors that are associated with the sun and a feeling of warmth.

Web: Rolls of paper used in the web or rotary printing process (in contrast to sheet-fed printing).

Yellow: One of the four process colors used in printing.

CONTRIBUTORS

Midge Bolt

Access Technology Photographer Midge Bolt
5317 Aldrich Avenue South
Minneapolis, MN 55419
612-823-1788

Midge Bolt has been involved in digital photography since 1993. She entered this world when an associate offered to teach her Adobe Photoshop in exchange tor marketing assistance. At the same time she worked with a photographer who was shooting with the early Kodak DCS digital camera. In 1994 she was hired by a prepress service bureau to set up and manage a digital photography studio. During her two-year stint, she found that in the digital world, a photographer also becomes the scanner; instead of sending off film to the lab and moving on to the next shoot, she was responsible for resolution, color, retouching, and archiving. Bolt now has her own digital consulting service and has also started a company specializing in the restoration of historical photographs and documents using digital technology.

Butkowski Photography

2803 Clearwater Road
St. Cloud, MN 56301
320-253-9493
Fax: 320-253-7314

Butkowski Photography is a full-service studio specializing in commercial, advertising, and industrial photography. It regularly serves a variety of clients in manufacturing, retail, and the advertising marketing community. Since opening the studio in 1989, owner Joel Butkowski has been the recipient of numerous advertising and photographic awards. During the past four years, Butkowski Photography expanded its services by locally pioneering the way in digital image capture. Butkowski has been featured as a keynote speaker at nationwide conferences on digital imaging and digital image capture, and is also sought after by educational institutions for his digital expertise.

Christensen Carver Digital (CCD)

286 Fifth Avenue, 8th floor
New York, NY 10001
212-563-0402
Fax: 212-279-2839

CCD is an established photography studio and production facility that uses the speed and flexibility of digital technology to enhance the creative control of traditional assignment photography. CCD was the winner of the 1996 Andy award for its collaborative work on the Levi's interactive kiosk, and CCD has been a Scitex Leaf Beta/Demo site for digital cameras and prepress software for three years. Photographer Paul Christensen has photographed both people and products, on set and on location, for leading advertising, editorial, and corporate clients for more than 18 years. In addition to his commercial experience, Christensen has worked in experimental photography and printing techniques.

In 1992, Christensen teamed up with multimedia producer/director Douglas Carver to provide clients with all the advantages of the newest digital technology for both print and interactive media. Carver has done still-photography projects for the American Ballet Theater, New York City's "7th on 6th" fashion runway shows, and the Grateful Dead. Carver has also produced, directed, and photographed corporate, industrial, and documentary events throughout the United States and Asia since 1980, for such clients as *Vogue* magazine and the New York City Opera.

Studio Fineman, Inc.

4912 SW 74th Court
Miami, FL 33155
305-666-1250
Fax: 305-284-9471
E-mail: fineman@earthlink.net

With Michael Fineman's training and background in advertising photography, and his having won more than 75 Addy, National Addy, Andy, and Gold Medal awards from the Art Directors Club of New York, he thought it would be a breeze to master digital. But for all his experience, he wasn't prepared for the steep learning curve required to control digital as he could control film. This involves understanding that digital sees light differently than film, computers, such imaging software as Adobe Photoshop, and prepress concerns. Although Studio Fineman is currently doing more and more client-direct catalog work, much of its business is high-end advertising, shooting digitally for Sony, Bacardi, DHL, Xerox, Marshall's, Ryder, and OZ/Fittipaldi.

Studio staff includes Ray Rodriguez, Imaging and Design; Sam Baker, Studio Manager; Gary Galasso, Prepress Specialist; and Thelma Conrado, Account Executive.

Holt Photography

7601 Washington Avenue South
Edina, MN 55439-2471
612-944-0202
Fax: 612-941-6576

Holt Photography was founded more than 20 years ago by Ralph Holt, who sought to follow his creative instincts. Having started with architecture, the studio evolved into specializing in food, jewelry, special effects, and motorcycle products. The studio has a 35-foot triple cove wall, full kitchen facilities, and drive-in/dock high doors. Since merging with TradeMark Communications, an Upper Midwest advertising agency, the studio has added digital camera equipment. This gives the client quick turnaround and, more important, increased control over the final output. All lighting and camera formats are available. Dale Hanson, one of the studio's photographers, has shot digitally for more than six years.

Stephen Johnson

P.O. Box 1626
Pacifica, CA 94044
415-355-7507

Stephen Johnson has been photographing since 1973, and teaching and lecturing on photography since 1977. He runs his own photography, publishing, and design business, scanning and preparing his photographic books, posters, and calendars digitally. His books, which include *At Mono Lake*, the award-winning and critically acclaimed *The Great Central Valley: California's Heartland*, and *Making a Digital Book*, have been exhibited, published, and collected nationally and internationally. Johnson's photographic work has concentrated on landscape projects: exploring wild, endangered spaces and human-altered lands, while focusing on soft color and abstract design. As his projects became more complex, he needed to assert even more control over the context and reproduction of his work so it seemed natural to use computer technology for the publishing and design tasks related to his photography. Johnson began to use digital photography software for image restoration, scan straightening, spotting, duotone creation, and fine-tuning color reparations. He has also worked on refining the new tools of digital photography with the hope of empowering individual artists to use these tools to express their ideas.

Les Jorgensen Photography

45 East 20th Street
New York, NY 10003
212-358-1092
Fax: 212-358-1093

Les Jorgensen worked as a psychologist for 16 years before deciding he wanted to pursue a career in photography. He attended Brooks Institute of Photography for formal schooling in photography's technical side before moving to New York, where he began his own business. He worked as a traditional photographer for six years before expanding to include digital, which has freed his mind to consider new possibilities, to do illustrative work, and to offer a better end product. Jorgensen's areas of photography include, in order of revenue, advertising, illustration, Internet, editorial, and increasingly, catalog. The percentage of digital work is growing. He is also active in fine-art and stock sales. Almost all of his work is done in the studio and would be traditionally known as table-top.

Lightspeed Studios, Inc.

217 NE Eighth Avenue
Portland, OR 97232
503-232-3812

Owner Andrew Haddock founded Lightspeed Studios in 1990 as a traditional photography studio, and expanded its services to provide digital image capture three years later. For three months in 1993, the studio experimented with the Leaf digital capture system and has been shooting digital ever since. Although Haddock originally used the Leaf digital back with a Hasselblad, he now use the Fuji 630GX body for the added lens swing and tilt movements. He chose the Leaf system in part because of its ability to work with strobe or continuous light sources. Almost more important, however, he has found the Leaf DCB software to be invaluable for fast, detailed control of the captured images.

The majority of Lightspeed Studios' work is for catalog and illustration/editorial jobs, and 95 percent of the time Haddock uses the digital system. For full-color location and people shots he still uses film and traditional methods. The most important change to the studio's work has been additional services it can now provide, such as QuickTime VR, Web development, interactive CD-ROM, and video editing.

Stafford Photography

1018 North Fifth Street
Minneapolis, MN 55411
612-333-2122
Fax: 612-333-2278

Stafford Photography is one of the first commercial studios to offer advertising agencies and other print-production customers a new, advanced digital photography service that owner Joe Stafford says crosses a threshold in digital technology. Through a unique manufacturer/user relationship, the studio has been a test site for the BigShot, a digital camera developed by Minneapolis-based Dicomed.

The BigShot is the first camera capable of capturing motion, large-format images, and a wider color dynamic range than other digital cameras or traditional analog cameras. After six months of testing the results of several print-production pieces using images made with the BigShot, Stafford believes that digital photography has come of age. He is confident in offering the new technology to clients, who save considerable time during the print-production process and, on certain projects, also money.

Stephens Photography Inc.
4764-B Hammerhill Road
Tucker, GA 30084
770-493-4009

Born to serious amateur photographers, Don Stephens began shooting and processing his own pictures at age eight. He photographed for his high school yearbook for two years, then paid his way through college with a photography business. He began his second photography business, Stephens Photography Inc., as a part-time venture a couple of years before retiring from the Army, where he served for 20 years. The studio became a full-time operation in 1982. Stephens specialized in commercial and industrial work, with most of his volume from catalog and advertising. The "shoot-to-size," gang-separated catalog illustrations that predominated his work in the 1980s became less important during the 1990s as color separations became less important, and Stephens gradually changed over to medium format for nearly everything.

Working closely with designers and color separators, he was aware of the potential of digital cameras to revolutionize photography for reproduction. Today he finds his medium-format gear slipping to a secondary position as his digital work grows and he gains new clients that he never could have brought on board with conventional photography. In 1996, Professional Photographers of America awarded Stephens the Master of Photography degree. He is active in the American Society of Media Photographers, serving on the board of directors of the Atlanta/Southeast chapter.

Eddie Tapp
1536 Hickory Drive
Lilburn, GA 30247
770-925-4482

Eddie Tapp has been working as a professional photographer in Atlanta since 1973, doing everything from commercial, industrial, portrait, and fashion photography, to his current foray into digital imaging and prepress. And his 12-plus years of experience in computer technology have lead him to the cutting edge of photography. As a frequent lecturer/teacher at professional workshops and schools throughout the United States, including Winona International School of Professional Photography, he has had the opportunity to share with others his extensive knowledge of digital imaging, prepress, and advanced photography. Tapp frequently runs seminars and personalized training programs at corporations, agencies, and photographic conventions, including Eastman Kodak Company. He has also served as a print judge for many professional photographic competitions.

An award-winning photographer himself, Tapp is the chairman of the Digital Imaging Specialty Advisory Group, serves on the Winona Education Committee for Professional Photographers of America (PPA), and is the Commercial Council representative to PPA for the Georgia Professional Photographers Association. He holds the Master of Electronic Imaging and Photographic Craftsman degrees and is PPA-certified. His articles have appeared in *Professional Photographer*, *Photo Electronic Imaging*, *Infoto*, *Southern Exposure*, and other magazines.

Andra Van Kempen
2803 Clearwater Road
St. Cloud, MN 56301
320-253-9493
Fax: 320-253-7314

A graduate of St. Cloud State University with a degree in mass communications, Van Kempen first became interested in photography through a close friend. After working in public relations as a university photographer, she joined the staff at the school paper, where photojournalism became a main interest; she was also able to work on a part-time basis at *The St. Cloud Times* for four years. Upon graduation, photographer Joel Butkowski hired her as an assistant. Recently she and her husband, photographer Paul Middlestaedt, opened their own studio. This husband-and-wife team's services include advertising, public-relations, sporting-event, and wedding photography. The studio also offers full service photo restoration, from touching up photographs and generating new negatives for prints, to image enhancement for all type of needs.

INDEX